NORTH LIGHT'S
BIG BOOK OF Painting

Watercolor
Flowers

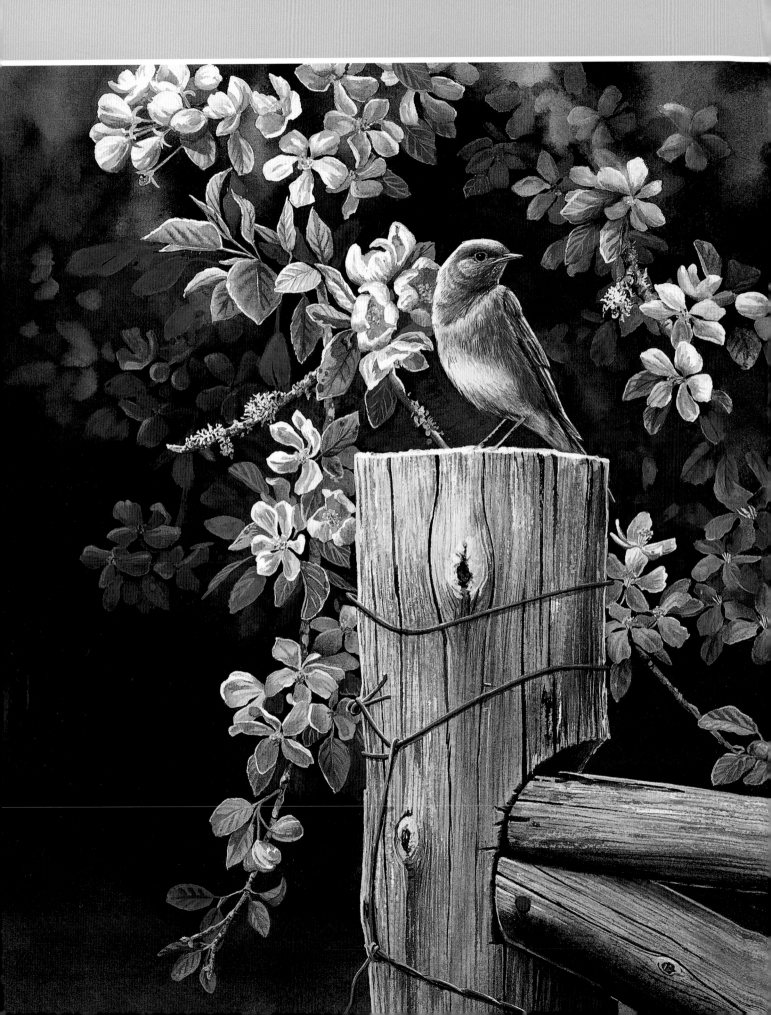

NORTH LIGHT'S BIG BOOK OF Painting Watercolor Flowers

Edited by **PAM WISSMAN** and **CHRISTINA XENOS**

NORTH LIGHT BOOKS
CINCINNATI, OHIO
www.artistsnetwork.com

BLUEBIRD AND APPLE BLOSSOMS
(Western Bluebird)
Susan Bourdet
26" × 18" (66cm × 46cm)

Material in this book was excerpted from the following North Light publications:

Painting Close-Focus Flowers in Watercolor by Ann Pember: pages 16–17, 20–21, 25–28, 30–31, 34–37, 40–43, 60–65, 70–71, 77–89, 100–109, 122, 125 (12, 13, 15, 18, 24, 25, 33, 34, 51, 52, 54, 55, 64, 65, 72, 73, 74, 75, 98–125, 131–133, 188, 189)

The One-Hour Watercolorist by Patrick Seslar: pages 40–43 (86–89)

Painting Flowers in Watercolor with Charles Reid: pages 10–11, 16–19, 26–27, 30–31, 34–37, 40–43, 74–75, 78–79, 84–85, 88–90, 94–95, 110–121, 134–141 (10, 11, 28–31, 52, 53, 56, 58, 59, 67, 76–79, 90, 91, 126–130, 146–171)

Painting Crystal and Flowers in Watercolor by Susanna Spann: pages 18–19, 40–41, 50–55, 100–109 (60, 61, 70, 71, 80–85, 172–181)

Watercolor: Pour It On! by Jan Fabian Wallake: pages 18–20, 31–33, 53–54, 80–85, 88–89, 96–101 (16, 20, 21, 26, 27, 46, 47, 66, 68, 69, 134–145)

Painting the Allure of Nature by Susan D. Bourdet: pages 14–15, 17, 26, 44–49, 62–67, 70–73 (14, 17, 19, 22, 23, 34–41, 45, 92–97)

Painting the Things You Love in Watercolor by Adele Earnshaw: pages 38–39, 66–71 (62, 63, 182–187)

Watercolor Wisdom by Jo Taylor: pages 13, 16–17, 71, 113–114 (42, 43, 44, 48, 49, 57)

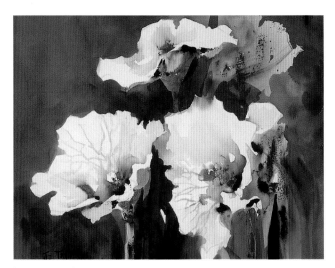

LOOKING FOR LIGHT
Jo Taylor
11" × 15" (28cm × 38cm)

Other fine North Light Books are available from your local bookstore, art supply store or direct from the publisher.

09 08 07 06 05 5 4 3 2 1

Library of Congress Cataloging in Publication Data

North Light's big book of painting watercolor flowers / edited by Pam Wissman and Christina Xenos
 p. cm.
 Includes Index.
 ISBN 1-58180-625-6 (pbk. : alk. paper)
 1. Flowers in art. 2. Watercolor painting--Technique. I. Title: Big book of painting watercolor flowers. II. Wissman, Pamela III. Xenos, Christina

ND2300.N82 2005
751.42'24343--dc22

 2004049239

Edited by Pam Wissman and Christina Xenos
Cover designed by Wendy Dunning
Interior designed by Barb Matulionis
Production edited by Jenny Ziegler
Production coordinated by Mark Griffin

METRIC CONVERSION CHART

To convert	to	multiply by
Inches	Centimeters	2.54
Centimeters	Inches	0.4
Feet	Centimeters	30.5
Centimeters	Feet	0.03
Yards	Meters	0.9
Meters	Yards	1.1
Sq. Inches	Sq. Centimeters	6.45
Sq. Centimeters	Sq. Inches	0.16
Sq. Feet	Sq. Meters	0.09
Sq. Meters	Sq. Feet	10.8
Sq. Yards	Sq. Meters	0.8
Sq. Meters	Sq. Yards	1.2
Pounds	Kilograms	0.45
Kilograms	Pounds	2.2
Ounces	Grams	28.3
Grams	Ounces	0.035

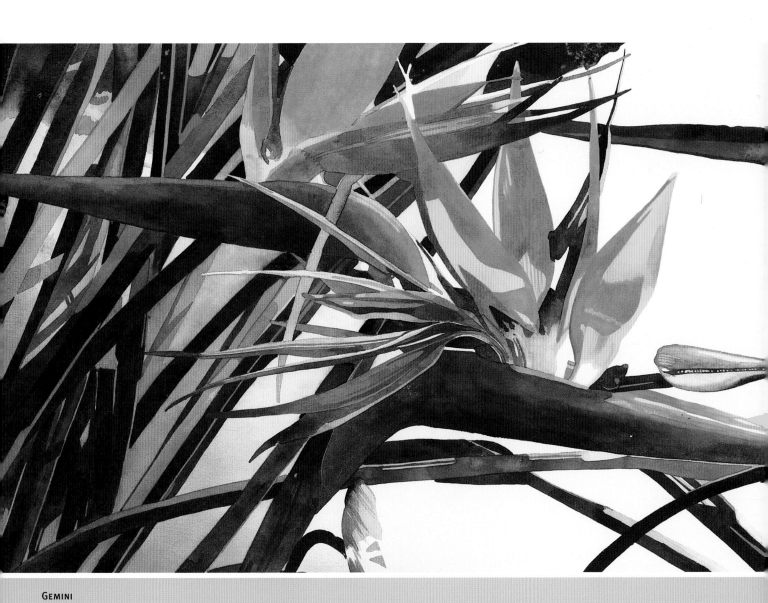

GEMINI
Susanna Spann
30" × 40" (76cm × 102cm)
Collection of Jackie Sinett

Table of Contents

Introduction 8

CHAPTER ONE

Getting Started 10

Learn how to set up your studio and use your materials, including paints, palette, paper and more.

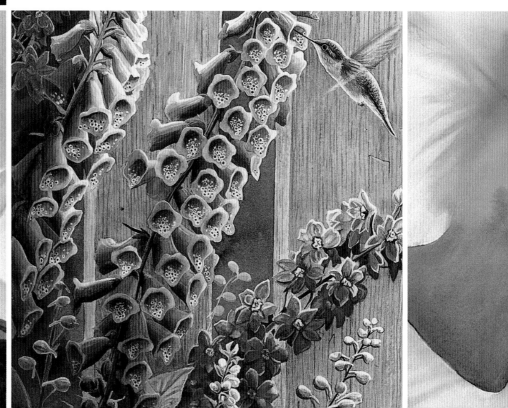

CHAPTER TWO 2

Basic Techniques and Color 22

Discover painting methods, brushwork tips, watercolor techniques and color properties.

CHAPTER THREE 3

Shapes and Composition 60

Master arranging your subjects into a powerful design. Learn to apply light and shadow to a variety of shapes. Create gorgeous floral paintings from reference photos.

CHAPTER FOUR 4

Demonstrations 90

Paint a variety of watercolor flowers using different techniques and styles to expand your range.

Gallery 188

Index 190

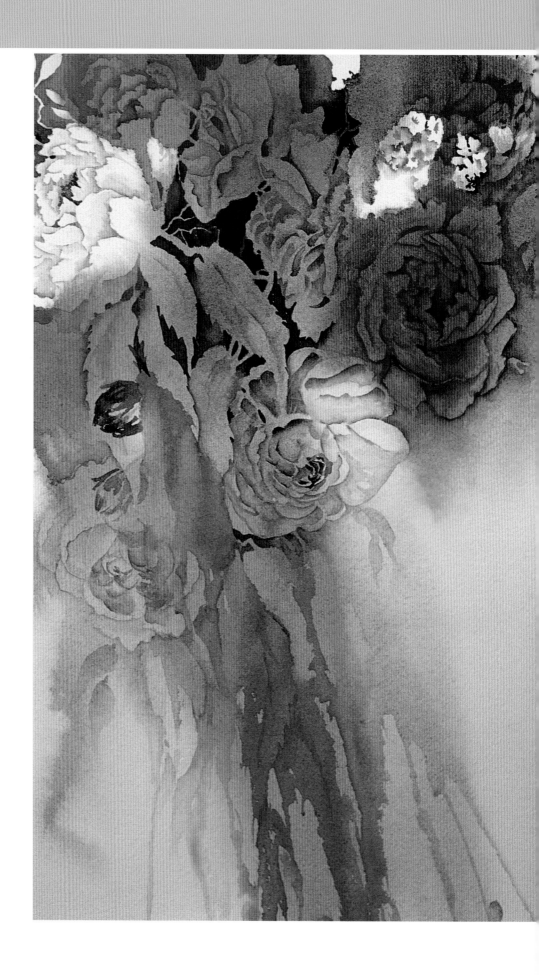

INTRODUCTION

If you have recently found yourself gazing longingly at beautiful bouquets of your favorite flowers, just wishing you could capture them in your watercolor paintings, then this is the book for you. No matter what your artistic level, the instruction in these pages will provide you with a wide range of techniques to paint these gorgeous flowers in watercolor.

You will learn North Light's best methods from eight of its finest authors. They will provide you with foundational techniques, while also showing you a myriad of tips and tricks.

Using flowers as your inspiration and this book as your guide, you will be well on your way to creating fabulous flowers in your watercolor paintings.

ROSE GARDEN II
Jan Fabian Wallake
14" × 10" (36cm × 25cm)
Collection of Donna Kidd

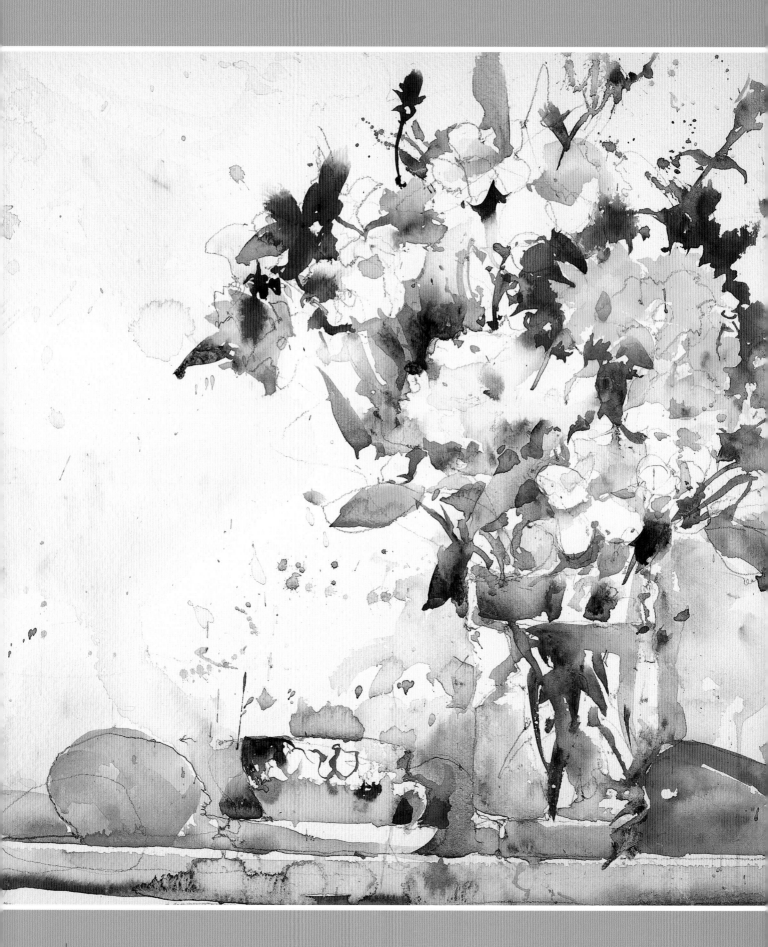

Getting Started

In this section you will learn the essentials for setting up your studio, choosing your materials and stretching your paper. If you have painted for a while, you'll already have paper and colors you're comfortable with; stick with them. It's fun to experiment, but don't make paper and color changes that might cause unnecessary problems. The one element you should pay close attention to is your brush. Select good quality brushes that have spring.

Economy is the key when you are working with your brush or mixing paint. Less is always better, with one exception: You'll need lots of moist paint. The fewer the strokes you take and the less you have to mix colors, the fresher your painting will be.

URCHFONT FLOWERS
Charles Reid
22" × 24" (56cm × 61cm)
Collection of Jan and Ian Wright

Studio Setup

Claim a spot for your studio if you haven't already done so. It will put you in the mood to paint whenever you go there. Even a closet is a possibility! It's great to have proper tools and storage for everything, but you can manage quite nicely with a simple table and easel.

Try Working on a Tilted Board

Working on a flat surface can cause puddling and increase the likelihood of making mud. With the paper tilted, gravity makes the paint move and mix, producing lovely passages of color. Though at first it may seem hard to control drips, after a few experiences you will learn how much water and pigment to use to retain control. The effect is almost like that of pouring paint on a wet surface; it gives a fresh look to the work. Try at least a moderate angle to get your paint moving. For example, start by placing a 2" × 4" (5cm × 10cm) piece of wood under the upper edge of your board on a table.

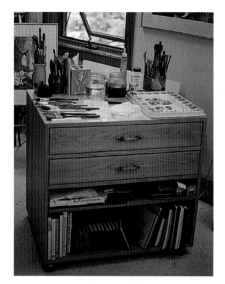

TABORET

This taboret is adapted from a wooden kitchen cart. It has a washable laminate top, two drawers and an open space with an adjustable shelf. It measures 32" (81cm) long by 29½" (75cm) high by 24½" (62cm) deep and is set on casters for ease of movement. The storage shelves on the bottom hold sketchbooks and extra supplies, and the two drawers hold paint and reference material.

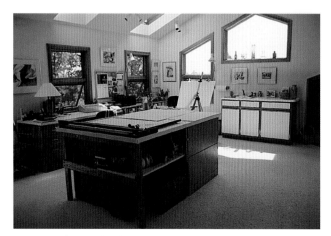

A cutting table used to frame artwork.

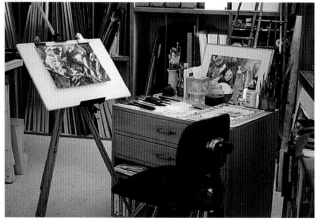

The painting area of a studio with an easel and taboret.

Choosing Your Materials

The most important consideration when purchasing materials is to use the best quality paper and paint you can afford, and use brushes that hold a clean knife-edge if flat or a fine point if round.

Paper

There are many variables in water-color papers, including: weight (thickness), manufacturing process (machine-made, moldmade or hand-made), sizing (an additive that makes paper resist fluid; it may be an exterior coating or it may impregnate the paper), and form (sheets, board or blocks). A good choice is a rag paper that resists buckling and allows easy lifting. Try 140-lb. (300 gsm) or 300-lb. (640 gsm) cold-pressed paper.

Purchase a trial pack with one sheet of several different papers. Materials can be personal, so try supplies like paper yourself to see what feels most comfortable to you.

When handling paper, be careful to hold it lightly by the edges. Pressing down with your fingers leaves oils that may repel paint and leave a mark. If you soak and stretch your paper (see page 21), use only a soft natural sponge without any sharp pieces of coral in it. Dust dry paper off with a soft 2- or 3-inch (51mm or 76mm) brush before beginning to paint. This gets rid of any dust particles that may dry into a wash.

Brushes

A brush is a wonderful tool, working as an extension of your hand and mind. Handle the bristles carefully. Oils from your skin could make them repel pigment as you paint, and may

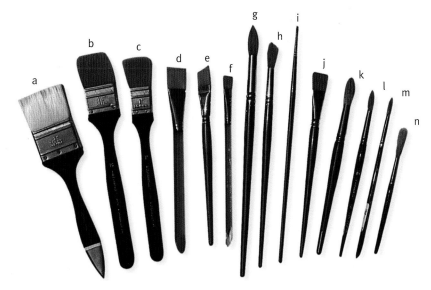

BRUSHES

From left to right, the brushes shown are: **a:** Robert Simmons 2-inch (51mm) Skyflow Wash 278W; **b:** Grumbacher Sable Essence 1½-inch (38mm) flat, no. 4424; **c:** Grumbacher Sable Essence 1-inch (25mm) flat, no. 4424; **d:** Holbein Series 500 1-inch (25mm) flat; **e:** Winsor & Newton Regency Gold ¾-inch (19mm) angled, no. 560; **f:** Maestro Gold ½-inch (12mm) flat, no. 500; **g:** Winsor & Newton Sceptre Gold no. 14 round, series 101; **h:** Winsor & Newton Sceptre Gold no. 12 round, series 101; **i:** Winsor & Newton Sceptre Gold no. 2 round, series 404; **j:** Winsor & Newton Sceptre Gold ¾-inch (19mm) flat, no. 606; **k:** Holbein Eldorado no. 18 round; **l:** Grumbacher Sable Essence no. 10 round, series 4420; **m:** Grumbacher Sable Essence no. 10 round, series 4425; **n:** Daniel Smith rigger, no. 2210.

age your brush prematurely. Try both flat and round brushes to see which feels best to you; most people prefer one or the other. You could get by with just a large and a small version of either flat or round brushes. Genuine sable brushes are very expensive but have the advantage of holding more pigment. They last a very long time with proper care. Many adequate, reasonably priced brushes, either all synthetic or a mix of synthetic and sable, are available in art supply stores and catalogs, often at a discount.

Whether you opt for sable or synthetic, always buy a good, reputable brand—there are some poor quality, less expensive brushes that look good but perform badly.

BRUSHES USED IN THIS BOOK

Round a brush with a round, pointed head.
Flat a brush with a flat, rectangular head and fairly long filaments.
Angled a brush with a angled head.
Liner a brush with a long slender head.
Fritch scrubber a brush with short synthetic filaments used to scrub, or lift, paint from a picture.

Palette

Use a large palette with deep wells and a large mixing area. You can even squeeze an entire tube of paint into each well and let it dry in there. Re-wet the colors each day before you start to paint, using a spray bottle. When the wells become contaminated with other colors, rinse the palette in running water, letting the water gently flush each well to keep the colors clean. This way, you waste very little paint and the colors stay clean and fresh.

One of the most vital lessons in painting is to keep your palette clean. Take the time to wash the mixing surface after each step in the painting process, because a dirty palette means muddy colors. When working on large wet-in-wet washes (see page 26) where you need to mix large puddles of color, mix the colors on a porcelain butcher's tray—then you can save the background color mixes in case you need to make a correction.

HAKE BRUSHES

When purchasing a hake brush, be sure to buy the stitched kind rather than the kind with a metal ferrule, which shed hairs at first and feel sort of clumpy. A hake brush's bristles gradually become tapered by abrasion on the watercolor paper, so the brush performs better with age. They are good for applying wet-in-wet washes.

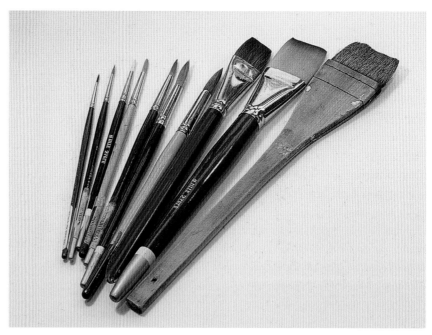

MORE BRUSHES
From left to right, nos. 1, 2, 4, 6, 8, 10 and 12 round sables or white sables, 1-inch (25mm) flat sable, 1½-inch (38mm) flat white sable and 2-inch (51mm) Chinese hake.

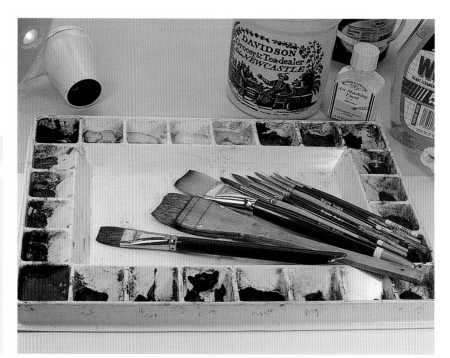

PALETTE AND BRUSHES
A palette with deep wells will hold a lot of paint, freeing you to focus on painting rather than gathering more colors for your palette.

Paints

You don't need to purchase every color because your palette of colors may be constantly evolving. There are many quality brands on the market. *The Wilcox Guide to the Best Watercolor Paints* (published by Artways) is a good reference for checking and comparing the qualities of each pigment made by each company. Be aware that not every pigment processed by every company is of lasting quality, nor do they all brush out and flow onto paper smoothly. It is important to check the lightfastness rating of the paint you buy. You don't want your masterpieces to fade away.

Start with a warm and cool (see page 46) transparent version of each of the three primaries (red, yellow and blue) and build slowly on that foundation. Leave a few wells on your palette empty so there is room to try new colors, or keep a small spare palette for this purpose. Above all else, be sure to squeeze enough pigment into the wells: at least a half-tube or more! Keep paint moist by wetting it often. This is more efficient if you flatten the pigment into the wells with a small palette knife. When you make a mound of pigment, the water runs down the sides and the top of the mound dries out.

A few tubes of pure, brilliant, professional-quality paints will produce the best results. Most manufacturers also offer a less expensive line, but these are student-grade paints. There are three basic differences between high-quality paints and the student lines.

Cost

Paint prices are based on how finely the pigment is ground, how rare the raw

BASIC PALETTE OF COLORS (ALL WINSOR & NEWTON EXCEPT WHERE NOTED)

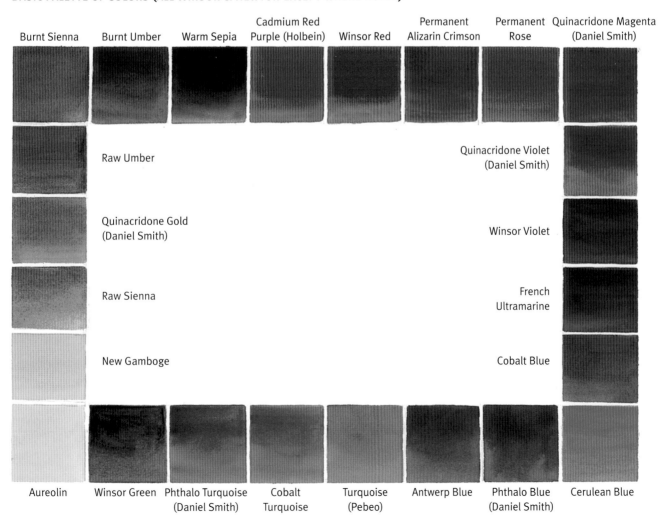

Top row: Burnt Sienna, Burnt Umber, Warm Sepia, Cadmium Red Purple (Holbein), Winsor Red, Permanent Alizarin Crimson, Permanent Rose, Quinacridone Magenta (Daniel Smith)

Left column: Raw Umber, Quinacridone Gold (Daniel Smith), Raw Sienna, New Gamboge

Right column: Quinacridone Violet (Daniel Smith), Winsor Violet, French Ultramarine, Cobalt Blue

Bottom row: Aureolin, Winsor Green, Phthalo Turquoise (Daniel Smith), Cobalt Turquoise, Turquoise (Pebeo), Antwerp Blue, Phthalo Blue (Daniel Smith), Cerulean Blue

material is and, finally, the ease of manufacturing. Student-grade paints are the least expensive because they contain a clay filler with less pigment, and the pigment is more coarsely ground.

Transparency

Pure, finely ground pigment is actually transparent; that is, light will go through the tiny specks of pigment and bounce off the paper below. You may hear of opaque transparent pigments. This means that the specks of pigment are not transparent but are ground so finely that they can be applied transparently. In this case, light will simply bounce off the paper around the specks of pigment. They can also be applied opaquely so that no light reaches the paper. The clay filler used in student-grade paints automatically diminishes transparency.

Permanence

Professional-quality paints are labeled with a permanence code. Permanence is the rated durability of paint on paper when displayed under glass in a dry place, freely exposed to ordinary daylight and atmosphere. A lightfast rating of A or AA will assure you of a permanent pigment. Look for it on the tube or pan color packaging.

Granulating or Sedimentary Colors

Some colors are *granulating*, which means that the pigments separate or mottle when washed onto paper. This is a natural, inherent quality that you can use to your advantage. These traditional pigments generally granulate: cobalts, earths and ultramarines. Sometimes distilled water will reduce granulation.

Staining Colors

Staining colors are those which cannot be lifted off the paper once they are put down. Modern, organic colors such as Hooker's Green, Indigo, Aureolin and most of the cadmium colors, for example, are made of very finely ground particles that cause them to stain. The intensity of the stain can be reduced somewhat by adding gum arabic to the paint. Look on the tube for a staining classification. You can also check a color chart at your art store for this information.

Nonstaining Colors

Nonstaining pigments do not bite into the paper and dye it. These pigments can be lifted from the paper and are best for glazing because they do not compromise the underlayers of glaze. Nonstaining colors will not destroy the translucent quality of multiple layers of glazing. If you must use a staining pigment for a glaze, generously dilute it with water.

Know Your Mediums

Mediums can aid watercolor paints in several ways. For example, gum arabic is a commonly used medium. It increases brilliance, gloss and transparency. It produces more granulation of pigments and reduces bleeding effects. Oxgall improves wetting and flow on paper.

Purchase pigments that have a high permanence rating and brilliance, which may be defined as intensity and depth of color, purity and transparency.

Tints, Tones and Shades

As you mix colors, you will also explore the use of *tints*, which are colors mixed with white; *tones*, which are colors mixed with gray; and *shades*, which are colors mixed with black. In watercolor we use tones, but since we don't use white paint very often, our version of a tint usually involves dilut-ing the color to allow the white of the paper to visually mix with the hue. Since we don't actually use black, we can create cool shades by mixing with Payne's Gray, which is really a dark indigo. Another way to create shades is to mix two intense complements (see page 56) to make a dark neutral, and then add that to the color.

Transparency

Watercolor pigments can be classified according to their degree of trans-parency. Some colors are very trans-parent, even when fully saturated. Other colors can be nearly opaque, so that the white paper can't be seen through the color layer.

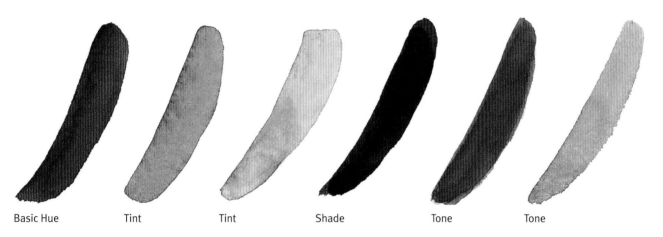

| Basic Hue | Tint | Tint | Shade | Tone | Tone |

ALTERING COLORS
You can alter the appearance of a basic hue like Quinacridone Pink by adding water to create tints, Payne's Gray to create shades and neutral grays to create tones.

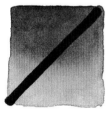 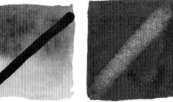

TRANSPARENT AND OPAQUE COLORS
The Hooker's Green Dark on the left is a transparent color. The black line clearly shows through when the pigment is painted over it. The Oxide of Chromium on the right is opaque. The pigment covers the black line when painted over it.

SEDIMENTARY COLORS
Transparent and partially transparent colors can also be sedimentary, which means that they are composed of fine particles that set-tle out when diluted, creating a slight tex-ture. Notice how both the Manganese Blue Hue and the Raw Sienna break down into smaller particles.

STAINING AND NON-STAINING COLORS
Many colors will stain the paper to some degree. If you wish to lift away some pig-ment to create a highlight, you must take into account that the color has actually pen-etrated the paper. Some staining quality is good when you are glazing pigments because these colors don't lift when others are glazed over them. A few colors, like the Phthalo Greens and Blues, will stain the paper so dramatically that they are impossi-ble to lift or rinse off. Ultramarine Blue on the left is a staining color, cannot be lifted, while Naples Yellow on the right is a non-staining color, can be lifted.

Other Supplies

In addition to the basics of paper, brushes, paints and palette, you will need a few other essential supplies before you begin painting.

Masking Fluid

Masking fluid can cover an area on your painting to temporarily prevent paint from getting into that area. It allows you to create a free-flowing wet-in-wet wash (see page 36) without struggling to paint around complicated shapes.

There are some things you should keep in mind when you are using masking fluid. Always check it for freshness; it should have a sharp ammonia smell. Masking fluid is a lot like rubber cement when it gets in your brushes. Always use synthetic brushes rather than true sable, because it tends to gum up on genuine sable hairs, ruining the brush. Save slightly frayed, older brushes for use with masking fluid. It helps to work a little bar soap into the bristles before you dip the brush in the fluid. Rinse the brush frequently during use and keep it wet; if masking fluid is allowed to dry on the brush, you'll have to throw it away. Cleaning with a little ammonia will help the brush last longer.

Spray Bottle

When you re-wet a painted area, you'll need to use a spray bottle rather than a brush because the brush will tend to pick up the pigment. Good sprayers are hard to find—most of them deliver a hard, focused blast that can mar the painted surface. Try recycling your old glass-cleaner bottles; the gentle spray is just right—not too hard, and not too drippy.

Water Containers

It's important to have good-sized water containers. Fill two so that you

USING MASKING FLUID

Technically, masking fluid is not a medium; it is a liquid rubber product. Some artists prefer a brand with a bluish or yellow color that is easy to see under washes. It spreads well and lifts off the paper easily with a rubber cement pickup.

You can thin masking fluid with water to help drag thin lines on your paper. Masking fluid dries out quickly when exposed to air, so pour just the amount you expect to use into a small container (old plastic 35mm film containers work well) and re-cap the original bottle. Soap up an old synthetic brush with a bar of hand soap. Dip the brush into the mask and apply it to your paper. Work for about sixty seconds, rinse your brush, and repeat the process as necessary. This will prevent the mask from drying on your brush.

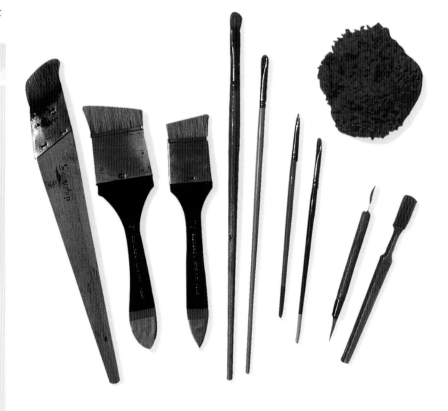

have one to rinse your brush in and another to use when you wet the paper or mix colors. Frequent water changes, especially after doing a large, dark wash, will also help to keep the colors in your artwork clean and unmuddied.

Miscellaneous Supplies

Additional tools you may find useful are:

- Palette knife
- Old toothbrushes, hard and soft
- Table salt
- 2B and 2H pencils
- Kneaded eraser
- Pencil sharpener
- Hair dryer
- Paper towels and clean, soft rags
- Old bath towels

Painting Area

The way you set up your painting area is as important as the tools you use. You'll need some color-corrected lights, a good, comfortable chair and a large flat or slightly tilted surface. Good natural light is a real asset but bright, full-spectrum artificial light will do. Full-spectrum light bulbs and fluorescent tubes are available in art supply shops and building supply stores. Place your palette and water containers conveniently on your dominant side, along with a soft, absorbent rag and your favorite brushes. Attach your hair dryer to an extension cord so you can grab it quickly and move it freely over the painting surface.

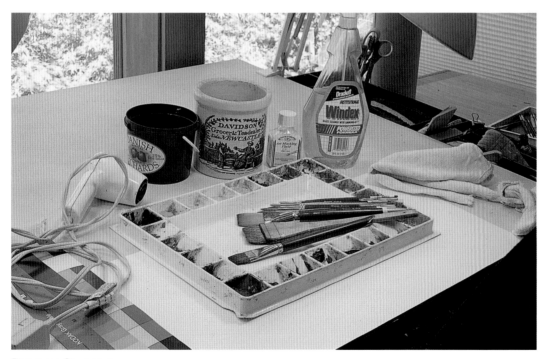

Painting Supplies
Here are just some of the supplies you may find useful when painting. Feel free to add these to your list of favorite items to use.

Paper Supports

A paper support is a surface on which to lay your watercolor paper. The board you choose will depend on what type of painting you intend to do, such as wet-in-wet, plein air or glazing.

Basswood Board

The best paper support is a basswood board. Be sure to get a good-quality basswood, not a thin basswood laminate over another board. Art supply stores carry the best boards. These medium-weight boards are best for stretching paper and will last for many years.

Gator Board

Gator board is a lightweight support board made from approximately ½-inch (1cm) thick foam with a waterproof plastic surface. For stretching paper, this board easily accepts staples, which remain firmly anchored. However, after many uses the foam-based board will break down and stretching will become harder to maintain.

Homasote

Homasote is a building product that can be purchased at builder supply stores or lumberyards. It is inexpensive and can be cut to any size. Do not use it for anything larger than 15" × 22" (38cm × 56cm), half of a standard 22" × 30" (56cm × 76cm) sheet, because it tends to warp when it gets very wet. It does take staples effortlessly and is reusable. Leaving your paper attached to this board for very long is not recommended, however, because it is not acid free.

Plexiglas

You cannot stretch paper on this surface, but quarter sheets do not always need to be stretched. If you give the back side of your paper a quick spray with water and clip the paper to the Plexiglas with large metal paper clips, it will stay flat while you paint.

Avoid using Masonite as a paper support. It is heavy, and you cannot staple down your paper. Plywood is also heavy and does not accept the ordinary desk-type staples needed to stretch paper.

Choose a paper support that you will be able to carry easily. Look for basswood, Gator board or Homasote for a reusable board on which you can staple down watercolor paper. For travel and plein air painting, try a piece of Plexiglas with some metal clips.

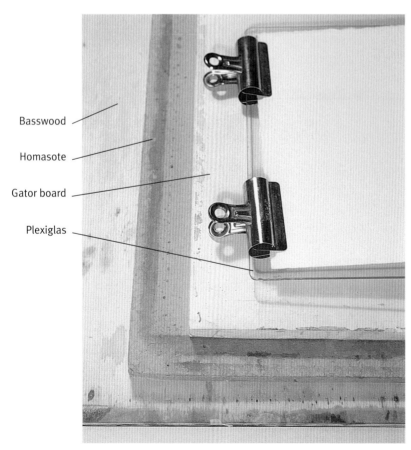

Basswood

Homasote

Gator board

Plexiglas

TYPICAL PAPER SUPPORTS

DIY GATOR BOARD

To make your own board, cut two pieces of rigid foam board ½" (1 cm) larger than your paper size all around. Place one board over the other, so the edges are flush. (Using two boards makes it less likely to warp.) Then stretch clear contact paper carefully over the whole thing, smoothing out any wrinkles. With large boards you may have to piece the contact paper to fit. Be sure to cover all edges to make it waterproof. Now you have a strong, lightweight, water-resistant board that washes off easily.

Stretching Watercolor Paper

There are many good reasons to stretch your paper. For glazing (see page 25), it is especially important to avoid the rippling that occurs when the paper gets wet. Glazing should produce a fine, even wash that is not mottled or streaked. When paper ripples, the pigments in a wash (or even in a single brushstroke across the paper) slide down off the hill and settle in the valley formed by the buckling of the paper. The result is a dark streak. By stretching the paper before you begin painting, you can easily eliminate this problem. (Flattening the paper after the painting is completed won't solve the dilemma.)

Some people pay the higher price for 300-lb. (640gsm) paper because it does not need to be stretched. It is heavy enough to withstand buckling when wet. However, 140-lb. (300gsm) paper is expensive enough, and stretching takes only a few minutes.

Ten Easy Steps for Stretching Paper

1. Run several inches of room-temperature water into a tub, large sink or tray. Gently slide the paper into the water. You may see tiny bubbles appear on the surface of the paper. This is the sizing bubbling out. Slide the paper back and forth, turn it over, and again slide it back and forth. This will break the bubbles and assure that every part of the sheet is wet. Allow the paper to soak for fifteen to twenty minutes.

2. Remove the sheet from the water. Allow as much water to drain off as possible. Be careful not to touch the paper except on the edges.

3. Lay the sheet on your paper support with the right side up. Can you read the watermark? Be sure to use a support that will accept ordinary desk-type staples easily.

4. With a stapler, put four staples close together in the middle of one edge. When working on a full sheet, start the stapling on one of the short sides. Place these staples about ½" (1cm) inside the edge of the sheet. Always work from the outside in so that your stapler does not rest on the paper.

5. Turn the board around to the opposite side. Pull the paper toward you. If you pull hard enough, a ripple will form down the center of the sheet. Hold the edge down with one hand and staple four staples close together in the center of this edge with the other hand.

6. Repeat steps 4 and 5 on each of the other two sides. Pull the paper at one corner and secure it with two staples.

7. Turn the board to the opposite corner (diagonally), stretch hard, hold and staple.

8. Now stretch and staple the remaining two corners.

9. Finish by stapling around the paper's edge every two inches (5cm). Allow the paper to dry. Your sheet will be approximately ½" (1cm) larger due to this stretching and will stay taut like the head of a drum.

10. After the paper dries completely, apply a 1½" (4cm) strip of masking tape over the staples and onto the support. The tape keeps glazes on the paper, offers a place to write notes, and prevents a wash from draining off the sheet and seeping under the stapled edge, resulting in the edge staying damp and perhaps forming an undesirable bloom (see page 33).

Taping the edges protects the staples from loosening and prevents water from seeping under the paper. The tape also provides a place to write notes on color or the direction of a glaze, or a reminder to save whites.

The soaked paper is softened and can be stretched. Pull the edge until a good ripple appears down the center. The final stretched piece will actually be approximately ½" (1cm) larger than it was before stretching.

Turn the board diagonally to the opposite corner. Stretch hard, hold and staple.

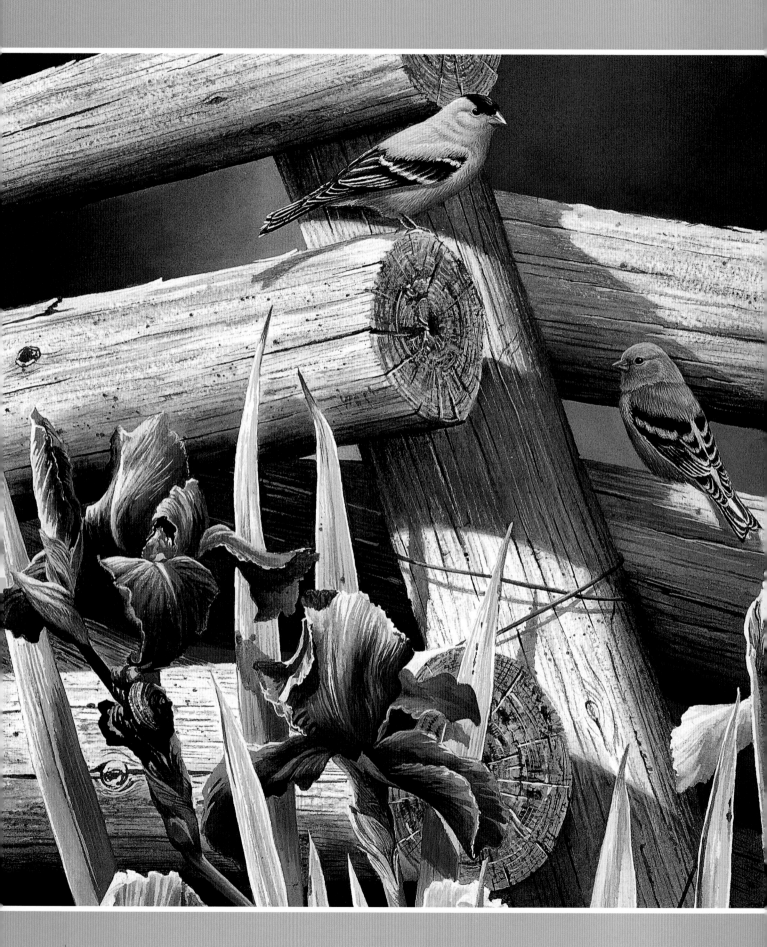

Basic Techniques and Color

Art should come from the heart, it's true. However, there is a technical side to painting, and no matter how much heart you put into your work, the results won't please you until you've gained an understanding of the basic techniques and color.

SHADES OF SUMMER
(American Goldfinches)
Susan Bourdet
16" × 37" (41cm × 94cm)

Watercolor Techniques

Wet-on-Dry Direct Painting

Direct painting is achieved by putting moist paint on a wet brush and applying it to dry paper. It can have a fresh look and be applied in any value from light to dark. The size and type of brush determines the amount of paint and water you can apply. Try to get it right with the first wash. Put the color down, soften any edges with clear water and a brush, and leave it alone!

Wet-in-Wet

Wet-in-wet painting is accomplished by applying paint with a wet brush to wet paper, making the paint run and move. There are several ways to achieve similar results.

The traditional method is to saturate the paper in a tub of cool water. Sponge off the excess water after about ten or fifteen minutes of soaking. Then staple, tape or clip the paper to a board that won't warp, or apply the wet paper to a board and squeeze out excess water with a rolled-up towel. Suction will hold the paper down for a time. Work quickly with this method and be aware that it is often hard to control the wetness and the paints' movements.

A more controlled method is to use a paper that resists buckling, and clip the four corners to a board while dry. Then wet an area with a clean wet brush, choosing one large enough to cover the area quickly. With another brush apply paint. Paint only as much as you can easily handle as one passage. Look for convenient stopping places to end the wash, such as where an element touches the edge of the paper, or where two elements meet. If that is not possible, just soften the edge with a clean wet brush. After it has dried you can carefully re-wet it, add paint from there on and the two areas will blend together. You can always wet the leading edge of your wet stroke as you move to another area, so that they blend together. At first you may get a few drips, but you'll gain control as you work more. This method takes advantage of the fluidity of the medium and still allows a hard edge if you want it.

DIRECT PAINTING
Direct painting will dry with hard edges unless you soften them.

WET-IN-WET
Wet-in-wet painting creates soft, flowing edges.

Drybrushing

Drybrushing involves moving a brush loaded with more paint than water over dry paper. This produces a textured effect as the brush skips over the surface of the paper. The greater the texture of the paper, the greater the resulting painted texture will be.

Glazing

Glazing involves the application of thin layers of transparent color, one layer over another. Each layer must be absolutely dry before the next one is applied, or you might disturb or lift the existing paint. Glazing gives the effect of looking through pieces of stained glass and can be very beautiful. The white of the paper glows through the transparent layers, producing luminous color. It is important to work on a paper that won't let the paint lift too easily. Experiment with different papers to see which ones you prefer.

Learn to compensate for the fact that the paint dries lighter in color than it looks when wet. Apply it a little more richly than you think it should be. You must be brave to do this, but it's worth trying. You can't paint timidly and expect dramatic results!

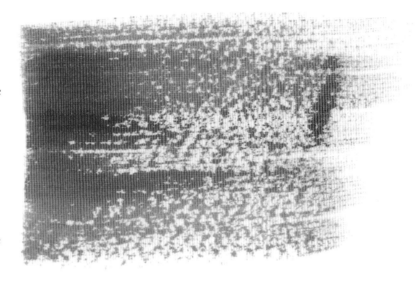

DRYBRUSHING
Create texture with the dry-brush technique.

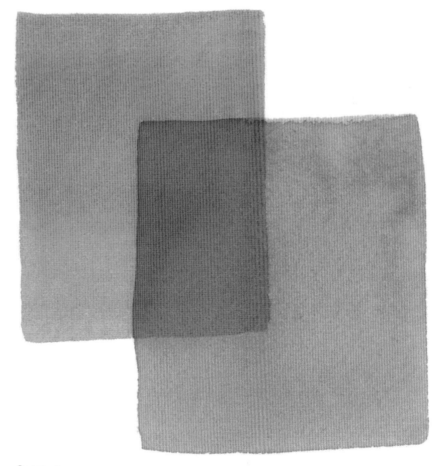

GLAZING
Permanent Rose is glazed with a transparent layer of Cobalt Blue.

Water-to-Paint Ratios

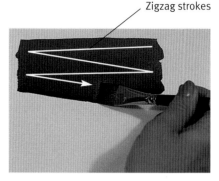

Zigzag strokes

EVEN WASH

Learning the basic water-to-paint ratios will help you apply the basic watercolor techniques by creating beautiful washes and skilled brushwork.

Mix a Proper Paint Consistency

To realize the maximum potential of each pigment color, mix a pool of water and paint to a creamy consistency. Start by putting a small amount of water on your palette. Then add enough pigment to form a creamy mixture (not water, not milk, but a light cream formulation). Do not be afraid of bold color. Use it to enhance your paintings by attracting attention. If you use a pigment to its optimal capacity, you will not need to continue to overpaint in order to strengthen the color tone.

There are, of course, situations in which you will want to alter the consistency of the paint to achieve special effects. For example, add more water to the mixture to achieve a paler wash. Add more pigment to create a heavy, possibly opaque effect that is good for drybrushing.

Brush an Even Wash

Prepare a large pool of paint. A light to medium consistency (milky to light cream) will be easiest to spread. Mix it well, and make sure you have enough to do the job, as you cannot stop in the middle of an even wash to mix more.

Load your brush from the tip to the ferrule with a lot of paint. (Use the largest brush you can for the wash area in your painting. A sable brush will hold more paint and dispense it more evenly than a synthetic brush.) If you dampen your paper first, the brushstrokes will be easier to control. Just remember, however, that a wet-in-wet situation results in a paler wash once everything dries.

Place your brush tip on the paper at an approximately forty-five-degree angle to the surface and move it across then back again, zigzagging down the paper. Notice the bead of paint that forms at the bottom of each stroke. Be sure to pick up the bead with each additional stroke.

As you continue this zigzag down the wash area, drop the angle of your brush so that more of the brush is sweeping the paper. This will help the paint flow out of the brush onto the paper. If you are washing a large area and must reload the brush, do it as quickly as possible and continue the zigzag stroking. Do not be hesitant when working on this technique. A good, even wash requires an aggressive brushstroke.

PAINT RATIO FOR WET-IN-WET

If you are working wet-in-wet (wet paint on wet paper), add slightly more pigment to your mixture since the color will be diluted by the water on your paper. Colors you put down on dry paper will lighten once they are dry; colors put down on wet paper will lighten even more, so formulate your water-to-paint ratio accordingly.

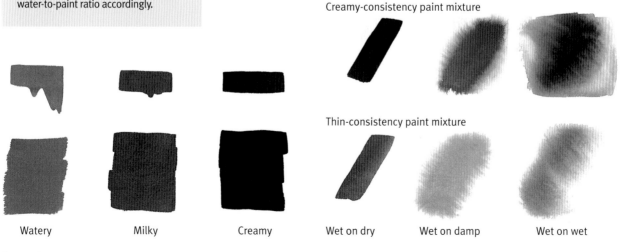

Creamy-consistency paint mixture

Thin-consistency paint mixture

| Watery | Milky | Creamy | Wet on dry | Wet on damp | Wet on wet |

PAINT CONSISTENCY

WATER-TO-PAINT RATIOS

Drybrushing

Drybrushing is a useful technique for creating images of weathered wood, dry grasses, ledge rock textures, bricks, stones, even faraway mountain crevices. You can use it with both paint and masking fluid. It requires a paint mixture that is heavier with pigment than the creamy consistency we generally use for painting. There are two methods of application.

Application 1

Hold the brush, fully loaded with paint, at a forty-five-degree angle to the paper surface. Then lightly move the tip of the brush across the dry paper, just touching its surface.

Application 2

Hold the brush parallel to the paper and move the brush sideways across the surface. You can drybrush over a dried wash and/or apply a wash on top of the texture once it has dried.

DRYBRUSHING: APPLICATION 1

DRYBRUSHING: APPLICATION 2

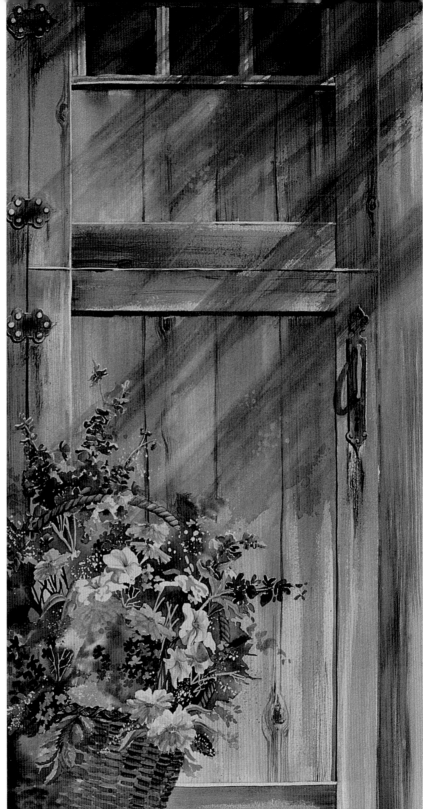

FINISHED PAINTING WITH DRYBRUSHING

The dry-brush technique is used in three areas of this painting. After washing in a base color for the old wood door, the artist drybrushed a darker color over it to create a weathered wood grain. Next, she drybrushed to indicate rust dripping from the metal hinges, and also used it to pull shadows across the scene.

WELCOME
Jan Fabian Wallake
30" × 15" (76cm × 38cm)
Collection of Jerry England

Round Brush Work

A good brush is essential to painting in watercolor. Even more important is knowing how to use it. These illustrations will help you become a master of the brush. Practice these techniques to enhance your painting.

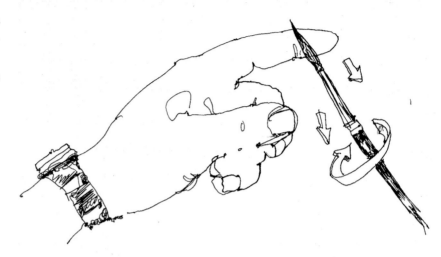

ROUND BRUSHES

Your round brush should have a sharp point. Wet your brush, give it a good shake and draw the body and tip of the brush across your index finger. Rotate the brush at the same time. The brush should come to a point.

THE TIP OF THE BRUSH

You'll need several brushes that point. You can't paint flowers with a blunt and tired brush.

Blunt tip (top): This is how watercolor brushes look when the tip is stroked over the paper. You must not stroke the tip of a round watercolor brush over watercolor paper (see next page). Watercolor paper is like sandpaper to a delicate brush tip.

Sharp tip (bottom): This is the way a damp brush should look.

THINGS TO REMEMBER

Don't paint with the tip of the brush; you'll ruin the point. Always paint with the body of the brush. Don't stroke and lift; keep your brush on the paper until you've finished a shape or have run out of paint. Don't paint with a floppy wrist. Your wrist should be firm but not rigid. Paint with your hand, wrist and forearm.

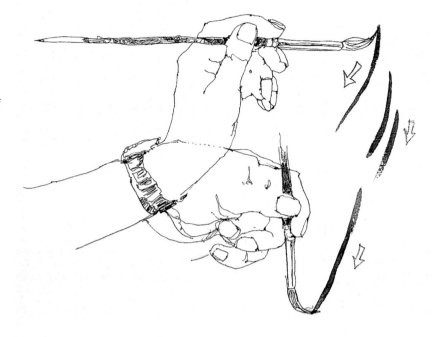

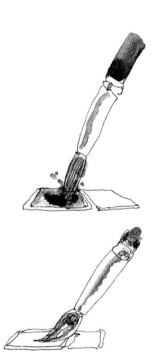

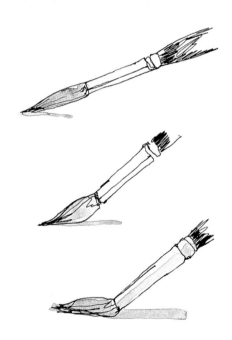

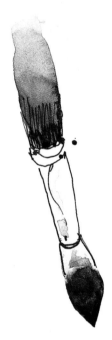

USE ADEQUATELY MOISTENED PAINT

Many people use too much water and not enough paint, often because their paint isn't wet. The colors in the wells must be wet. You should be able to stick the tip of your brush into the paint. Your brush should never just pass over the surface of a color in the well. You'll just be painting with water.

PRACTICE A BASIC BRUSHSTROKE

Any round brush will do to practice your brush work. Wet and shake your brush. Start with the tip of the brush and immediately press your brush against the paper, almost to the metal ferrule. This is correct brush position. You should always paint with the body of the brush, never with just the tip.

FORM SHAPES WITH A ROUND

When the brush is pressed, stroked and lifted abruptly, you'll have a darker color value and harder edge at the beginning of the stroke and a lighter color value and softer edge at the finish. The tip and sides of a round brush are designed to form shapes.

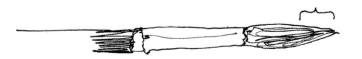

LOAD YOUR BRUSH WITH COLOR

After rinsing and shaking your brush, load it with color from the tip to about a third of the way up the body.

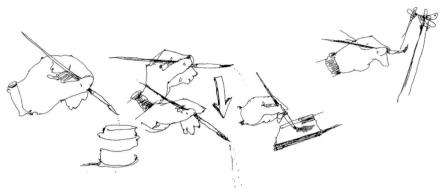

WATER, SHAKE, PALETTE, PAINT

Remember these four words; they'll remind you of steps you can take to assure success: *Water*—rinse your brush. *Shake*—shake your brush to lose excess water. You'll need newspaper on the floor. If you're worried about your floor, you can pass your brush across a sponge, tissue, paper towel or piece of cloth towel. Don't blot your brush; that will remove too much water. *Palette*—you should be taking paint to your picture, not water. Ninety-five percent of the time you should be picking up paint after a rinse and partial dry. *Paint*—put the brush to your painting.

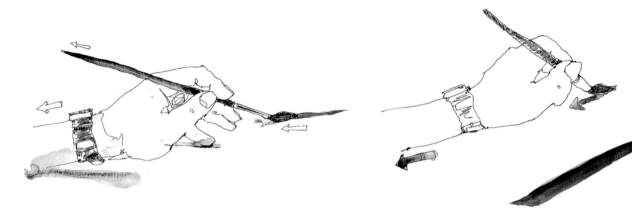

MAKE A STROKE

You'll need water, a no. 8 round brush, a palette and any dark, moist paint. Remember: *water, shake, palette* and *paint*. Place the brush's tip. Start pressing the brush, and at the same time, start moving your hand. Make a stroke about 4 inches (10cm) long and lift in one fluid motion.

CONTROLLING YOUR BRUSH FOR AN ACCURATE STROKE

Making accurate, specific shapes is necessary in flower painting. The tip of your little finger should touch the paper as you move your hand.

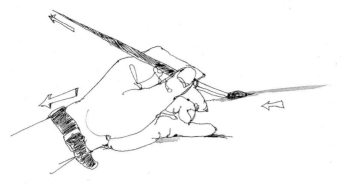

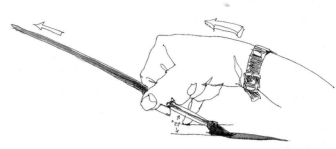

CONTROLLING YOUR BRUSH FOR AN ACCURATE STROKE

Rest the side of your hand on the paper as you make a stroke.

STROKE UP FROM THE BOTTOM

Always start your stroke where you want the darkest color value. (Your brush should be fully loaded at the beginning of a stroke.) Place the tip of your little finger on the paper, bend and lock your wrist. Press the brush into the paper and make an upward stroke, pushing with your upper arm.

PAINTING LARGE AREAS

You should usually hold your brush at about a forty-five-degree angle, but when painting larger areas, hold the brush at 75 degrees or 80 degrees. Press the brush almost to the metal ferrule. Make a zigzag stroke by rolling your wrist back and forth. Don't lift the brush until you run out of paint.

PAINTING A DARKER BACKGROUND AROUND A LIGHTER SUBJECT

Start your stroke where you want the darkest value and the firmest edge. The tip finds the boundary of the white flower, presses and then paints around the flower and works into the background. The brush is held at right angles to the flower boundary. If you start in the background and paint toward the flower, you will make a fuzzy edge and a lighter value.

Texture

You can produce a variety of effects in watercolor. The type of paper you use affects the results, as do the pigments and the amount of water. For our flowers you don't need to be too concerned with creating textures. Most textures will be somewhat subtle and can be applied with your usual painting tools. Do not let texture become too important. It can easily overwhelm the painting. Use it only to add variety and strengthen your painting. Vary the amounts of paint and water to get different effects.

Spray

Spraying disperses drops of water or paint over the paper. Depending on the type of sprayer, the drops can be small and fine or large and runny. Choose your sprayer carefully, and always test on scrap paper first to avoid a disaster. Use a pump or trigger spray bottle—any empty sprayer you may have around the house will work.

Spatters

Spattering makes a more widely dispersed pattern of droplets. Try this on wet and dry surfaces, using more water for more spatters. With a toothbrush or a paintbrush loaded with either water or paint, flick the bristles with your finger, or tap the handle against your hand or against another brush handle. This helps control the direction in which the spatters fall.

Phthalo Blue on cold-pressed paper is sprayed with clear water from a bottle.

One color is spattered over another while wet.

Blooms

Blooms occur when a liquid touches a damp area. Apply paint or water into, or next to, a slightly damp passage. The fluid will flow into the damp area, forming an uneven edge as it picks up paint and moves it away before drying. This is often an unwanted effect, but sometimes it can be surprisingly welcome. Play with making some blooms to learn what to expect if you add fresh paint to an almost dry area.

Drops

With a small dropper or dropper-topped bottle, drop water or paint into a damp or wet area. You can also drop mixed paint from a brush (a round works best). Many variables can change your results: the paper surface, the paper's degree of wetness, the amount of paint and water in the mixture, the humidity of the air, the height from which the paint is dropped and the angle of the paper.

Chemical Reactions

You will find that some pigments mix and spread differently from others. Such differences may result from varying sources, wetting agents or binders.

Practice mixing your colors in a variety of combinations so you can predict how they will react when mingled in a painting.

Color is charged into damp paint to create a bloom.

Winsor Violet and Aureolin chemically react to form texture on cold-pressed paper.

Winsor Green and Quinacridone Magenta chemically react to form texture on cold-pressed paper.

Painting Wet-in-Wet

The essence of watercolor is the wash. In order to create successful watercolor paintings you must first understand the delicate balance between pigment and water. There are two basic approaches for applying watercolor paint: one is the wet-on-dry method, in which you mix your color to the desired consistency on your palette and then apply it to bone-dry paper. The other is the wet-in-wet method, in which you moisten the paper first and then apply the color, previously mixed to the desired consistency, to the wet surface. Wet-in-wet is a wonderful technique for watercolor backgrounds, or when you want a soft-edged, spontaneous effect rather than a controlled, hard-edged look.

With this type of application, the color will flare or spread on contact with the wet paper, resulting in movement and blending of the colors. This technique can be used not only for backgrounds, but also for some larger foreground objects, because it is simply the most efficient way of applying paint to a big expanse of paper. At first, the flare effect can seem a little scary because it is somewhat unpredictable. With a little practice, however, you'll be able to control how much flare you get, and you'll love the wonderful, spontaneous blends that happen all by themselves. This technique provides the magic that sets watercolor apart from all other mediums.

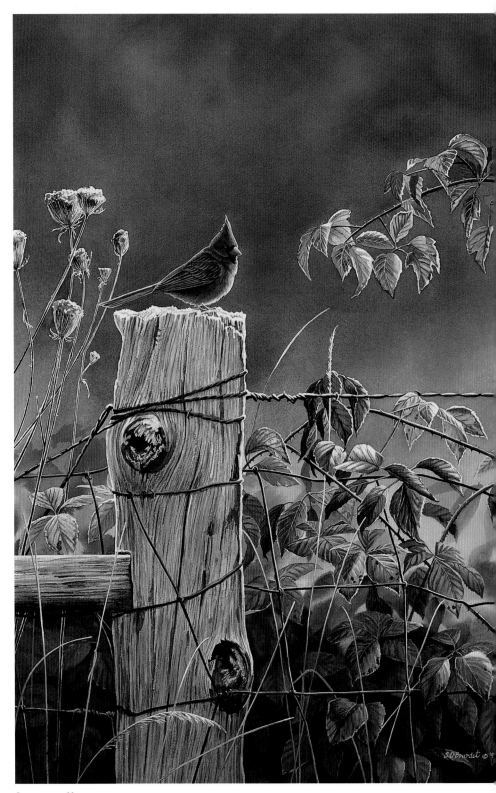

SEPTEMBER MORNING
(Northern Cardinal)
Susan Bourdet
22" × 15" (56cm × 38cm)

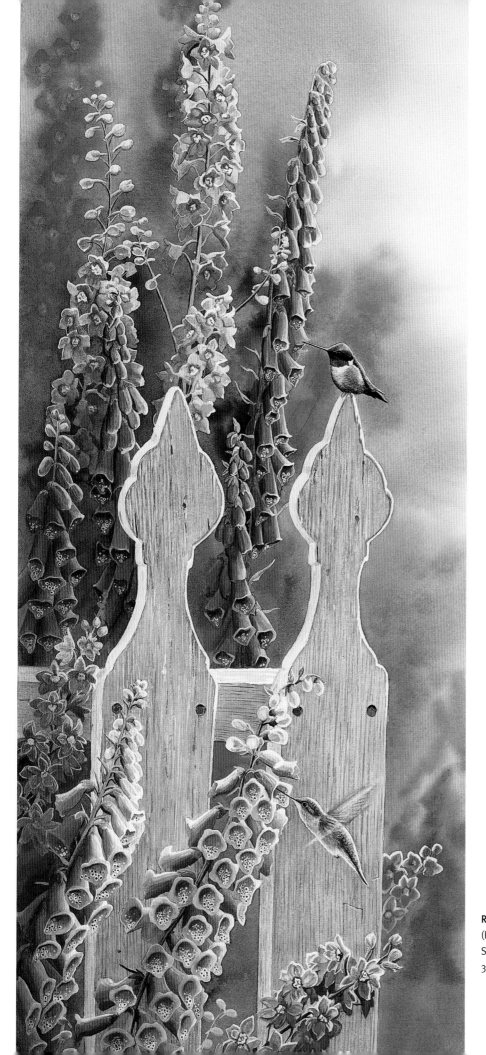

RUBIES AND FOXGLOVE
(Ruby-Throated Hummingbirds)
Susan Bourdet
38" × 15" (97cm × 38cm)

Painting a Wet-in-Wet Wash

Materials

PAPER
300-lb. (640gsm) cold-pressed paper

BRUSHES
2-inch (51mm) flat Kolinsky sable,
 white sable or 2-inch (51mm) hake

WATERCOLORS
Oxide of Chromium
Payne's Gray
Quinacridone Gold

OTHER
Palette with large wells and mixing area
Large water container
Old terrycloth bath towel
Spray bottle
Hair dryer

Always begin with good paper, properly prepared. If you're using 140-lb. (300gsm) cold-pressed paper, you will need to stretch your paper as described on page 21. Heavier 300-lb. (640gsm) paper is good for wet-into-wet techniques because it is a bit more absorbent than the lighter-weight paper, making it better for building up washes. It also requires no stretching unless you're doing a very large painting. Be careful when handling watercolor paper, as fingers with any oil or lotion can leave their mark. Scratches and abrasions will also show themselves in a wash because they absorb more pigment than the rest of the sheet.

Using the right brush can make a difference. Make sure you choose a brush size appropriate for the size of the area you're painting. Use a 2-inch (51mm) hake brush for large areas. Switch to a no. 10 or 12 round for suggesting foliage shapes. A large wash brush such as 1½ inch (38mm) white sable or Kolinsky sable also works well for large areas. For smaller wash areas, you can use either a 1-inch (25mm) flat sable or a no. 10 or 12 round. You will notice as you experiment with these brushes that the sharp corners of the flat brushes sometimes leave marks in the wash. A hake brush leaves no marks, but it takes time to break in a new one. At first it will seem too bulky and will have the annoying habit of shedding. As the paper abrades the hairs, the brush becomes shorter and more tapered, improving its performance.

ACHIEVING THE RIGHT CONSISTENCY

To prepare large paint puddles, squirt about a teaspoon of fresh pigment on the palette and add an equal amount of water. Work the mixture with your brush, adding more water a little at a time until you have a creamy consistency. When you can drag your brush through the puddle and make a valley that doesn't run together immediately, you have the right consistency.

1 | Arrange Your Materials

Start with fresh pigments, clean water, a clean palette and all your tools. Mix water with each color, working the individual puddles with your 2-inch (51mm) brush until they are the consistency of thick cream. Make a large enough puddle of each color so you won't have to remix them during the wet-in-wet wash process. Remember that pigments may fade up to 40 percent as they dry; therefore, a dark wash like this one should not be diluted too much.

2 | Flow the Wash Onto the Paper

Place a large terrycloth towel under your paper. Wet the paper, applying the water evenly. To ensure uniform coverage, look at the shine from an angle to make sure there are no puddles or runs.

Blot your brush lightly before you pick up the pigment to avoid diluting the color. Load the brush well so that you don't have to dab.

Flow the pigment onto the wet paper with 2- to 3-inch (51mm–75mm) strokes, letting the water do some of the work. Avoid over-brushing or scrubbing.

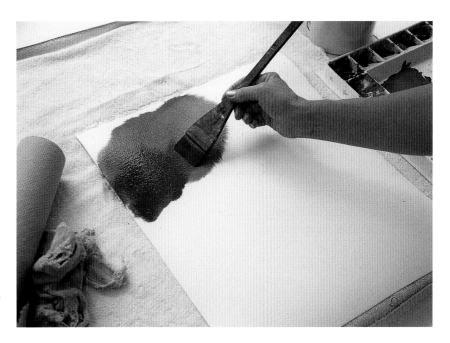

3 | Add More Color

While the paper is still shiny-wet, you can add more color or add other colors. The process of adding other colors is called *charging*. Use this technique to suggest leaf shapes or background foliage. Don't get too carried away when charging additional color to suggest foliage. A complicated background will compete with your foreground rather than enhance it.

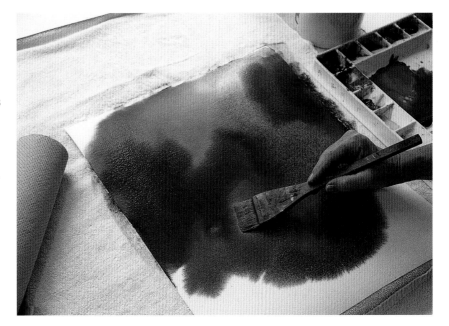

4 | Tilt the Paper

You can carefully tilt the paper to create soft blends.

WATERMARKS

Introducing more color, water or brush-strokes to a damp wash after the wet shine is completely gone will create watermarks. Avoid these by introducing color only when a wash is shiny-wet.

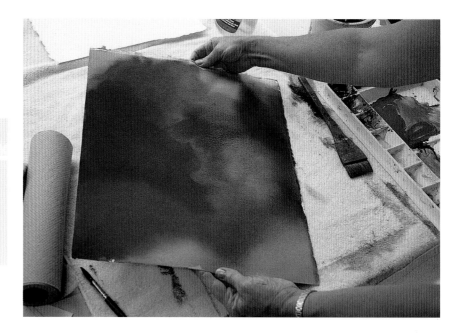

5 | Use a Hair Dryer

If the wash begins to dry before you're happy with it, or if the colors fade more than you'd like, use your hair dryer to dry it until bone-dry—no longer cool to the touch—then re-wet it with your spray bottle. Introduce more color to the sprayed area by brushing it very gently so as not to disturb the first coat. Dry with a hair dryer until it is bone-dry.

ADDING COLOR

If you wish to add color to only part of the background, spray the area with water, wetting a larger patch than you wish to paint. Introduce the color just to the shiny part of the sprayed area and tilt the paper to create soft blends. The sprayed patch will dry without leaving a watermark because the edges have been finely misted.

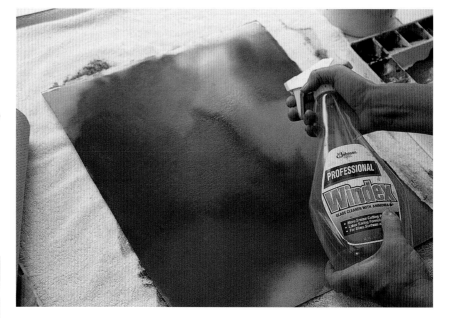

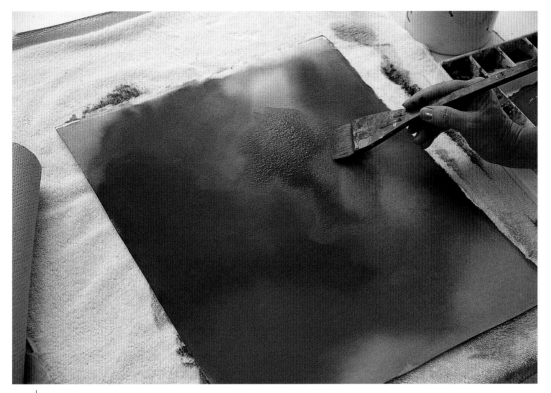

6 | Add More Color

Lightly brush on more color. Use a delicate touch to avoid disturbing the first layer of color.

12 TIPS FOR SUCCESSFUL WASHES

- Always start with fresh pigments, clean water and all the tools you will need.
- Place a large terrycloth towel under the paper to prevent excess water from leaking back under the paper.
- Make a mental plan of where you want to apply your colors; think it through before you begin.
- Mix large puddles of color on your palette, creating smooth, even consistencies.
- Use separate brushes for each color.
- Remember that colors applied to wet paper will fade up to 40 percent as they dry, so make your mixtures rich and creamy.
- Apply the water evenly when wetting the paper to create a uniform shine.
- Blot your brush lightly before picking up the pigment to avoid diluting the color. Load the brush well so that you don't have to dab.
- Let the water do the work. Flow the pigment onto the wet paper with 2- to 3-inch (51mm–75mm) strokes.
- Add more color or different colors while the paper is still shiny-wet.
- Tilt the paper to create soft blends.
- Use a hair dryer, moving in a rapid circular motion to dry the surface as evenly as possible.

Mastering Foreground Techniques

Materials

PAPER
300-lb. (640gsm) cold-pressed paper

BRUSHES
Nos. 2, 4 and 6 rounds

WATERCOLORS
Cobalt Blue
Quinacridone Pink

Foreground subject matter requires a controlled approach, using smaller brushes and less water. While the shapes and subjects in the foreground may vary, there are some basic techniques that you will use for nearly every subject you tackle.

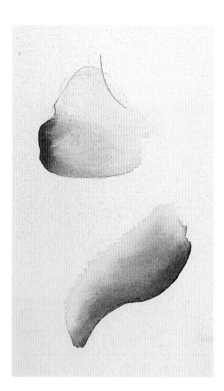

1 | Create a Curved Form

For many objects in nature, you'll indicate a curved or rounded form by *lifting*: applying water to paint already on the paper to dilute the color. Apply the color to dry paper in the darkest area of the object and let the stroke of pigment soak in for a few moments.

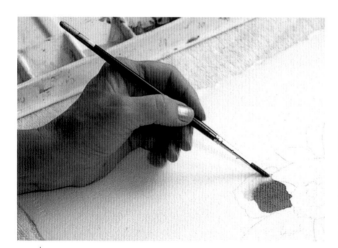

2 | Soften the Color

While the paint is still wet, use a brush wet with water to lift or soften the color.

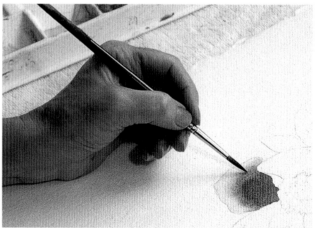

3 | Lift More Color

If your first lift doesn't remove enough color, rinse the brush and repeat. Keep a rag handy to blot excess water from the brush. As you practice, you'll notice that the amount of water you use on the brush can be adjusted to control the amount of flare.

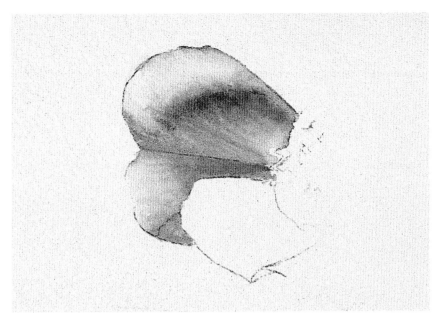

4 | Build the Washes

You will create most forms by building up washes. The most important part of this process is careful placement of the darks so that they can be lifted to create dimension. Build up the values by applying several lifted layers of color, drying between coats. Apply each successive layer so that some of the layer under it is still visible. Here Quinacridone Pink was applied to the shadow area of a petal, then pulled inward toward the center to create the concave area and outward to create the convex curve.

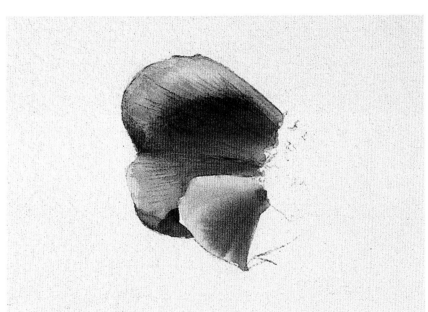

5 | Add a Color Mix

To build up the form, a mix of Quinacridone Pink and Cobalt Blue was applied to the darkest area after the first wash was dry, then softened at the outer edge and pulled in toward the center.

Painting With a Palette Knife

In this technique, color is laid on with moist, thick paint using a small, pointed palette knife. This is very much like palette-knife painting with oils; however, you do not apply the paint all over the paper in this manner.

Plan a subject first and very loosely sketch it on your paper. Next, use your knife to pick up two, three or more colors on at a time, using primarily dark colors. The tip as well as the sharp edge of the knife can be used to apply paint to the paper. When you're finished applying dark colors, wipe your knife clean and pick up some lighter colors (for the background, perhaps).

After applying the paint, and while the thick paint is still wet, flood the paper with clean water using a large wash brush. This is very exciting and a little scary because the colors explode into many surprises and are so fresh and beautiful. Brush as little as possible while the beautiful fusion of color is taking place. Let the watercolor flow, and be ready to leave some of the lovely accidents that happen.

Smaller brushes may be used if needed for more detailed areas. All of your palette knife paintings may not be successful, but keep practicing with different colors, brushes and amounts of water. You will have fun and eventually get more creative results.

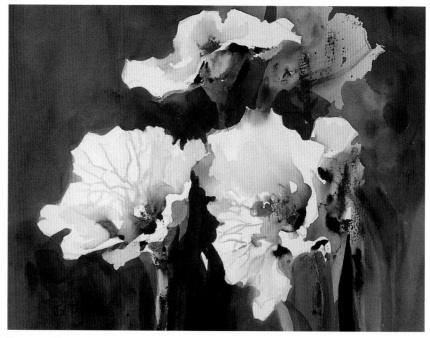

Palette Knife Painting With Dark Colors
Pure Indigo, Alizarin Crimson, New Gamboge and a small amount of Sap Green were used for the first application of paint to the centers and undersides of the flowers. Red, orange and a small amount of Burnt Sienna were used as accents on the stems of the flowers, and the paint left on the palette knife was applied lightly onto the background in a scumble (or rough brushstroke) to create texture. These strokes were barely visible after two wash applications on the background. The darker washes were needed to dramatize the flowers and give them more visual impact.

Looking for Light
Jo Taylor
11" × 15 " (28cm × 38cm)

Detail
This part of the painting was not worked on or touched after the paper was flooded with water. This detail shows the fusion and flow of color that took place.

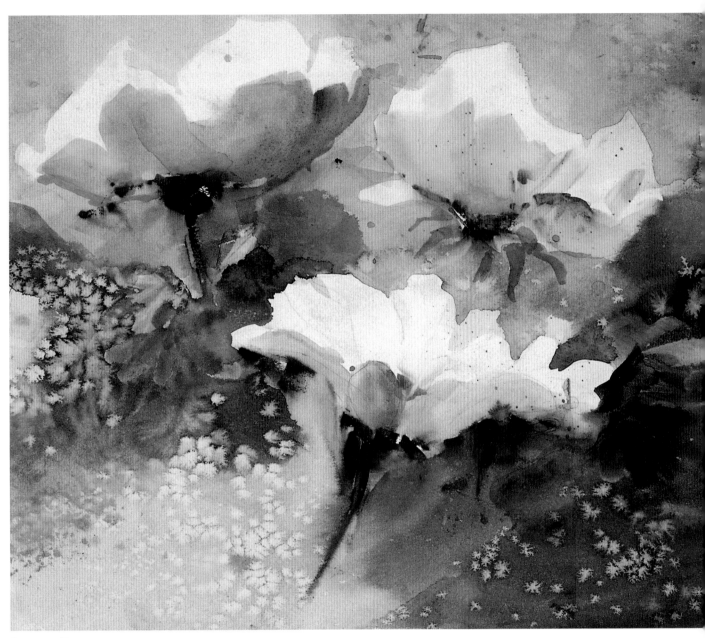

Combine Techniques

A combination of techniques created this painting. The flowers were lightly drawn in pencil first. A palette knife was used to place accents of color underneath and on the outer edges of the flowers. A 1½-inch (38mm) brush flooded the dark accent areas with clean water. With the tip of the same brush, the water and pigment were carried over the background and to the top where the petals of the flowers were defined.

 While all of the paint was still wet, salt was sprinkled onto the background. Salt absorbs and bleaches the pigment, creating interesting textures. A ¾-inch (19mm) red sable was used to paint the shadows on the undersides of the flowers, and the detail of small leaves was drawn with the side tip of the brush.

Pedula Bouquet
Jo Taylor
11" × 15" (28cm × 38cm)

The Color Wheel

The very first artists did not have a color wheel. They used whatever pigments they could find to depict the colors of the things they saw. In the seventeenth century, Sir Isaac Newton discovered the prism or scale of colors. It was some time later, in the early eighteenth century, that the color wheel came into being.

The color wheel shows in a simple way the relationships between colors. Make use of this important tool to help you understand color and how you can use it to create better paintings.

Color Terms You Need to Know

You're likely to hear the same terms brought up time and time again when color is the topic of discussion, but do you know what they really mean? The first step to understanding color is to know the language. Here's a primer:

Hue A color as described by its location on the color wheel or spectrum.

Value The relative lightness or darkness of a color.

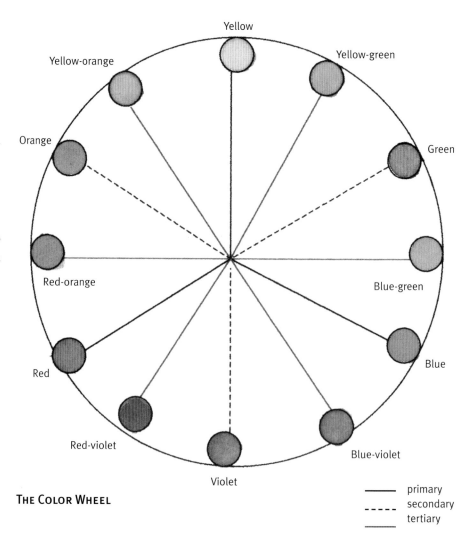

THE COLOR WHEEL

——— primary
- - - - secondary
——— tertiary

Intensity or Chroma The brilliance of a color, ranging from dull to bright.

Key The value of a color or the value dominant in a painting, ranging from light to dark.

Primary colors The three basic colors (yellow, red and blue) from which all other colors are created.

Secondary colors Colors (violet, orange and green) created by combining two primaries.

Tertiary colors Colors (blue-green, red-violet, etc.) created by combining a primary with an adjacent secondary color.

Complementary colors Colors that are opposite each other on the color wheel.

Analogous colors Colors that are next to each other on the color wheel.

Warm colors Colors (red, yellow and orange) that generally appear warm in

temperature. The perception of the warmth or coolness of a color is always relative, so even a warm color can have a cool version. For example, red-violet is typically cooler than red-orange. Any warm color will appear warmer when placed next to a cool color.

Cool colors Colors (blue, green and violet) that generally appear cool in temperature. Cool colors can appear warm depending on their comparison colors.

What You Can Do With Color

The possibilities with color are endless. When you design a painting, you plan a composition around a central idea. Your center of interest can be emphasized by the colors you choose. You can also use color to de-emphasize an element of your composition or to make it recede, as in the case of background foliage. Repetition of color can unify a design or add a strong directional element. Remember that using complementary colors—opposites on the color wheel—will make both colors appear brighter. Analogous colors—colors adjacent to one another on the color wheel—will create a harmonious effect. You can completely change the character of a painting with color, using warm tones and bright highlights for a sunny feel, and cool, muted tones for a moody effect. Your color scheme is as important as your idea, so give it careful thought.

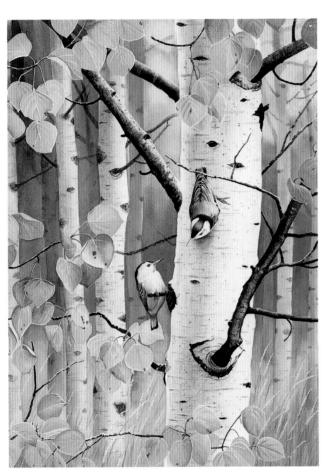

ANALOGOUS COLOR SCHEME
This example uses colors adjacent to one another on the color wheel. All of the foreground colors are warm, while the background colors are made to recede by the use of cool shades.

AUTUMN GOLD
(White-Breasted Nuthatches)
Susan Bourdet
21" × 15" (53cm × 38cm)

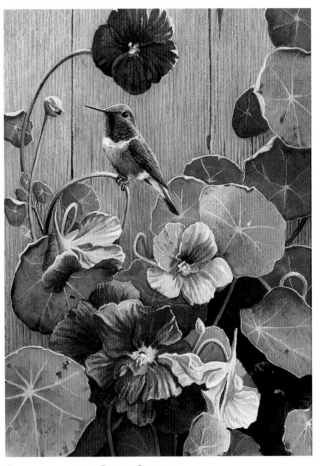

COMPLEMENTARY COLOR SCHEME
Here the use of two dominant colors directly across from one another on the color wheel gives strong emphasis to the subject. The background, composed of tones of the same colors, shows the use of sedimentary texture.

RUFUS HUMMINGBIRD AND NASTURTIUMS
Susan Bourdet
13" × 6" (33cm × 15cm)

Warm and Cool Colors

The color spectrum is a marvelous array of brilliant colors. It is a joy for artists to mix vibrant hues, but there is more to successful color choice than pretty pigments. Learning how to make the best use of your colors will allow you to create movement, indicate depth of field, evoke a mood, boost excitement, even cause a pulsating impression.

Color Temperature

Every pigment on your palette has a temperature. It might be warm or cool or somewhere in between. It is especially important for watercolorists to recognize the properties of the colors they use, since this medium often requires rapid application.

Look at the basic color wheel. It divides naturally into a warm side and a cool side. Red, orange and yellow are generally considered to be warm. Green, blue and violet form the cool side. Hues that appear to have more yellow in them are warm, while those that have more blue content are cooler.

There is, however, more to it than that. The temperature of any given color is actually dependent on its relation to the colors placed next to it.

Color temperature can be altered by adjacent colors. A hue that appears warm when it stands alone may become cool when surrounded by warm tones. For example, Winsor Red is considered a warm color until it is placed next to an even warmer color, such as Cadmium Scarlet. The stronger warmth of Cadmium Scarlet dramatically changes our perception of Winsor Red's temperature. In comparison to Cadmium Scarlet, Winsor Red is cool.

The size and placement of color areas also affect the impact of temperature. A small spot of warm yellow within a large area of a cool color like Antwerp Blue will have more zing than equally sized areas of warm and cool tones. Because the unique, bright yellow color is unusual within the vast area of blue, it becomes dominant and the contrast will attract attention.

Color is often used to establish a mood. For example, warm red is a fiery, passionate color, while cooler reds such as Alizarin Crimson suggest a more somber, perhaps regal feeling. Warm pigments are aggressive, inviting, alive, happy. Cool tones are

more restful. They are used when the mood is mysterious, sad or calm.

Atmosphere

In a natural setting, distant objects become muted in tone and cooler in color temperature. The reason for this is that we view distant objects through progressively thicker atmosphere; in other words, we are looking through more dust particles and water vapor. Things far away become muted because dust and water vapor refract tiny bits of light. The distant objects appear cooler in color temperature because water vapor reflects light from a blue sky. On a cloudy, gray or foggy day, when the atmosphere is saturated with water and little sunlight gets through to bounce refracted light, there is less definition between far and near objects.

The interplay of warm and cool colors will create exciting interpretations of light and space in your paintings because warm colors advance and cool colors recede. By skillful placement of color temperatures, you can suggest clear, sun-filled environs or humid, moisture-laden air.

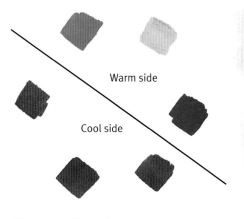

Warm side

Cool side

WARM AND COOL COLORS

COLOR CAN SUGGEST MOOD
Remember that warm pigments can suggest happiness or aggression, while cool tones can suggest calmness or sadness.

Depth of Field

Color temperatures are used by artists to create depth in a painting. We can use cool colors to push areas of our painting back into the distance. Warm tones will make objects or spatial areas appear closer to the viewer. With selective temperature control, an artist can turn a dull, flat image into a vibrant series of planes that advance and recede. By using progressively stronger values of warm and cool colors, you will create more dramatic depth in the spatial planes of your painting.

Movement

You can promote eye movement in your paintings by shifting pigment temperatures. The interplay between warm and cool creates an attention-getting friction that guides a viewer around the scene.

More Color Terminology

Pigment is the physical substance of paint and describes a more specific formulation name. For example, Alizarin Crimson is not a hue but a specific formulation of a hue. Paints are often named for the mineral or chemical used to make them.

Tint is a color with white added. In watercolor, we can tint a color with clear water and use the white of the paper as a lightener.

Shade is a color with black or another dark color added.

Tone is a mixture of a pure hue plus gray.

Neutral means white, black or gray. These are achromatic hues.

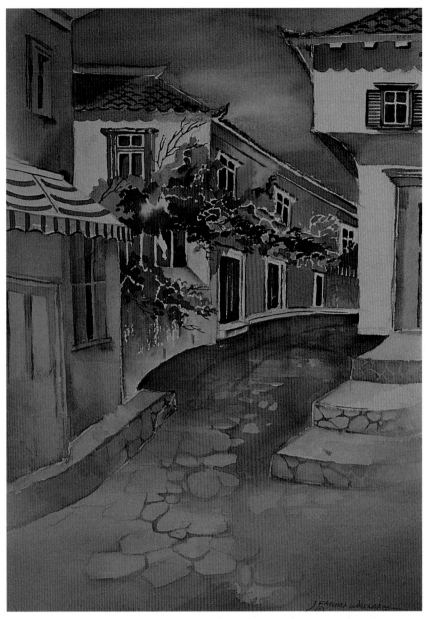

This painting was done on location in Greece. The artist wanted to capture the quiet, serene mood of the street scene. She used violet and blue glazes in the shadows to cool down the hot, sunlit atmosphere. She exaggerated the intensity of the shadows to dramatize their contrast with the sunstruck walls. She also glazed the foreground with warm tones to bring that area closer to the viewer. Cool tones in the background and warm tones in the foreground create receding and advancing planes. Atmospheric temperature changes between cool and warm areas generate eye movement and add interest to the painting.

VIEW OF HYDRA
Jan Fabian Wallake
14" × 10" (36cm × 25cm)
Collection of Joan Cimaglia

Mixing Color

Few painters paint with pure or "raw" color straight from the tube. While you may want to apply pure color occasionally, you must understand color mixing to create the colors of nature. For example, Phthalo Green makes beautiful natural greens when tempered with Burnt Sienna. Carmine is useful for warming up certain colors.

Many artists mix colors in the center of a clean palette and adjust colors as they paint because all colors need to be toned down or grayed as they recede into the distance. This principle applies to still lifes as well as landscapes.

You can always gray down a color by adding its complement (see page 56). A very small amount of a complement will gray a color a lot. To adjust the value to a darker version of the same color, adding a color from the same family will keep the color more vibrant and luminous than if you added black or the complement (which tends to gray the hue). For example, if you need to darken Winsor Red, add another version of red such as Alizarin Crimson.

As you practice painting and mixing colors, your own personal taste will influence your color choices and combinations. The best way to learn about color mixing is to paint!

Matching Color

During the painting process there is not only a lot of color mixing, but also color matching. Matching color is more exacting and difficult to do than mere mixing. Unless you can create a painting in one sitting without interruption, there will be times when you must walk away from a painting and return to work on it after the watercolor has dried, and it will be easier to pick up where you left off if you can easily match your colors.

To sharpen your skills, pick out an old or unsuccessful painting and try to match the colors exactly. Judge the color you are trying to match by asking yourself: Is it lighter or darker? Warmer or cooler? Watercolor always dries lighter by one or two shades, so wet the old painting first with water, using a very soft brush. This will make the color you're matching as dark as the color you're mixing. Then put swatches of color beside the corresponding colors on the painting until you are satisfied with the matches you've made.

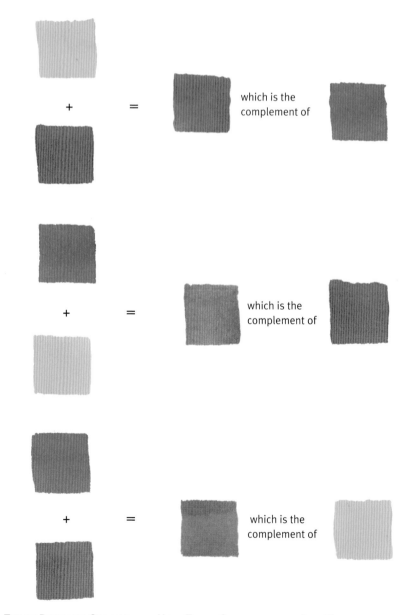

THREE PRIMARY COLORS AND HOW THEIR COMPLEMENTS ARE MADE
The complements of red, yellow and blue are made by combining the other two primaries.

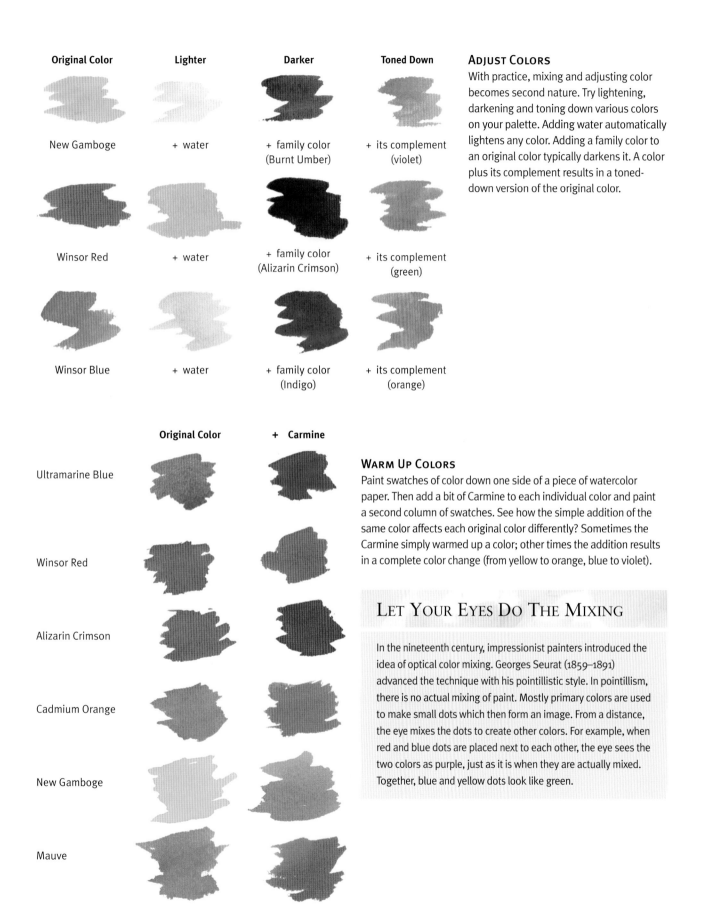

Original Color	Lighter	Darker	Toned Down
New Gamboge	+ water	+ family color (Burnt Umber)	+ its complement (violet)
Winsor Red	+ water	+ family color (Alizarin Crimson)	+ its complement (green)
Winsor Blue	+ water	+ family color (Indigo)	+ its complement (orange)

ADJUST COLORS

With practice, mixing and adjusting color becomes second nature. Try lightening, darkening and toning down various colors on your palette. Adding water automatically lightens any color. Adding a family color to an original color typically darkens it. A color plus its complement results in a toned-down version of the original color.

	Original Color	+ Carmine
Ultramarine Blue		
Winsor Red		
Alizarin Crimson		
Cadmium Orange		
New Gamboge		
Mauve		

WARM UP COLORS

Paint swatches of color down one side of a piece of watercolor paper. Then add a bit of Carmine to each individual color and paint a second column of swatches. See how the simple addition of the same color affects each original color differently? Sometimes the Carmine simply warmed up a color; other times the addition results in a complete color change (from yellow to orange, blue to violet).

LET YOUR EYES DO THE MIXING

In the nineteenth century, impressionist painters introduced the idea of optical color mixing. Georges Seurat (1859–1891) advanced the technique with his pointillistic style. In pointillism, there is no actual mixing of paint. Mostly primary colors are used to make small dots which then form an image. From a distance, the eye mixes the dots to create other colors. For example, when red and blue dots are placed next to each other, the eye sees the two colors as purple, just as it is when they are actually mixed. Together, blue and yellow dots look like green.

Triadic Pigments

Many workshops and books are based on using triadic pigments: nearly pure primaries (see page 44) that have similar characteristics of consistency, intensity, weight and look. They produce harmonious results when used together. There are three types of triadic pigment groups: nonstaining transparent, staining transparent and opaque. To get a feeling of light, use transparent pigments (both staining and nonstaining).

Nonstaining Transparent Pigments

Uses: Clean washes; clear glazes; easy lifting.

Nonstaining colors can be lifted easily without staining the paper and have the clean look necessary for glazing. These are clear, delicate colors that give the feeling of atmosphere, airiness and light. They do not have great intensity or carrying power, and their range of values is light to middle, so they do not make effective darks. Nonstaining transparent pigments mix to make lovely, clean, luminous colors, including beautiful grays. They are well suited to the subject of flowers.

Staining Transparent Pigments

Uses: Rich darks; clean, jewel-like color; underpainting that won't lift.

Staining colors have tremendous intensity, provide a full range of values, and make lovely, deep, clean darks without any loss of transparency. These jewel-like colors are very useful for painting strong value contrasts with dramatic results. They cannot be lifted easily and will stain everything—including your palette. Some, such as Winsor Green, are too harsh to use alone, but they mix beautifully.

If you find that your work does not have a powerful impact, dare to add some staining transparent colors, especially in the darks. These pigments are not terribly effective in pale, subtle washes because they lose their intensity when diluted. While staining colors demand planning and an understanding of their traits, they will bring drama to your work.

Opaque Pigments

Uses: Good coverage; beautiful granulations when mixed.

Opaque pigments, such as Cerulean Blue and the Cadmium colors, tend to be dense, heavy and chalky. They cover well and can be used almost full strength to hide the paper, but are unsuitable for glazing. They do not lift easily because of their density. Avoid using more than one opaque in any mixture for a clean result. They can produce mud if over-mixed or if too many opaque hues are used together. For best results, try to achieve the color you want with the first wash, then leave it alone.

In certain combinations, the granulating quality of opaque pigments is quite handsome; some of the pigment particles settle out into the valleys of the paper, creating a texture. They also make attractive mixtures with some of the staining pigments.

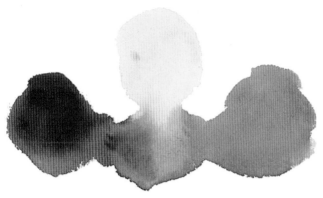

Nonstaining Transparent Triad

The primary pigments that make up this triad are Permanent Rose, Aureolin and Cobalt Blue.

Staining Transparent Triad

The primary pigments that make up this triad are Permanent Alizarin Crimson, Winsor Yellow and Winsor Blue.

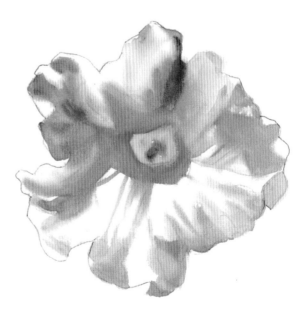

Opaque Triad

The primary pigments that make up this triad are Cadmium Red, Cadmium Yellow and Cerulean Blue.

Basic Principles of Color Mixing

Usually we look at something and then try to figure out what color to use. Let's reverse the process. For this exercise, you'll need a very red apple and a ripe lemon, a round no. 8 brush with a good point, watercolor paper (preferably 140-lb. [300gsm] cold-pressed), a board to place underneath the paper, and these four colors: Alizarin Crimson or Carmine, Cobalt Blue, Cadmium Yellow Pale and Yellow Ochre. If you're new to watercolor, working on a flat surface might be easiest for these beginning exercises. The table should be about waist level. Always have your water, palette and paper as close to one another as possible.

Essential Principles of Color Mixing

- Do not overmix your paint. When you look at your palette's mixing area, you should see individual colors.
- Your palette's mixing area should have color swatches, not puddles of mud.
- Your palette's mixing area should never look watery.
- After rinsing and a shake, your brush should go to the color supply, make a brief stop in the mixing area and then go directly to the paper, not back to the water.
- Don't aim for a perfectly homogenized wash; you should be able to see the colors you are combining. You should have a sense of paint rather than water.
- Keep your palette clean. Clean it constantly so you won't be able to use that tired watery stuff in the mixing area.
- Clean your palette with paper towels rather than tissues. Many tissues have additives that leave an oily film that causes your paint to bead. New palettes should be cleaned lightly with a paper towel and a cleanser to remove the oily film.

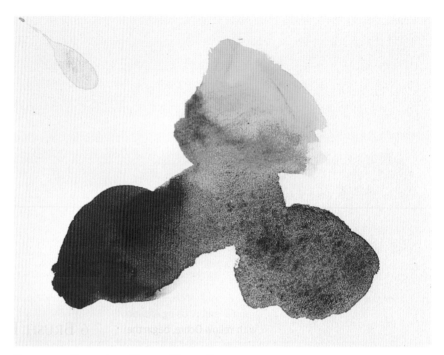

Allowing Colors to Mix on Their Own
Arrange the swatches of Alizarin Crimson, Cobalt Blue and Yellow Ochre in a triangle, leaving a space in the middle. Make the swatches fairly wet but not watery. Rinse your brush and shake it with a flick of the wrist. Brush color from each swatch toward the intersection. Your brush should move color, not mix it. Once the colors meet, lift your brush. You'll probably need to do several sets of swatches. It's OK to lift your board and jockey the colors a bit at first. Just don't use your brush for mixing. The colors might need as long as two minutes to blend before they are dry. The purpose of this exercise is to show just how beautiful watercolor can be if you don't mess with it.

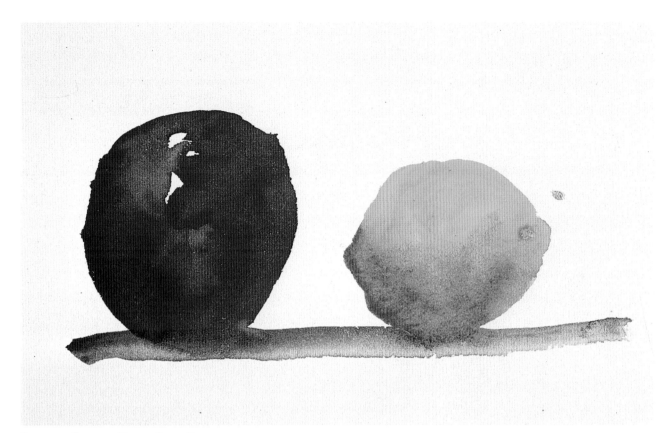

DEVELOP OBJECTS USING PURE COLOR

Let's turn these swatches into an apple and a lemon. Using Alizarin Crimson, make an apple shape. Then, with Yellow Ochre, begin the underside of the lemon, working toward the top. Before you get there, rinse the brush, shake it and do the top of the lemon with Cadmium Yellow Pale. Don't try to blend the colors. Starting at the left, run a stripe of Cobalt Blue under the apple, then continue on to the lemon; don't lift the brush until you've passed beyond the lemon. Put down the brush and watch what happens. The point is to learn about paint-to-water ratios, and when to put the brush down and just watch.

6 BRUSH TIPS

- Always start a stroke where you want the darkest value and hardest edge.
- When your brush tip is fully loaded, the tip and sides of your brush make a hard edge when the brush is pressed into the paper.
- Hold the brush at about a forty-five-degree angle most of the time.
- Stroke in the direction the brush handle points.
- Push the brush into the paper, stroke according to the shape of the subject, then lift it abruptly. It helps if you load just the tip.
- The edge will be softer and the value lighter where the body of the brush leaves the paper.

Mingling Colors

It is important to vary colors as you charge paint into the wet areas while painting with the wet-in-wet or direct method. This technique gives the washes variety. Each time you go back for more paint, vary the color, changing often from warm to cool. For instance, you might charge more than one blue pigment into an area of blue. Then you might add some pink or yellow and so on. The wet paper will make the paint mix, and the tilt of the paper encourages the paint to move, forming gradations. As you go along you can judge how much paint to add with each stroke. The mixture will be cleaner and richer if it mixes on the paper rather than on the palette. You control the mixtures by regulating the amount of water you put on the brush, by how wet the paper is and by how much pigment you charge into the wet areas.

Method of Mingling Colors

When mingling, work with a limited palette of two to five colors for clarity.

Choose transparent pigments rather than opaque. Wet the paper in stages as you paint, and don't try to paint too large an area at once. This will put you in control.

A round or flat brush of at least medium size, capable of holding a generous load of paint, works best with this technique. Always choose the biggest brush that can do the job. It will let you work faster and show fewer strokes. Be sure to wet the paints in your palette or put out fresh pigment.

Pick up paint with a wet, but not dripping, brush (touch it to a sponge or paper towel to remove excess moisture). You may make a puddle of that color on the mixing area of the palette. When it is well loaded, touch the brush to the wet paper and stroke the color on. Then dip into another color, perhaps of a different temperature (you don't always need to wash out the brush before picking up a new color), and add that next to and touching the edge of the first color. If

there is too much water and not enough pigment on the brush, a bloom will form, pushing the first color away instead of mixing with it. The two colors should fuse together softly.

Continue in this manner, changing the color often. If you are using only two colors, keep switching back and forth. Be sure to pick up enough pigment, making it darker than you think it should be because it will dry lighter. Tilt your paper to aid the mingling process. You can also pick it up and move it in different directions to make the paint move. You will have a bead of paint at the bottom of the painted passage. To prevent a bloom from occurring, touch the bottom edge of the bead with a thirsty (just damp) brush to remove the excess, or carefully touch it with a tissue or paper towel. Let the paint dry before judging the results. Do many trial washes of mingled color to get a feeling for how much water and pigment to use.

MINGLED COLORS
This is a full range of mingled colors from yellows and reds to blues. Notice the variety of mixtures possible. Try this with colors from your palette.

Permanent Rose, New Gamboge,
Antwerp Blue

Quinacridone Magenta, Winsor Violet,
Cobalt Turquoise

Turquoise, Quinacridone Magenta, Aureolin

Antwerp Blue, New Gamboge,
Permanent Rose

French Ultramarine, Permanent Rose,
Burnt Sienna

Winsor Green, Winsor Violet,
Quinacridone Magenta

EXAMPLES OF MINGLED COLORS

Try mingling many combinations of colors from your palette. You might want to keep a
sketchbook dedicated just to color exercises. Label everything so that you will have a handy
reference for deciding what colors to use together in a painting.

Mixing Vibrant Grays

There are two kinds of grays: bad grays and good grays. Bad grays happen when you overwork or use tired puddle color from the mixing areas of their palettes.

Good grays are made with complementary colors, are mixed freshly each time from the color supply, and aren't overmixed. Mix your colors on the paper as much as possible. Let the complements mix on their own with as little interference as possible.

You don't need to worry about the color wheel; just remember that the complement of red is green, the complement of blue is orange, and the complement of yellow is purple or violet. The color swatches below will teach you two things. The first is that the juxtaposition of a pure color against a more neutral color suggests a richness that wouldn't be possible with colors of equal intensity. The second lesson is that colors that have been partially mixed on the paper are more interesting than thoroughly mixed colors from the palette's mixing area.

CADMIUM RED LIGHT AND GREEN
This swatch shows Cadmium Red Light mixed with green to create gray. (Alizarin Crimson and Carmine are more transparent than other reds; when these are mixed with green they tend to make a darker gray.)

CADMIUM ORANGE AND BLUE
Swatches like these look lovely in themselves, thanks to the pure color placed next to the partially blended color. You won't see this if you overmix.

CADMIUM YELLOW, BLUE AND CARMINE OR ALIZARIN CRIMSON
Experiment with various blues and yellows as you make your own swatches.

RAW SIENNA OR YELLOW OCHRE, BLUE AND CARMINE OR ALIZARIN CRIMSON
You can use either Raw Sienna or Yellow Ochre for yellow.

BURNT SIENNA, BURNT UMBER AND BLUE
Either Burnt Sienna or Burnt Umber mixed with blue makes a rich, dark gray. Don't use Cerulean Blue; it's too opaque and light in value.

Using Values to Create the Illusion of Form

The understanding and use of *value*, the degree of lightness and darkness, are necessary tools in describing form. In the examples below, numbered values are assigned to the different areas to help you paint them more accurately.

VARY VALUES OF LIGHT AND SHADOW

There should be a difference of three or four degrees of value between the part of the object in direct light and the part in shadow at the point where the plane change occurs.

VALUE SCALE

There are many more values existing than can be measured. However, this scale is an adequate tool for approximating the measure of lightness and darkness needed to create convincing form. Zero represents white, and ten represents the darkest dark. In some value scales these numbers are reversed, but the scale works the same either way.

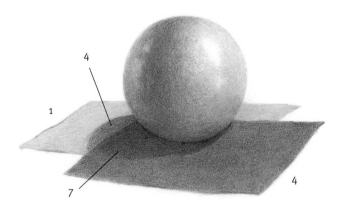

CAST SHADOWS IN BLACK AND WHITE

This example with two pieces of construction paper of different values indicates the importance of the use of value in creating form. In addition, it illustrates the complexities of cast shadows. It is interesting to note that the ball casts only one shadow but the shadow creates two different values as it falls across the two pieces of paper. On a sunny day, try to observe this phenomenon in nature.

CAST SHADOWS IN COLOR

The red and green construction papers in this example are approximately the same value (value 3). The shadow made by the ball has only one value (value 6), even though it is made up of two different colors.

Painting Local Color Values

Local color is a confusing term. You may think it refers to a small section of color in an object, but rather it refers to the object's intrinsic, overall color and value. Local color may include various values, and it is independent of the effects of any light that falls on the object.

Picture an arrangement of fruit on a table, with light shining on the fruit. Many students will try to paint the color and value they see on the light parts of the fruit. This is dangerous, however, because a strong light can wash out color, distorting the viewer's perception of a hue. You must be aware of the effect of strong light on the intensity of a color and compensate for it. Never paint for the color value you see in the light; instead, paint the color value you see in the halftones. The halftone is the value where shadow and light meet. Always paint colors in the mid-to-light value range richer than they appear because you will find that what appears to be a strong color value will fade as it dries. You'll never learn to paint effectively if you use color and value timidly.

Look at "Adding Light and Shade" on page 59 and observe that each object has an overall color value. Work for a two-degree difference in value between light and shadow at this stage. No rule always applies since painting is full of contradictions, so consider the "two-degree light and shade difference" simply a handy reference. Notice that the darkest part of a round object's shadow appears somewhere in the middle of the shadow. The purpose of the three examples on pages 58 and 59 is to train you to see local color values and to compensate for the lightening of water washes as they dry. You might want to try these exercises yourself.

5 Quick Painting Tips

- Never paint with dried-out paints, and try for a ratio of 25 percent water to 75 percent paint.
- Never correct a weak painting by adding darks.
- Use paint directly from your paint supply. Don't use color from your mixing area. You want as pure, undiluted color as possible.
- Use as little water as possible, just enough to make the color flow.
- You can leave single highlights using the white of the paper. They help suggest form but shouldn't be overdone.

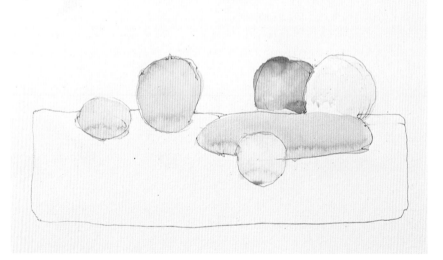

WEAK LOCAL COLOR
Here's a washed-out selection of vegetables. Usually a problem like this results from dried-out paint and too much water. Sometimes it's due to the fear of commiting paint to paper. The more expensive the paper, the more fear you may have; so work small in your sketchbook, or use less expensive paper to practice.

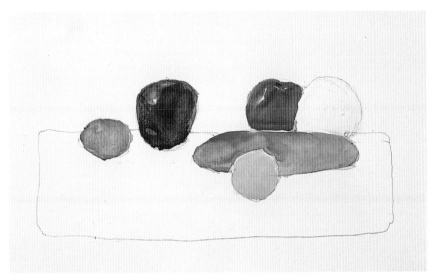

CREATE STRONG LOCAL COLOR

Place your fruit in flat light with no noticeable highlights and shadows. Paint the fruit almost as flat shapes and then allow the paint to dry. Don't rush to add the shadows and darker values; you'll add those later. You want your local color value to be dry to the touch. Don't be too mechanical here. Let some accidental watercolor things happen, but concentrate on the true color value of each piece of fruit and try to achieve this true color value with the first try. If you can manage this, you're on your way!

Study each piece of fruit. Compare their relative colors and values: the lemon to the cucumber, the cucumber to the tomato and white onion. Remember that degrees of value cannot be measured unless they're compared with something else. Leave a skinny rim of dry white paper between some of the adjacent fruit to keep the colors from mixing with one another.

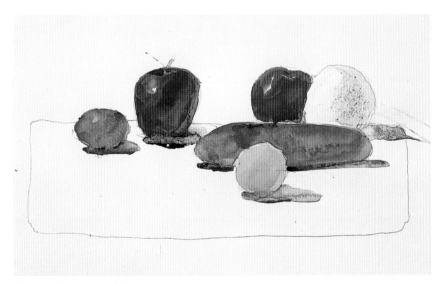

ADDING LIGHT AND SHADE

This should be easy if the first layer of paint is totally dry and you have good local color values. If you've done well establishing local color, you won't see dramatic differences when you add the darks. A simple rule: Intense local color and objects with dark local values will not be as affected by strong light as less intense local color and objects with lighter local values. Mull this over a bit and make sure you understand the concept.

COLOR NOTE

Most of us have trouble with greens. You can mix blues and yellows to create greens and use premixed greens as a backup. You also can get a variety of colors and temperatures when you mix blues with a cool yellow (Cadmium Yellow Pale), a warmer yellow (Cadmium Yellow Light) and then a warmer one still (Cadmium Yellow). If you want a really warm green, substitute Yellow Ochre or Raw Sienna. Choose your blue based on its value. If you want a lighter green, choose Cerulean Blue with the Cadmium Yellows, but don't use it with Yellow Ochre or Raw Sienna (too opaque). The darker the blue, the darker the green. Cobalt Blue makes a medium to dark green. Ultramarine Blue makes the darkest green. Ivory Black with a yellow or Raw Sienna can also make a dark green.

Adding a complement will gray or lessen the intensity of a color in light-valued color mixes where you use water to control the value. In darker mixes, where you use less water, adding a complement will lessen the intensity, but more importantly, it will darken the value of the mix. Many students add complements in their mixing areas and make homogenized, deadly darks that usually kill any possibility of luminosity in their shadows. Don't use any complements in your middle and darker areas; use only colors from the same color family.

In cast shadows, you can use Ultramarine Blue or Cobalt Blue, but you don't want all your cast shadows to be cool, so try Raw Umber for warmer cast shadows, as under the lemon. Color from the object should move into the cast shadow. The connection between a cast shadow and the object should always be painted wet-in-wet and blurred. The outside boundary of a cast shadow should be hard, especially near the object. Boundaries away from the object can blur slightly.

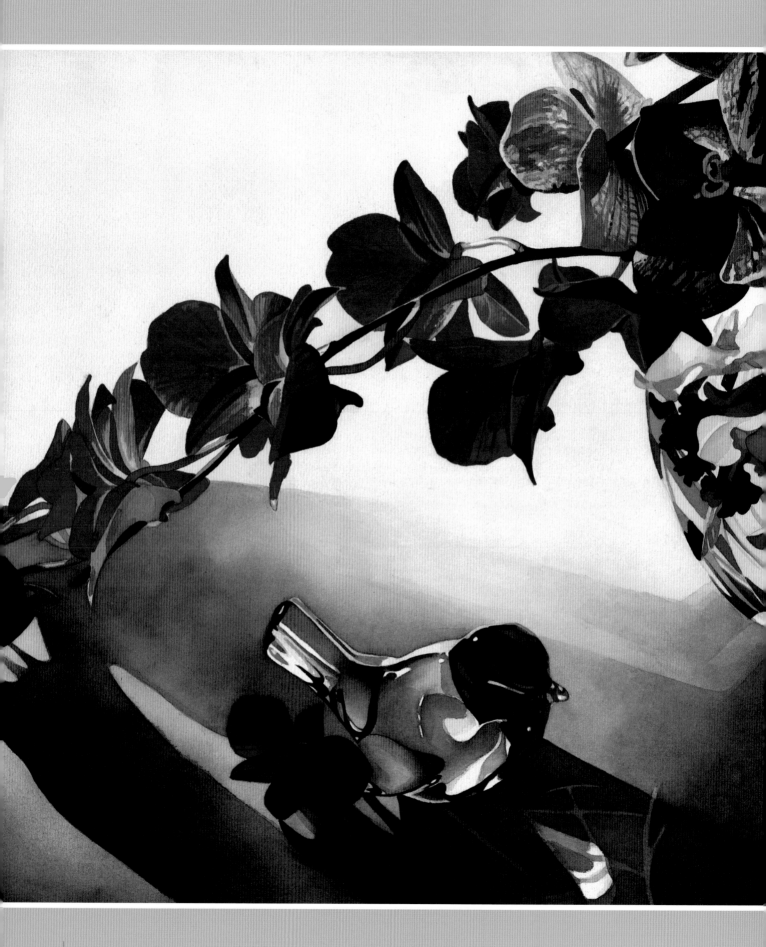

Shapes and Composition

For the enthusiastic artist, knowing what to paint is the easy part. The difficulty comes in composing the elements into an interesting, unusual, powerful or pleasing design.

UNDER THE RAINBOW
Susanna Spann
30" × 42" (76cm × 107cm)
Collection of Barbara Howard

Using Light and Shadow

When you first start to paint, teach yourself to squint. Squinting reduces everything to lights and darks, or values, simplifying confusing detail into mass. Light and shadow are important components of paintings. But whether you use candlelight or sunshine, the shapes created by light and shadow can be used to create powerful compositions.

The light shapes within a painting can unify or disrupt a composition. Light shapes attract the eye. By placing these shapes purposefully you can control the way the eye moves around the painting.

Don't forget that you can change the shape of the light areas you see by darkening or eliminating them to enhance your composition. Dark shapes, such as shadows, can be used in the same way as light shapes. Cast shadows can be as or more important than the object casting the shadow. For example, when shown under low-morning or late-afternoon light, an ordinary tree can be transformed with a long shadow stretching across the sidewalk, down the curb and into the street.

FINDING LIGHTS IN YOUR PHOTOS

It is easier to see the shapes and patterns of light in a reference photo if you hold the backside of the photo to a light, or put several sheets of tracing paper over the photograph. Do this when you are selecting a reference and deciding where to crop it. Look for a pleasing arrangement of light that flows through the image.

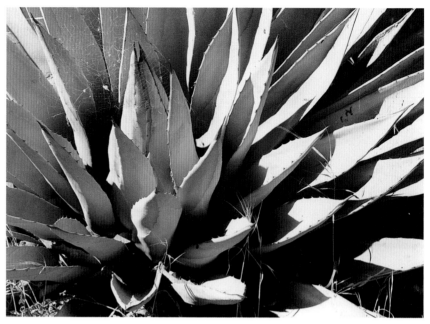

SQUINT AT YOUR REFERENCE PHOTO
Look at this reference photo through half-closed eyes. Forget for a minute that the subject is an agave, and look only at the shapes and pattern of light. Light or dark shapes can create an effective way of moving the eye around a painting. Consider using these shapes as the foundation for your composition.

TRACE THE LIGHT SHAPES
If it helps you to see the patterns of light, trace only the light shapes in your reference photo, then look at the composition formed by these shapes. Is it interesting? Are any of these shapes awkward? Make changes, eliminating or simplifying shapes; then incorporate the changes into your final drawing.

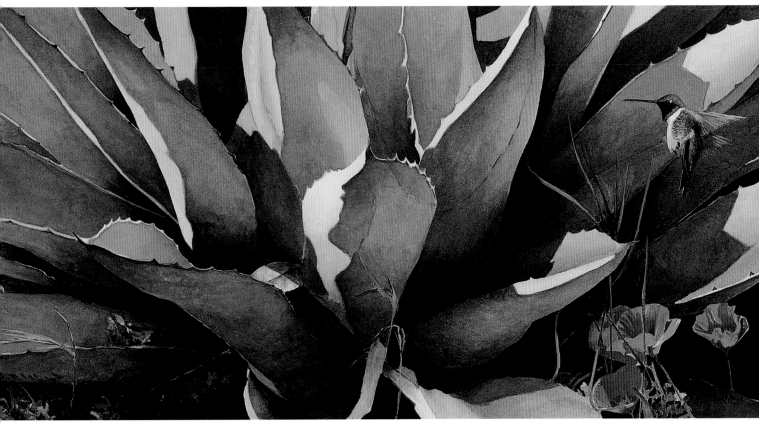

REWORK THE LIGHTS AND DARKS

You can see how much of the reference material the artist eliminated (see previous page). As soon as she traced the light areas, she realized the painting would be far too busy. She eliminated much of the light by cropping into the image. A few of the remaining sunlit areas were awkward so she darkened the value, putting them in shadow.

ARIZONA MORNING
Adele Earnshaw
12" × 24" (30cm × 61cm)
Private collection

Rose: Creating a Value Sketch

Materials

PAPER
140-lb. (300gsm) cold-pressed paper

BRUSHES
¼-inch (6mm), ½-inch (12mm) and
¾-inch (19mm) flats
No. 6 round

WATERCOLORS
Warm Sepia (Sepia or Black will
work as well)

OTHERS
Pencil

Plan your composition before your final drawing by painting several small sketches using sepia or black watercolor to work out the value patterns and areas of mass. Think about what kind of statement you want to make. Then, draw the subject lightly in pencil. Combine shapes and values to create simple patterns. Good shapes are the foundation of your painting. Describe shapes with care and give them variety.

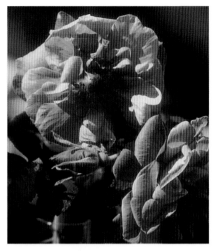

ROSE REFERENCE PHOTO

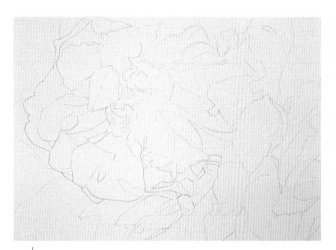

1 | Create the Drawing

Create a simple drawing of a rose.

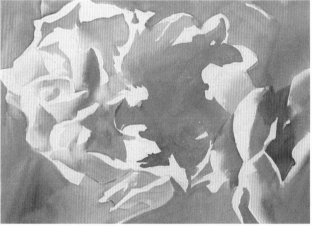

2 | Apply the Middle Values

Begin by painting in the midtones of the upper petals, leaving the white of the paper as your lights. Wet each area with a large brush before floating on paint with a medium-size brush. Connect the areas by wetting the edges and softening them with a clean, wet brush. Move down through the center of the flower and into the lower petals. Don't concentrate on the petal you're working on itself, but rather, think about the value shapes, and combine several.

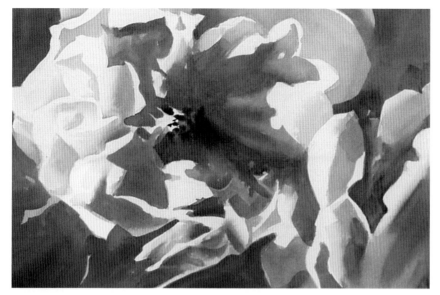

3 | Apply the Dark Values

As the paint begins to lose moisture, carefully charge in darks.

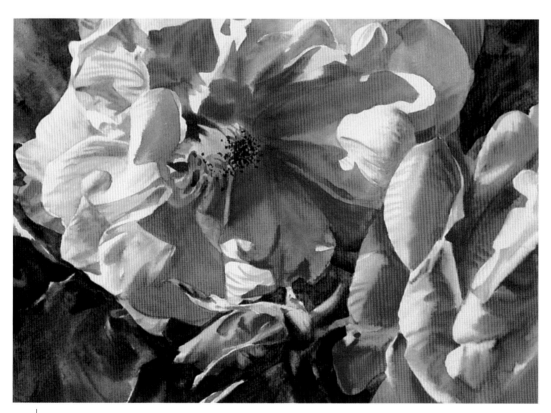

GLOWING ROSE
Ann Pember
11" × 14" (28cm × 36cm)

4 | Final Painting

Achieving balanced values and colors of the right intensity is important to making a painting work.

Planning Shapes

Form or shape refers to an area. Shape can be geometric or organic, open or closed, active or static. Some geometric forms are triangles, cones, rectangles and squares. Architectural shapes are usually rigid and hard-edged. Organic shapes are less rigid than geometric ones. These include natural forms such as flowers and leaves, and the forms of humans, animals and other things that can flow and move.

In addition to the positive shapes of actual objects, there is shape in the spaces around those objects. Develop an eye for these negative shapes; they have form too. Usually, the positive shapes of objects stand out, but negative shapes can dominate over positive shapes to create unique visual impressions.

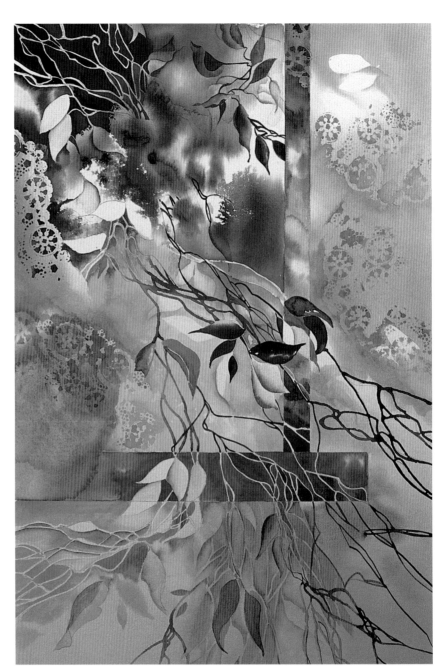

NOTICE ORGANIC AND GEOMETRIC SHAPES

This painting is expressionistic in style but still has a recognizable theme. Organic objects are more pronounced when combined with geometric shapes. Positive shapes are more interesting when countered with negative ones. In this case, the overall design was more important than rendering a realistic subject.

WINDOW VISIONS
Jan Fabian Wallake
27½" × 17" (70cm × 43cm)

Seeing Negative and Positive Shapes

Positive shapes are the objects you're painting. Negative shapes are the background and objects behind the thing you're painting. Many students consider only the objects they're painting and think of the background as a separate issue to be dealt with later. This is dangerous. Oddly enough, the background is often more difficult to paint than the objects in your still life. Backgrounds are an integral part of a composition and should be given as much attention as the subject of your painting. If you do a good job on your still life and haven't done anything with the background, you'll become traumatized with fear of ruining your still life with a tentative background.

Negative shapes are most important when you have a light-valued flower and need a darker shape or background to give the light flower substance and shape.

Capture the Essence

Find a color photo of a white flower with radiating petals with a medium-dark background. Take a quick look at your white flower, look away and then ask yourself: What is the essence of this flower? Is it the essence of white? Or is it about small fussy details? This is an important test. Think about it. Now spend a little more time studying the picture, and make a contour drawing with careful attention to the outside shape of the flower.

WATERCOLOR TECHNIQUE TIPS

- Don't outline with a linear dark.
- When you paint a background, use strokes that are both parallel and perpendicular to the form. Think fat. Create broad strokes using the middle of your brush.
- Use wet-in-wet so you'll get some variation in value as well as color around your flowers. Even with fairly hard edges, this value variation will keep your flowers from looking cut out and pasted down.

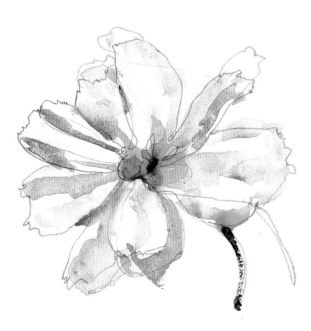

TOO MUCH DETAIL
This is what happens when you're consumed with the texture and detail in the white flower and ignore the background. The more you study the flower, the more details you'll see and want to paint.

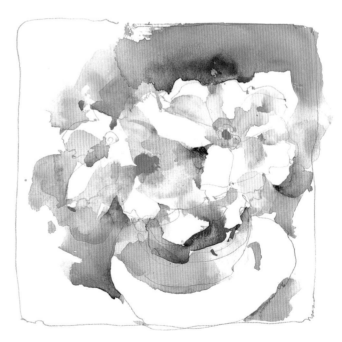

GETTING THE WATERY BUT NOT WASHED-OUT LOOK
This painting of a bunch of peonies allows more interchange between the flowers and the background. Most students want to overdefine every flower and leaf. If you overdefine and explain every petal, you will lose the sense of softness and mystery. Your flowers will look rigid and brittle if you overdefine.

Arranging Shapes in Your Paintings

To understand how solid shapes are affected by the negative space around them, cut geometric shapes of various sizes out of black paper. Move the shapes around the design area and overlap some shapes. By moving part of one or more shapes off the edge of the design, you can give the impression that your subject lives beyond the frame, and that adds intrigue. Remember to use a variety of sizes with your shapes. For example, a basket of roses is much more interesting if some are in full bloom and some are just buds. Likewise, it is more interesting if some shapes overlap others. The basket of roses will have depth and look more natural if some flowers are tucked behind others.

Avoid bringing any shape just to the edge of the painting area. For example, it would be better to carry the top of a tree right off the edge of the painting than to have it just touch the edge. This creates an undesirable nervous tension. The tip or point of any shape that just barely touches one of the four edges of your paper is visually irritating because it psychologically evokes a poking sensation. Also avoid aiming any shape toward a corner; it leads the eye quickly out of the picture.

Now look at the arrangement of shapes you have planned out. Do the solid shapes connect into a pleasing pattern? Are the negative shapes interesting? Do both positive and negative shapes work together to enhance the overall design? Is there a focal area—an area of the design toward which all shapes lead the eye?

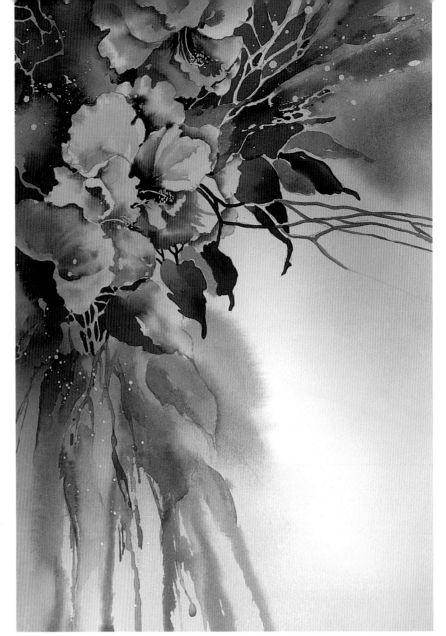

A COMPOSITION BALANCED WITH SHAPES

Here, the artist overlapped the flower shapes, carried some shapes off the edges, varied sizes and used both positive and negative shapes. A large part of the painting has been left unpainted. This area creates a shape just as important as the floral shapes. The lower-right portion of the painting is quiet and restful. It counterbalances the active shapes at the top. All of these shapes lead to and support the flowers as the center of interest.

HIBISCUS
Jan Fabian Wallake
21" × 14"
(53cm × 36cm)
Collection of
Kitty Chandler

PLACING SHAPES IS THE KEY TO GOOD DESIGN

French postimpressionist Paul Cézanne altered the direction of art when he questioned traditional realism and looked at the arrangement of shapes as the basis for design. His interest was not in painting realistic pictures; his focus was on creating a balanced design. He was prepared to sacrifice conventional correctness for a more interesting composition. Cézanne showed us a new way to look at the world. Shape and how it relates to the other elements of design is more important than subject.

Compositions get confusing when so many shapes stand alone.

There is nothing leading the eye to the focal point (large circle).

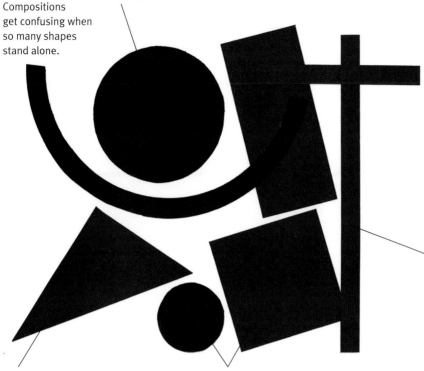

Ineffective Composition

If we reduce all objects in a scene to their most basic form, we can arrange the geometric shapes into a good composition. This example highlights several errors. There is no recognizable center of interest. No directional pull leads the eye on a path toward a specific area. Some shapes are just touching the picture's edge, which causes an irritating visual "poke." Other shapes aim toward a corner and lead the eye out of the composition. This arrangement is chaotic.

Placing the vertical or horizontal line parallel to the paper's edge creates dead space in the area between the line and the edge of the paper.

These shapes are fighting for attention. Without a directional pull, the eye wanders from form to form.

This shape points at a corner, directing the eye off the paper.

These shapes are placed right on the edge of the visual area, creating a nervous tension.

There is a directional pull toward the focal point (large circle). All other shapes support this thrust.

These negative spaces are interesting shapes.

The horizontal line is slanted and creates a better negative space, adding interest.

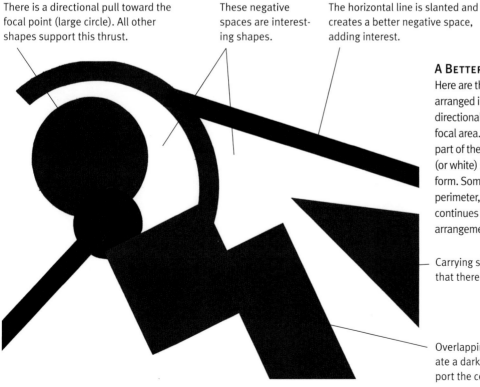

A Better Arrangement

Here are the same geometric shapes arranged in a strong composition. Notice the directional pull of dark shapes toward the focal area. All shapes lead the eye to that part of the composition. Both dark and light (or white) shapes are interesting in their form. Some shapes travel right past the perimeter, indicating that the composition continues beyond our visual scope. This arrangement of shapes offers intrigue.

Carrying shapes right off the edge indicates that there is more to the composition.

Overlapping shapes add strength and create a dark value pattern that works to support the center of interest.

Lighting Shapes for Photo Shoots

Value

Look at the flowers and their value relationships with one another. A petal may need to be backlit, or perhaps a leaf darkened for eye appeal. To get this effect, place your light behind or under the flower, creating a translucent shine. This adds more drama and punch.

Shadows

Long shadows create a magnificent, graceful sweep. To create long shadows, place your light level with the subject, slightly away from it.

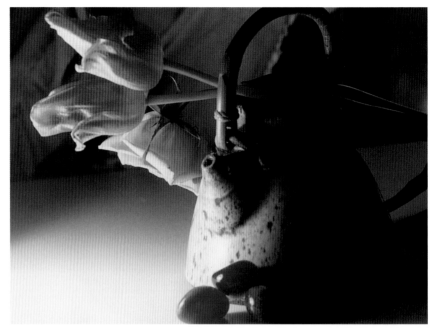

GOOD VALUES
Shining a strong light on your subject can be tricky, as the flower will wilt if the lightbulb is too close or is left on too long.

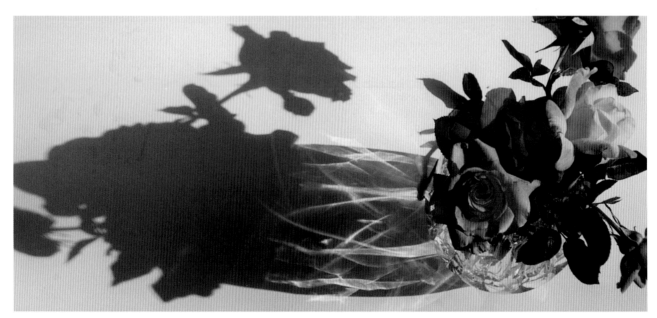

INTERESTING SHADOWS
Overlapping and interlocking the shadow and subject creates a strong artistic partnership.

Negative Space

Negative space and positive space need to enhance one another, not battle for power.

Reflections and Refractions

Reflections and refractions give crystal its textural uniqueness. A reflection is light passing through the cut facets of the glass and descending onto a surface. Only lead crystal gives the incredible brilliance that takes your breath away, but other glass can be just as pretty when put in a painting.

Refractions are color and value changes within the glass object itself. This results from the bending of color and shape (stems, leaves, waterlines, etc.) along the lines of the facets of the cut glass.

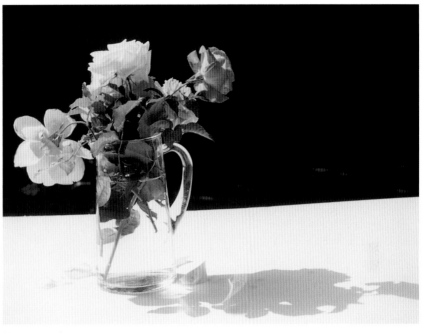

NEGATIVE SPACE
The strong negative of a dark background and the stark white table contrast with the gray shadow.

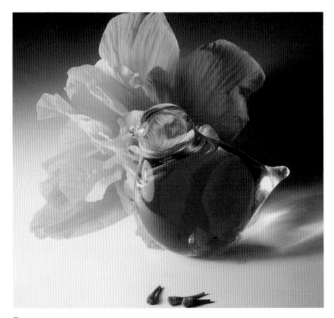

REFLECTION
Light passes through the glass bird and reflects shapes on the tabletop.

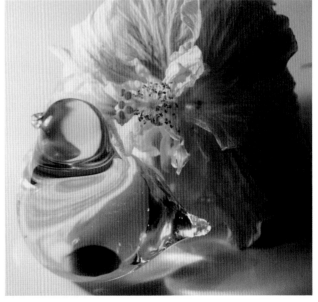

REFRACTION
The cream color of the hibiscus is refracted in the crystal bird. The round shape of the glass bird causes the flower shape and color to distort.

Flower and Petal Shapes

Circular Flowers

Many flowers are round. The petal shapes are more important than the outer shape, however, and a round flower like the peony may contain a variety of shapes. These may be large or small, and may have angles, curves or curled edges. They give you endless design possibilities. Connecting or linking shapes is critical in designing interesting patterns with these flowers.

The petals of most flowers are translucent and will let light shine through them if the light is strong enough or if the petal is not shielded from the light. This translucence can be used to advantage in designing light patterns for your painting. Look for ways to improve your design with these qualities.

Conical Flowers

Cone-shaped flowers such as gloxinia, amaryllis and lilies have fewer petals to design with, but offer beautiful colors and shapes. This is an opportunity to design with fewer shapes and really simplify. You might use only three to five petals in your design.

Clustered Flowers

When the flower is made up of a cluster of small flowers, such as delphinium or hydrangea, you have a chance to design by linking the smaller flowers together to make larger shapes. Use the patterns formed by the lights and darks to assist your design choices. You might also link some petal shapes with background shapes for interest.

Combined Flower Forms

Flowers such as gladiola and iris are made up of more than one circular form. The petals are few, but quite large, and their frilly edges are interesting. It is important to consider patterns of light and shadow when designing with these shapes. Be sure to edit your subject, linking and overlapping patterns of shapes, values and light.

Buds also make good design elements, from the tightly wrapped young ones to those beginning to unfold. Perhaps you could combine one or two with a flower form for a creative design.

PARTIALLY OPENED DAHLIA

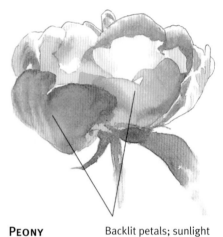

PEONY

Backlit petals; sunlight shines through

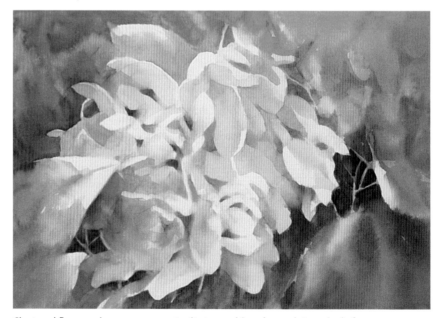

Clustered flowers give you an opportunity to combine shapes into a single form.

HYDRANGEA
Ann Pember
10" × 12" (25cm × 30cm)

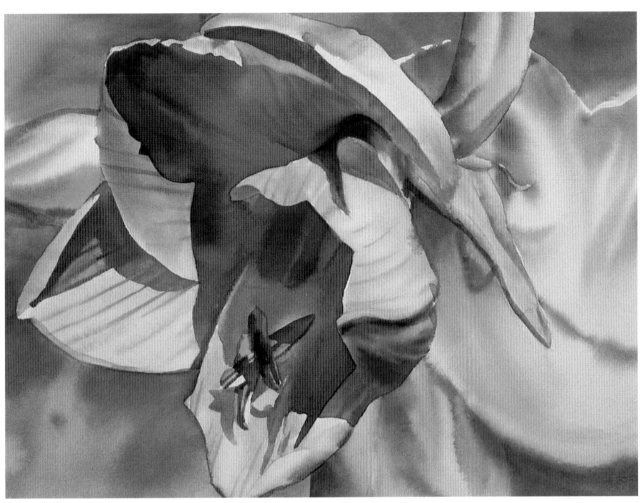

AMARYLLIS
Ann Pember
110" × 15" (25cm × 38cm)

Defining Shapes With Varied Edges

The edges of your painted shapes should vary in texture, size, color and value for interest and variety. They are an important means of expression and will help you communicate the mood of the subject.

Hard Edges

When you lay down wet paint on dry paper and allow it to dry, it forms a hard edge. Hard edges draw attention to an area, but too many hard edges can be jarring and stop the viewer's eye from moving through the paint-ing. This element is especially impor-tant when painting flowers close up. A common mistake is to paint a large, light flower shape with all hard edges formed by a dark background. This looks harsh and unnatural.

Soft Edges

Softening some edges as you work creates transitions from one area to another. You can also soften edges after the painting is dry. This can be helpful, but doing so while the passage is wet is preferable.

To soften an edge, put down a wash and while it is still wet, touch the area you want softened with a fairly large flat or angled wet brush. The additional moisture draws the painted mixture in a wicking motion and dilutes the color, forming a bleed. If the brush is too wet, you may get a bloom. If it is only damp, it will not produce a softened edge, but will pick up color instead. It takes a bit of prac-tice to get the feeling of how much water to put on the brush.

ALL HARD EDGES

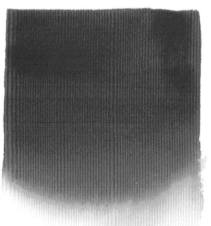

ONE EDGE SOFTENED WITH A LARGE, WET BRUSH

ALL SOFT EDGES

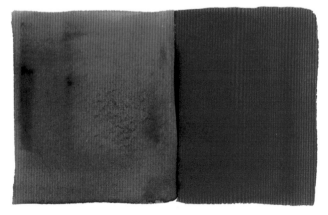

To get a hard edge, paint a color on dry paper and let it dry before painting a second color adjacent to it.

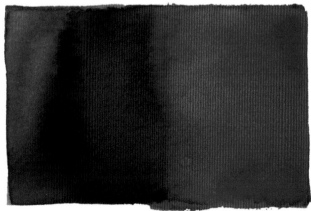

To get softened edges, paint a color on dry paper, then immediately paint a second color adjacent to it. The edge where they touch will bleed and soften.

Lost and Found Edges

A variety of lost and found (hard and soft) edges is pleasing and will encourage the viewer's eye to move through the painting. Watercolor is well suited to forming a wide variety of edges. Take advantage of this to explore many ways of expressing your own style with beautiful edges. If you use pen and ink, avoid outlining all the shapes; instead, employ it creatively within the design, perhaps in or near the center of a flower. Different degrees of wetness produce a great variety of edges for you. Experiment with how many you can produce.

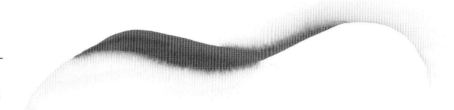

Create lost and found edges.

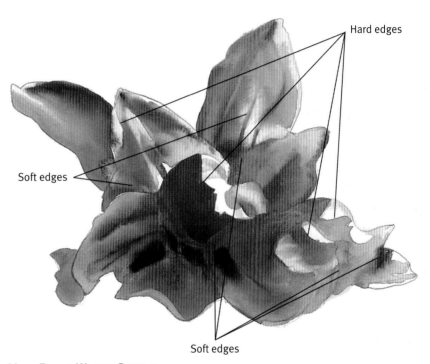

Hard edges

Soft edges

Soft edges

VARY EDGES WITHIN PETALS

Choose a limited palette and a few simple shapes. Wet the petals in stages and charge colors onto the wet paper, letting them bleed together and mix. These dahlia petals were painted with Permanent Rose, Permanent Alizarin Crimson, Antwerp Blue and New Gamboge. Let some edges dry to become hard. Soften others.

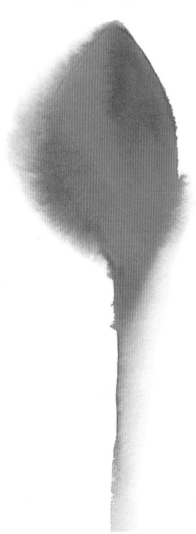

Paint a shape on dry paper, then soften some edges.

Mixing Simple Shapes on Paper

Materials

PAPER
140-lb. (300gsm) cold-pressed
 watercolor paper

BRUSH
No. 8 round

WATERCOLORS
Cadmium Orange
Cadmium Yellow
Mineral Violet
Olive Green

Set out your complete palette in an orderly fashion. You will be limiting yourself to one color for each flower, then adding a stem. You will not use glazes. Any value change will be done wet-in-wet in the first wash. Paint each flower shape on the first try with no corrective brushwork. You will make a series of the same flower shape for this demonstration, experimenting with slight variations in your water-to-color ratio. You must capture the essence of a flower with value changes and hard and soft edges with your first strokes.

1 | Paint the Basic Shapes

Mix up a rich swatch of Mineral Violet on your palette, rinse and shake your brush, place the tip at the base of the flower, press the brush to the paper and make your upward strokes, lifting abruptly at the end of each stroke. You must have more paint than water to manage this.

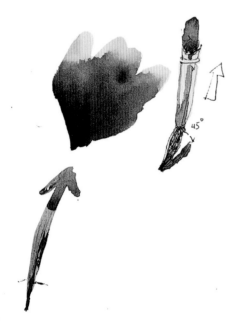

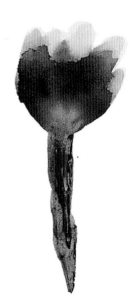

2 | Create a Stem

Quickly rinse, shake and mix up a rich swatch of Olive Green. Start your stem stroke at its base and brush up and into your flower.

3 | Watch the Colors Merge

Lay your brush down and see what happens. The green and the violet should merge.

TULIP
Charles Reid

Mixing Detailed Shapes on Paper

CLUSTER FORMS

Now try the same brushstrokes as used for mixing simple shapes but make smaller individual shapes, letting some overlap and run together on their own. You just place the paint; the color, water and paper do the mixing. Learn to live with mistakes. Use your no. 8 brush for the stems as well as for the blooms.

RADIATING FORMS: DAFFODILS

Use Cadmium Yellow for the flower. Your no. 8 brush point starts at the petal's tips, presses and strokes toward the center. Make a series of radiating forms. Several should overlap, but there should be islands of white paper within the cluster. Rinse your brush, shake it and dip it into Cadmium Orange. Place a spot of orange into the center of each flower while the flower is still wet. Add the stems using Olive Green.

Developing Leaf Forms

Materials

PAPER
140-lb. (300gsm) cold-pressed rough watercolor paper

BRUSH
No. 10 round sable

WATERCOLORS
Cadmium Orange
Cadmium Yellow Light
Cadmium Yellow Pale
Carmine
Cerulean Blue
Cobalt Blue
Hooker's Green (optional)
Ivory Black
Olive Green (optional)
Raw Sienna
Ultramarine Blue

MIXING GREENS

For this demonstration, don't use any premixed greens. Instead, use Raw Sienna with one of the blues for a warmer green. Cerulean Blue and Cadmium Yellow Pale make a good cool light green. Try mixing Ivory Black with a little Cadmium Yellow Light for a dark green. However, you could add a premixed green of your choice. If the plant's leaves were generally warmer, you could add Olive Green to your list. If the plant's leaves were cool, add Hooker's Green.

Now let's paint a section of a gardenia plant. You want a clean, fresh, uncluttered blush of white and light pink. These leaf forms take patience. In this case the leaves form a pattern of darks and medium darks with some distinct light leaf and flower edges. The trick is to keep some of these light edges firm and distinct while letting some of the darks and medium darks blend. It's the old lost-and-found game that's essential in all painting.

You should make a considered contour drawing. The drawing will help you get centered in the right side of your brain. You can't indicate or suggest any complicated leaf form or pattern. Your drawing must be accurate. You're weaving darks and lights and midtones. You're making an illusion of something that appears complicated. Paint it simply, and carefully consider every edge and value relationship. Careful detail with firm edges in some parts and blurs in other parts makes a good painting.

Here you'll use a simplified gardenia, with some firm boundary edges

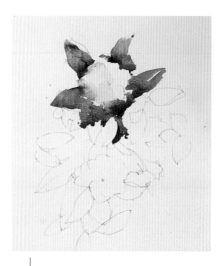

1 | Start At the Top

Place your brush tip at the dry boundary of the dry flower. Define the outside shape of the flower with the darker leaf, leaving some white paper, but don't isolate the gardenia with a fence of dark leaves.

Mix Carmine and a trace of Cadmium Orange with water for the off-white part of the flower. Paint this blush color on the left side of the gardenia. Leave a rim of dry white paper. Continue painting your rich, fluid (but not watery) greens so they can merge with the blush in the flower.

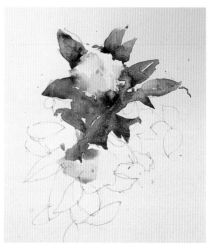

2 | Paint More Leaves

Vary your shapes. Use your source colors rather than the mixing area. Experiment with warm and cool colors. You want definite separations and shapes but also a watery look with different greens and the flower colors mixing together. Leave rims and islands of dry paper where you see light. Create definite separations between dark and light.

along with soft, wet-in-wet borders in other places. The color you mix for your greens isn't important as long as you can make it rich and dark with your first try. Never start painting a white flower by looking at the white flower. Always look for a darker leaf or flower shape next to the flower. Paint the dark shapes and eventually you'll have your white flower. This image is 8" × 6" (20cm × 15cm).

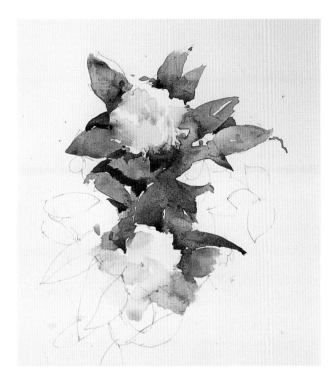

3 | Add the Lower Flower

You want rich darks and medium darks running together, with some separations and islands of light. Wait for everything you've painted to dry. Once dry, add some darker shapes.

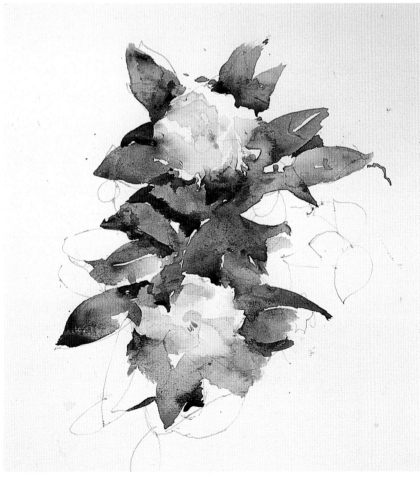

4 | Finish the Painting

Keep it fluid but defined, with lost and found edges and evident color changes (because you didn't overmix on your palette but mixed colors and values on your paper). Don't overdefine. Try for 50 percent definition and 50 percent mystery.

GARDENIA
Charles Reid

Types of Compositions

There are all types of compositions and the way an artist uses them becomes part of her particular style.

THE *C* COMPOSITION

A *C* composition is where paint touches or bleeds off three sides of the watercolor paper but not the fourth, which retains the white of the paper. The letter *C* may face upward as if it were a *U*, or face either side of the paper. Using this composition encourages you to create lost edges with very light values that appear to evaporate into the white of the paper. To help you remember this concept, "make a place for the birds to fly in and the birds to fly out."

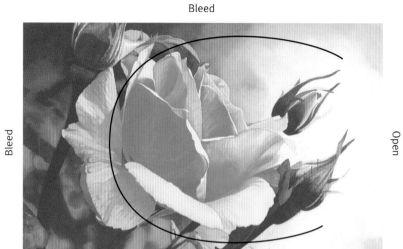

Bleed

Bleed

Open

Bleed

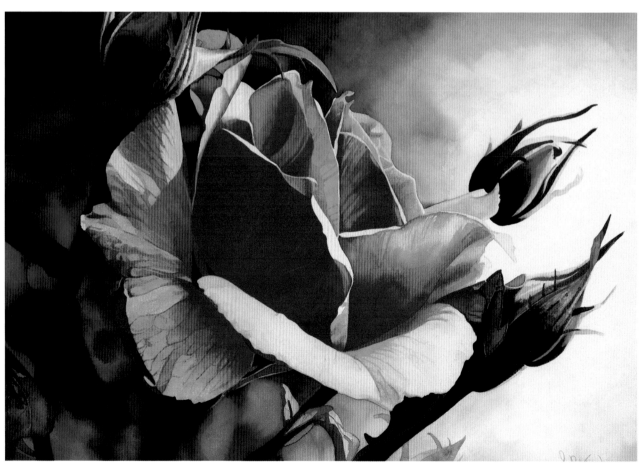

SENTIMENTAL JOURNEY
Susanna Spann
30" × 40" (76cm × 102cm)
Collection of Donna and Jon Burrichter

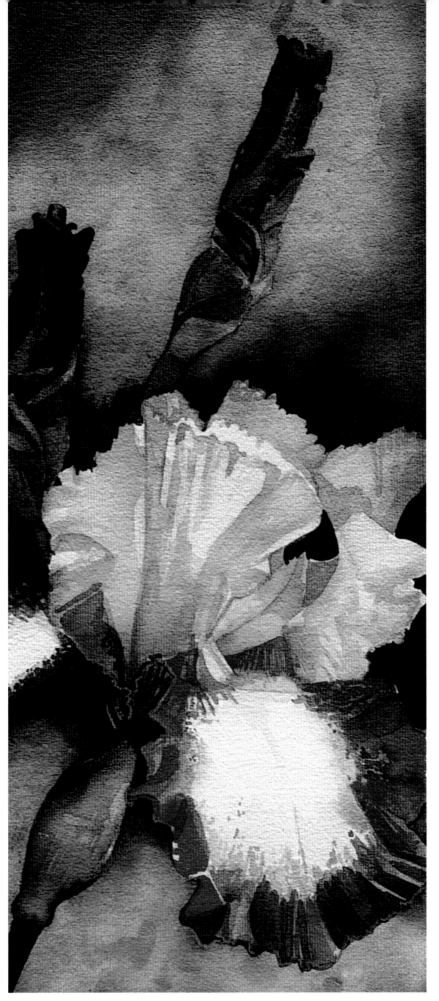

Stem

Top of T

THE *T* COMPOSITION

The *T* composition has the main elements of the painting positioned along a horizontal line, like the top of a *T*. It then has an anchor area or stem in the middle or off center. You can also position it as an upside-down *T*.

NORTHERN LADY
Susanna Spann
23" × 13" (58cm × 33cm)
Collection of Nancy Schleicher

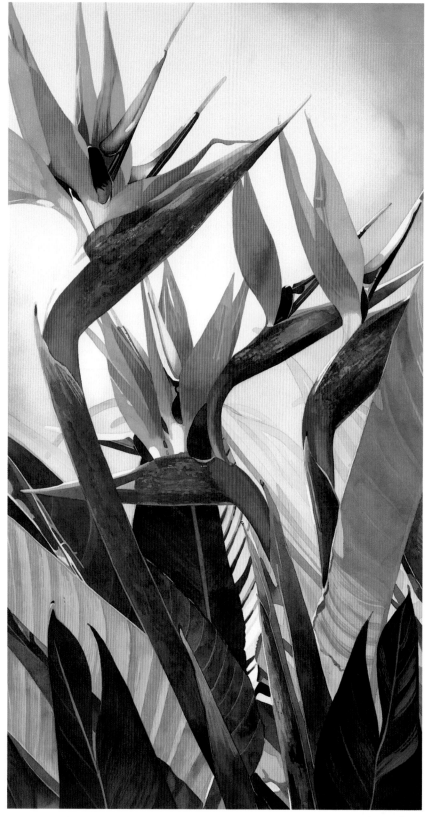

INSIDE EDEN
Susanna Spann
60" × 40" (152cm × 102cm)
Private collection

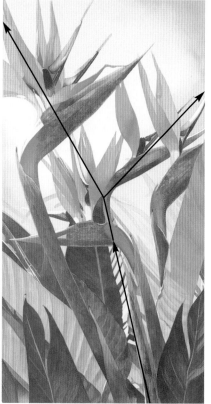

Leads out

Leads in

THE *Y* COMPOSITION

The *Y* composition is like the *T*, except with more of an angle from the horizontal lines. This composition leads the eye into a painting and then takes it out. You can also use this composition upside down or sideways. Think of it as a road map.

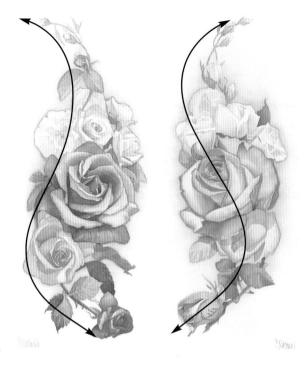

Backward *S* Forward *S*

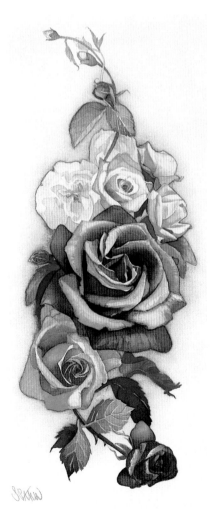

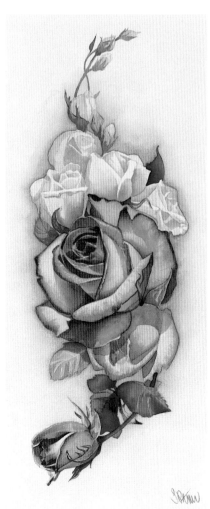

THE *S* COMPOSITION

The *S* composition is very graceful and can be designed with a mate for a matching pair of paintings. The *S* may be forward or backward. The important elements should follow the curve of the letter *S*.

JEWELS OF JUNE
(far left)
Susanna Spann
30" × 19" (76cm × 48cm)
Collection of Barbara and Bill Cloche

GEMS OF JULY
(near left)
Susanna Spann
30" × 19" (76cm × 48cm)
Collection of Barbara and Bill Cloche

THE *X* COMPOSITION

The *X* composition is formed with diagonal lines from corner to corner. The "sweet spot" occurs at the intersection and becomes the ideal location for your center of interest. This could be a flower, a bright color or an added element in the composition that you want to emphasize.

The sweet spot

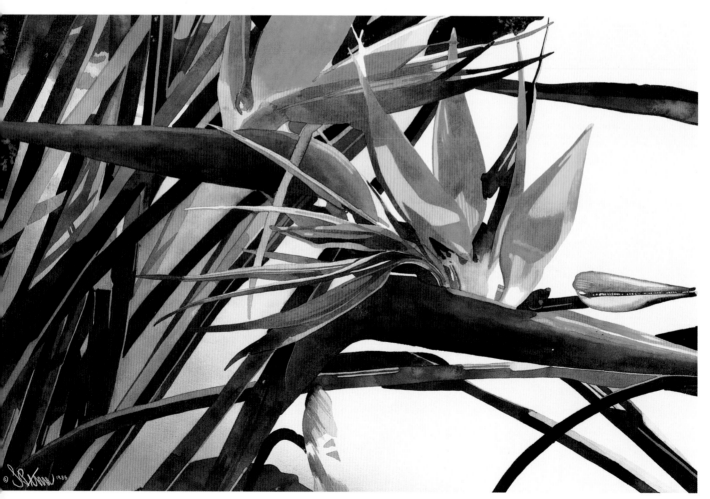

GEMINI
Susanna Spann
30" × 40" (76cm × 102cm)
Collection of Jackie Sinett

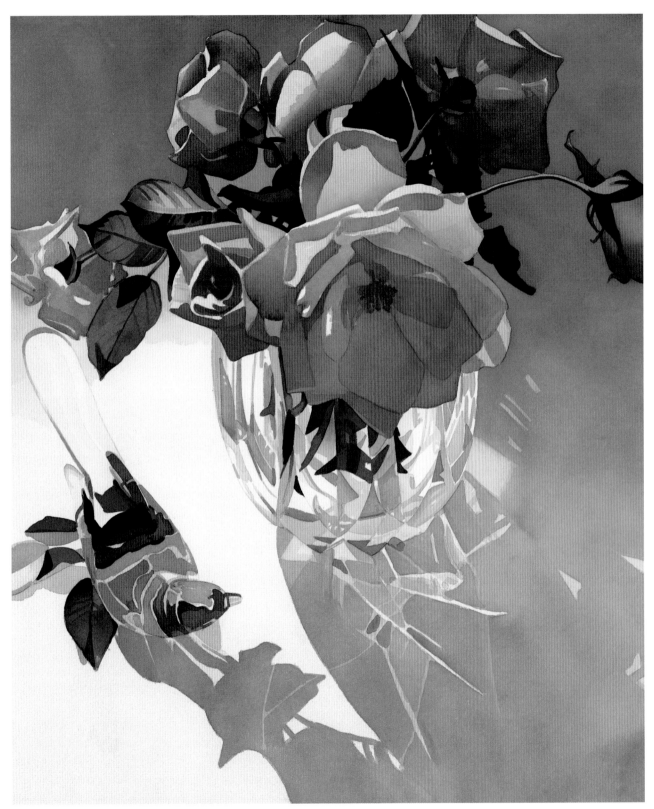

PERSPECTIVE COMPOSITION

You can construct a composition that takes the viewer's eye to an unusual place. The viewer of this painting has a bird's-eye view, looking down at the subject.

SUNDOWNER'S BLUES
Susanna Spann
35" × 31" (89cm × 79cm)
Collection of Green Bridge Association

Enlarging Reference Photographs

Materials

PAPER
10" × 7" (25cm × 18cm)
watercolor block

BRUSHES
1-inch (25mm) flat
No. 1 liner
No. 4 round

WATERCOLORS
Alizarin Crimson
Cadmium Yellow Medium
Charcoal
French Ultramarine Blue
Sap Green
Warm Sepia
Yellow Ochre

OTHER
6" × 4" (15cm × 10cm) photograph
Tracing paper
Ruler
T-square
Clear acetate
Masking fluid
Fine-point permanent marker
No. 2 pencil

This point marks the height proportionate to Line A for the same proportions as the photograph.

Line D

Draw this diagonal line.

Mark this edge of the photograph.

Line B

Place the photographic print here.

Line C

Mark this edge of the photograph.

Line A 10" (25cm) baseline

1 | Find the Proportions

A 6" × 4" (15cm × 10cm) photographic print scales up almost (but not quite)
to a 10" × 7" (25cm × 18cm) watercolor block. To keep the same proportion in
the finished painting as in the reference photograph and to make sure every-
thing fits, grab a slightly larger piece of tracing paper and a ruler, then draw a
10" (25cm) baseline (A), and two vertical lines (B and C) at either end to repre-
sent the sides of the enlarged image. Next, place the photograph on its side in
the lower left corner of the U shape and mark the top and right sides of the
photograph in pencil. Then remove the photograph and use a ruler to mark a
line diagonally upward until it intersects the vertical line on the right. To com-
plete the box, use a drafting T-square to draw a second horizontal line (D)
across the top at the point where the diagonal line intersects the vertical line
(right). The box measures 10" (25cm) wide and just over 6⅝" (17cm) tall.

2 | Create a Grid

Lay a piece of clear acetate over the photograph and, using a ruler and a fine-
point permanent marker, draw lines around the outer edges, then divide the
"box" in half vertically and horizontally. To make enlarging easier, again halve
each of the blocks you've just created, with two more vertical and two more
horizontal lines. For very complex subjects or for complex areas within a
subject, you may want to subdivide some or all of the blocks another time to
provide for more precise placement of details.

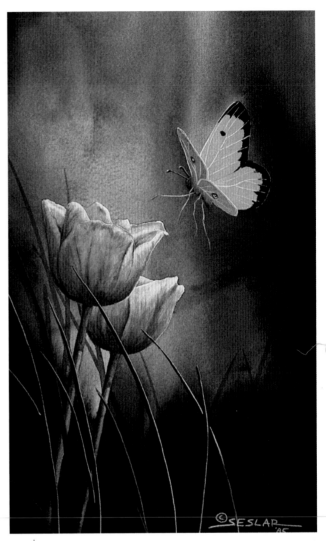

3 | Draw the Other Grid and Evaluate the Composition

Next, draw lines to divide and subdivide the box you drew on the tracing paper earlier until it has the same number of blocks as the acetate overlay on the photograph. (The blocks on the paper will be larger.) Then, with the grid on the photograph as a guide, use a no. 2 pencil to draw shapes on the tracing paper corresponding to those in each grid box on the photograph. To add interest to his composition, the artist positioned a tracing of a butterfly beneath the tracing of the flowers and drew its outline as well.

When the artist placed the tracing over a 10" × 7" (25cm × 18cm) block of 140-lb. (300gsm) cold-pressed paper, he decided the composition would be stronger if he moved the entire image down slightly.

Now redraw each of the lines of the drawing on the back of the tracing paper with the pencil to cover them with graphite. Finally, turn the tracing face up once again and go over each of the lines with the pencil to transfer them to the top sheet of the watercolor paper block.

4 | Paint the Composition

Mask the flowers, stems and butterfly with liquid masking fluid, then paint the background with a 1-inch (25mm) flat brush wet-in-wet with various mixtures of Sap Green, Warm Sepia, Charcoal and Yellow Ochre. When that dries, remove the masking and paint the stems with the same colors and a no. 4 round brush. Finally, paint the blossoms with the same brush and mixtures of Alizarin Crimson and French Ultramarine Blue. For the butterfly, use Charcoal and Cadmium Yellow Medium. Paint the antennae, the legs and the veins on the wings with a no. 1 liner brush.

TULIPS
Patrick Seslar
10" × 7" (25cm × 18cm)

Enlarging a Photo With a Pantograph

Materials

PAPER
300-lb (640gsm) cold-pressed paper

BRUSHES
1-inch (25mm) flat
No. 8 round

WATERCOLORS
Burnt Umber
Charcoal
Chinese White
Cobalt Blue
Cobalt Violet
Naples Yellow
Olive Green
Yellow Ochre

OTHER
Pantograph
Tracing paper
Ruler
T-square
Masking fluid

A pantographs is a slightly higher-tech solution for enlarging. It's a rather ungainly looking assembly of bars and pins that attaches to the edge of a table. By moving pins at the pivot points of the interlocking Xs, you can alter the degree of reduction or enlargement the pantograph will produce by tracing key elements on your reference. Pantographs can be a bit awkward, but they're inexpensive (usually under thirty dollars) and effective. You can find one at your local art supply store. Here's an example of a simple enlargement made with a pantograph.

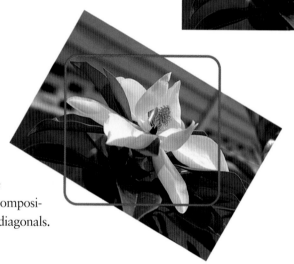

1 | Reference Photo
Here's one of several shots that will make an interesting painting, but the present orientation is boring.

2 | Rotate the Photo
As you can see, rotating the reference changes a stilted composition into one of interesting diagonals.

3 | Enlarge the Photo
Using the pantograph's nylon tracing point, follow the contours of each leaf and petal on the photograph with the enlargement ratio set at two. This creates a rough outline on tracing paper that you can smooth out afterward with a drafting French curve template. This artist left out some leaves during the pantograph session and slightly altered the shapes of several other leaves and petals before tracing the enlarged and rotated drawing onto an 8" (20cm) rectangle of 300-lb. (640gsm) cold-pressed watercolor paper.

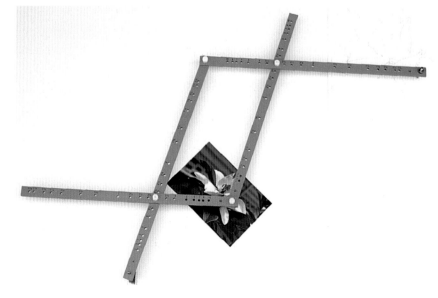

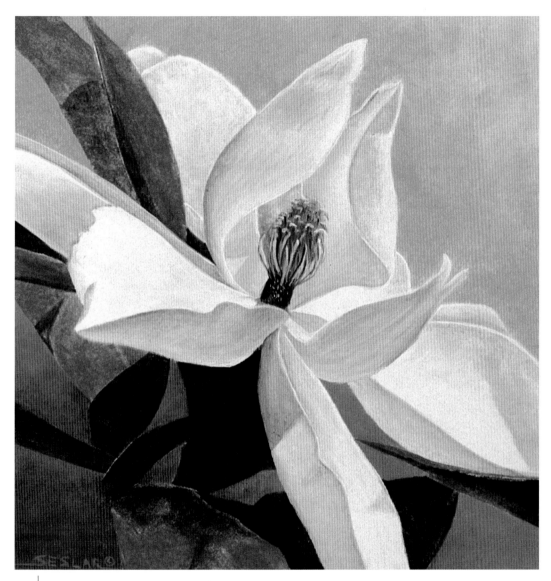

4 | Finish the Painting

After masking out the blossom and leaves with masking fluid, paint the background as a graded wash using a 1-inch (25mm) flat brush and mixtures of Cobalt Violet, Chinese White, Cobalt Blue and Charcoal. When that dries, remove the masking and use a no. 8 round brush to paint the leaves with mixtures of Olive Green, Burnt Umber, Charcoal and Naples Yellow. Paint the blossom with the same brush and mixtures of Naples Yellow, Yellow Ochre and Chinese White.

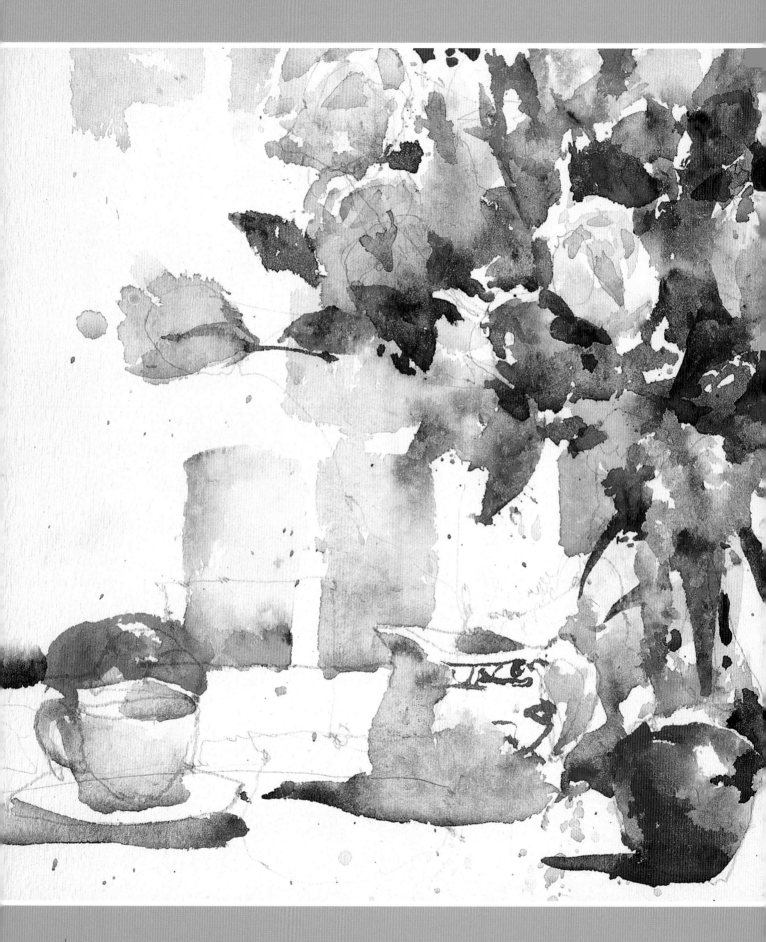

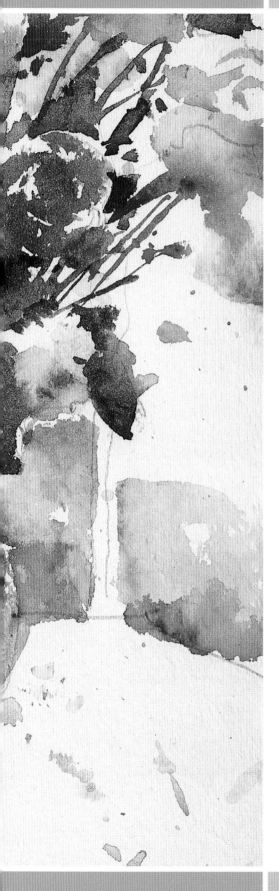

Step-by-Step Demonstrations

This section is filled with ideas you can incorporate into your own work. If you're new to painting, don't worry about copying a specific style. All painters are influenced by those who went before, but you will develop your own personal style the more you paint. Don't limit yourself to following "how to" books like this one—experiment! Good luck and happy painting.

YELLOW TULIPS AND MIXED FLOWERS
Charles Reid
16" × 20" (41cm × 51cm)
Collection of Sandra Smith

Using Transparent Washes

Materials

PAPER
300-lb. (640gsm) cold-pressed
watercolor paper

BRUSHES
Nos. 2, 4 and 6 rounds
Old no. 1 synthetic round

WATERCOLORS
Cobalt Blue
Hansa Yellow Light
Quinacridone Pink
Winsor Violet

OTHER
Hair dryer
Facial tissues

Flowers, with their delicate petals, present a unique challenge—painted blossoms can easily look heavy and stiff. Even if the form is well drawn, a painted flower will lose its delicacy if the artist uses a heavy hand. To avoid this problem, build up the washes with thin layers of color to retain the transparent quality. Also, keep in mind the direction of the light so that it not only defines the shape of the flower, but also shines through the petals in a few places.

LIFTING COLOR

Once a wash is damp-dry, color may be lifted to enhance highlights, using a damp brush to take away color. This works best with nonstaining pigments. Lifting can also be done once a wash is dry by scrubbing gently with a damp brush, then blotting the color away with a tissue.

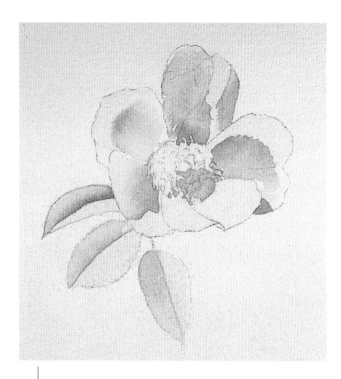

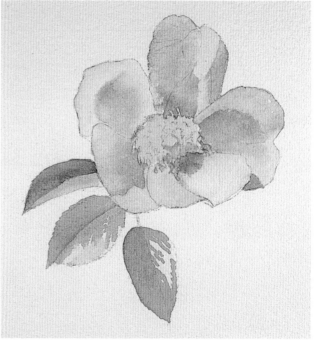

1 Lay the Foundation Washes

Paint pale yellow or pink underwashes on the sunlit areas, and blue or violet underwashes in the shadow areas. To paint adjacent washes without bleeding, make sure the first wash is bone-dry before doing the second.

2 Add the Light Values

Continue the building-up process by adding the lightest values of the flower color over the dried underwash; conserve the highlights using the lifting technique (pages 40–41).

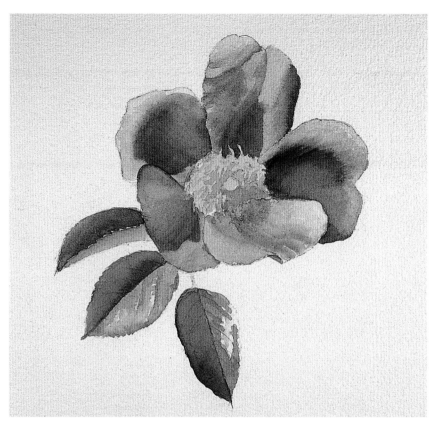

3 | Enhance the Values

While the base wash is still wet, it may be charged with more color to enhance the values or to add a blush of color. This is a good way to indicate soft-edged shadows and color variations. (For hard-edged cast shadows, use the wet-on-dry technique without pulling out to keep a crisp edge.) How much flare you get in the charged areas depends on how wet the surface is when you add pigment. If you want more control, use less water. This means that as you progress in the building-up process, you'll use less and less water until, with your finishing touches, you will be softening the edges with a damp brush.

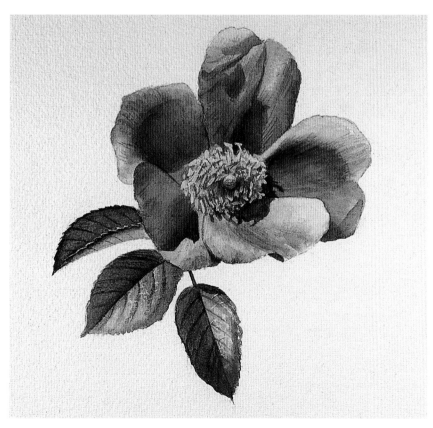

4 | Add Final Details and Finish the Glazes

By changing the colors and areas of application with each coat and drying between coats, you can glaze the subject with transparent layers, gradually building up the form. Add fine details once the last glazes are finished.

DAHLIA
Susan D. Bourdet

Daisies: Defining Shapes With Shadow and Contrast

Materials

PAPER
300-lb. (640gsm) cold-pressed watercolor paper

BRUSHES
Nos. 2, 4 and 6 rounds

WATERCOLORS
Cobalt Blue
Hansa Yellow Light
Payne's Gray
Quinacridone Gold

OTHER
Hair dryer

These simple daisies are dramatic against a dark background. The crisp white of the paper contrasts nicely with the cool blue shadows. For white subjects, shape and form are indicated by painting the shadow areas, leaving the white paper to represent the highlights.

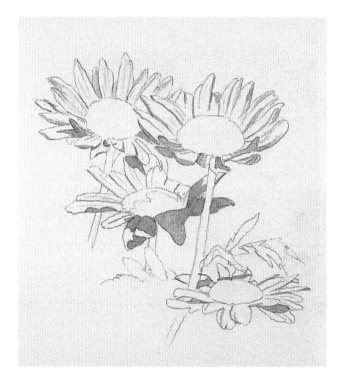

1 | Lay In the Shadows

Cool underwashes and details work well to enhance the white flowers. Use a mixture of Payne's Gray and Cobalt Blue on the shadows, then dry and detail those areas with the same mixture.

2 | Glaze the Centers

Wet the centers, then apply an underwash of Hansa Yellow Light. Glaze the shadow areas with Quinacridone Gold.

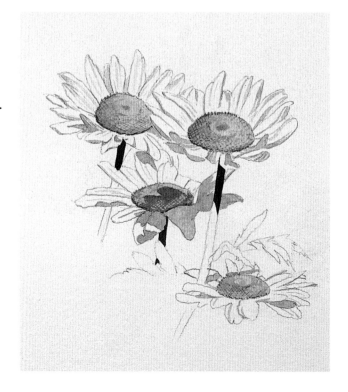

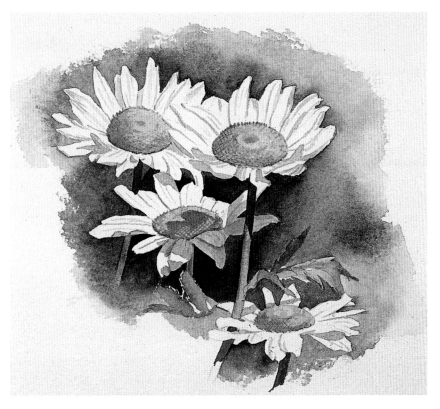

3 | Paint the Background

A contrasting background makes the flowers stand out.

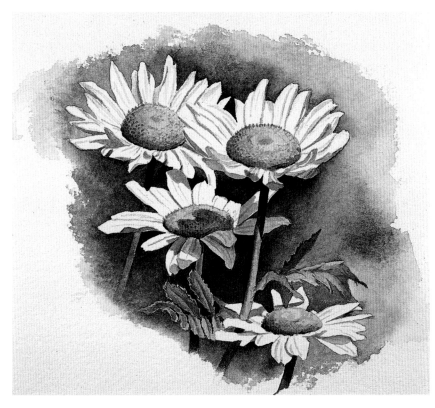

4 | Add Final Details

Paint Quinacridone Gold on the centers after they've dried.

DAISIES
Susan D. Bourdet

Apple Blossoms: Charging In a Delicate Blush of Color

Materials List

PAPER
300-lb. (640gsm) cold-pressed
 watercolor paper

BRUSHES
Nos. 2 and 4 rounds

WATERCOLORS
Cobalt Blue
Hansa Yellow Light
Hooker's Green Dark
Payne's Gray
Quinacridone Pink
Quinacridone Sienna
Sap Green

OTHER
Workable fixative
Hair dryer
No. 2 pencil

Many flower petals are streaked or delicately tinted. This effect can be created by *charging*: adding a stroke of color to the dampened petal for a soft-edged blush.

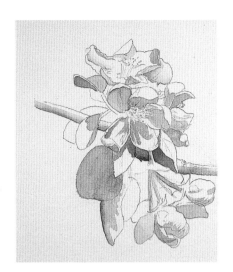

1 | Establish the Shadows

Create your drawing and spray it with workable fixative. Use a no. 4 round brush to paint the shadows with a mixture of Payne's Gray and Cobalt Blue. Dry with a hair dryer.

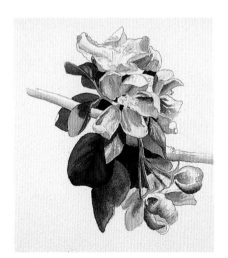

2 | Paint the Leaves and Petals

Paint the next wash on the leaves with Sap Green and charge with Hooker's Green Dark. Working on one petal at a time, dampen the area slightly and then charge in Quinacridone Pink here and there for a streaked effect.

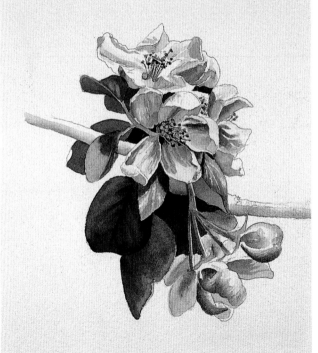

3 | Add the Flower Centers

Detail the flower centers with Hansa Yellow Light and Quinacridone Sienna using the no. 2 round.

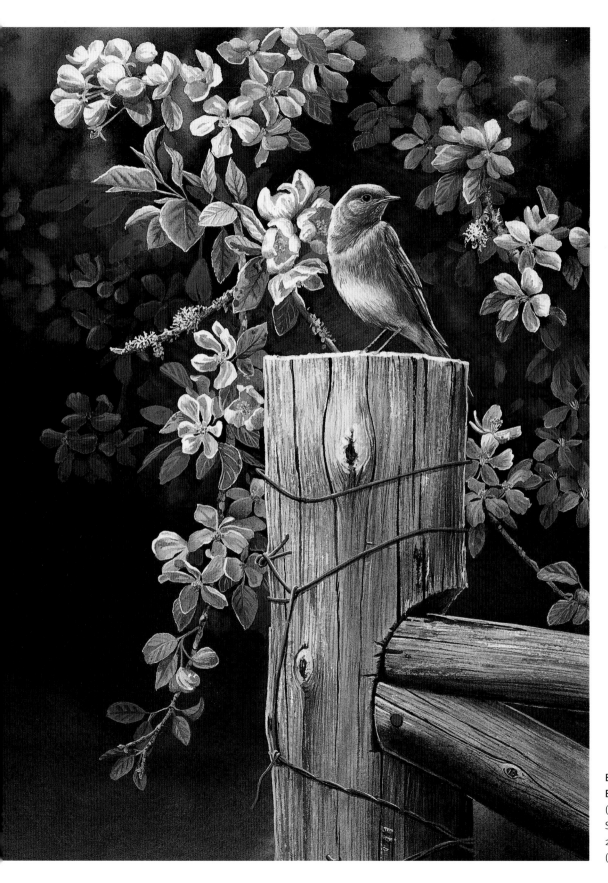

BLUEBIRD AND APPLE BLOSSOMS
(Western Bluebird)
Susan Bourdet
26" × 18"
(66cm × 46cm)

Try a Limited Palette

Beautiful paintings can be achieved with only one to three colors. If you have trouble with color mixing, try simplifying the process by painting with just one warm and one cool color. You might also explore painting with analogous or complementary color schemes (see pages 44–45 for more information on these terms).

By simplifying your color choices you can focus your attention on the elements of good design and other aspects of painting, but your paintings will still look unified and harmonious.

Aureolin and Winsor Violet

Burnt Sienna and French Ultramarine

Permanent Rose and Phthalo Turquoise

Quinacridone Magenta and Winsor Green

Quinacridone Gold and Phthalo Blue

Permanent Alizarin Crimson and Turquoise

MINGLE COLORS WITH A LIMITED PALETTE
Try mingling various pairs of colors together, using only one warm and one cool pigment at a time.

Pink Phlox: Using a Limited Palette

Materials

PAPER
140-lb. (300gsm) cold-pressed
watercolor paper

BRUSHES
Nos. 12 and 18 rounds

WATERCOLORS
Permanent Rose
Phthalo Turquoise

OTHER
No. 2 pencil

Develop a painting using only one warm and one cool color. Mix the colors in as many different combinations as you like, in a variety of values. See how inventive you can be and have fun exploring the possibilities.

This is a great way to test the full range of your colors. Remember to mingle colors, work with value patterns, create edge variety and employ the elements of good design.

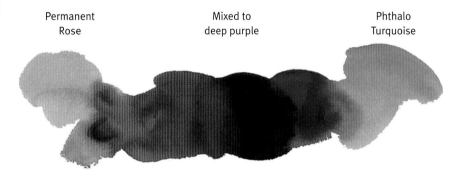

Permanent
Rose

Mixed to
deep purple

Phthalo
Turquoise

Paint with a limited palette of two colors: a warm and a cool.

1 | Draw the Phlox

Create a simple drawing of the phlox.

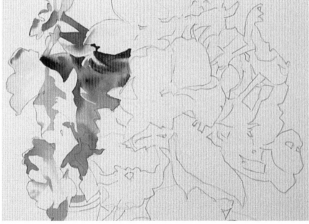

2 | Begin Mingling Colors

Using your smaller brush, start painting with both colors right away, allowing them to mingle on wet paper one section at a time. Vary the intensities and values, including a few darks.

3 | Link the Shapes

Use your smaller brush to connect the sections by softening mutual edges to blend them. Continue including darks to balance the values as you work. You should not need to come back to add them. The main dark is the foliage under the center flower; use a deep mix of pigment, tending toward the turquoise. Avoid getting caught up in too much detail there. Paint the dark leaf and stem shapes together as one shape with your larger brush.

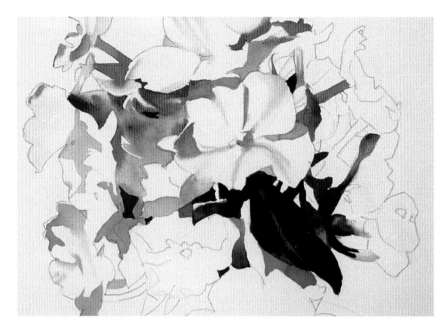

4 | Paint the Shadow Side

Add more shadow darks, using less water with your paints, creating a deeper value on the petals to the right side. Paint them as one general shape, adding definition with additional color and your smaller brush just before the wash dries.

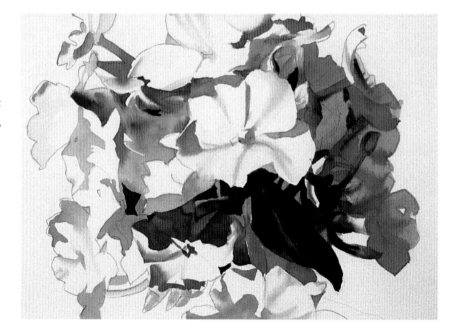

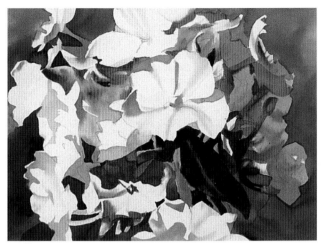

5 | Paint the Background

Paint in the background with the larger brush, mingling the shades of blues, purples and pinks. Make it dark enough to give contrast to your flowers, painting carefully around the light shapes.

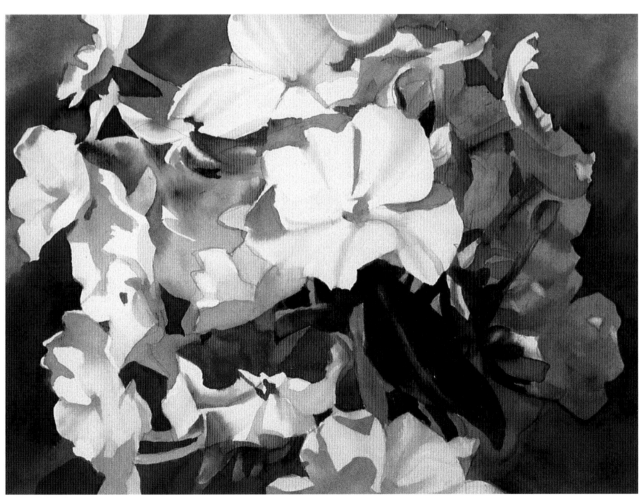

6 | Add Final Touches

Add definition to the petals where needed and darken the background with additional layers of color to get a strong dark value.

PINK PHLOX
Ann Pember
7½" × 11" (19cm × 28cm)

Hollyhock: High-Key Floodlight Effect

Materials List

PAPER
140-lb. (300gsm) cold-pressed
 watercolor paper

BRUSHES
½-inch (12mm), 1-inch (25mm) and
 1½-inch (38mm) flats
No. 10 round
Small fritch scrubber

WATERCOLORS
Antwerp Blue
Aureolin
Cadmium Red Purple
New Gamboge
Permanent Alizarin Crimson
Permanent Rose
Raw Sienna
Raw Umber
Winsor Green

OTHER
Pencil
Facial tissues
Tracing paper (optional)

The dictionary defines *floodlight* as "artificial illumination of high intensity, usually with a reflector that causes it to shine in a broad beam. Flood—to cover or fill."

High-key paintings give a feeling that the whole subject is bathed in an even illumination of light from overhead. Contrast is greatly reduced, creating softer edges. Because there are fewer hard edges, there is more movement. With this kind of lighting, it is beneficial to link shapes, providing a rhythm through the painting. Think of this lighting as if you were looking at things through a filter. You actually are doing just that, because the atmosphere acts like a filter. With floodlighting, it is possible to see the more subtle colors that may be obliterated by a harsher light. Be sure to make color an important element; look for the subtle colors, especially in the shadows. A high-key painting can be somewhat moody and mysterious because it looks as if you are observing things through a thin veil. Look for subjects for this type of painting on a hazy, atmospheric day.

REFERENCE PHOTO FOR HOLLYHOCK

REFERENCE PHOTO, CROPPED FOR BETTER SHAPES

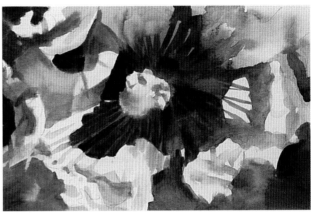

1 | Create the Drawing

Avoid too much detail and emphasize good shapes in your drawing, linking them when possible. You may want to make the drawing on tracing paper and then transfer it to the watercolor paper.

2 | Make a Value Sketch

Make a simple three-value sketch to plan the painting. (See pages 64–65 for more information on value sketches.)

3 | Begin Painting

Wet an area in the center of the flower a little larger than you need using the 1½-inch (38mm) flat. Use a small brush to charge the area with Aureolin and New Gamboge, letting them mingle on the paper. Add darks of Permanent Alizarin Crimson and Raw Sienna. These can be added while the yellows are still wet. Paint a few deep accents with harder edges after the area has dried. Also work on the petals on the lower left, mingling Antwerp Blue, Permanent Rose and New Gamboge.

4 | Develop the Lower-Left Petals

Paint in the pale pink of the petals using a small brush with Permanent Rose and Antwerp Blue, leaving white paper for the veins. Paint around the white areas carefully. Soften some edges using a clean, wet brush. You can clean up any ragged edges with a stiff bristle brush such as a fritch scrubber and blot with a tissue.

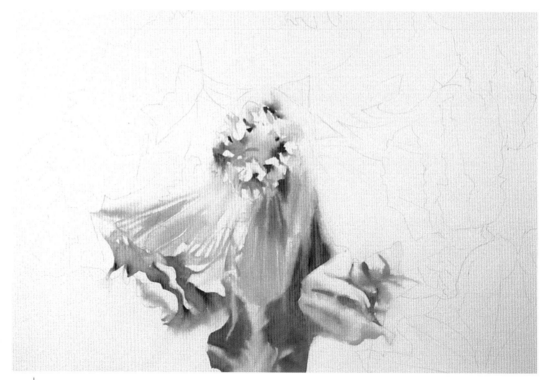

5 | Develop the Petals Beneath the Center

With your blender, wet the whole area of petals beneath the center, and even over part of the center. This will prevent any hard edges. Paint the deep yellow using New Gamboge, Raw Sienna and Raw Umber down toward the petals with a large brush, changing color along the way. Soften some edges and lift whites for the veins with a clean, thirsty brush and tissue.

Carry over to the right with minglings of Antwerp Blue, Permanent Rose and New Gamboge near the petal edges.

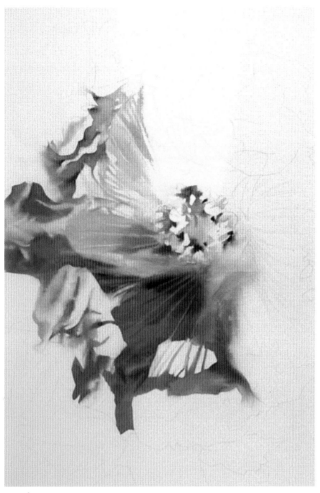

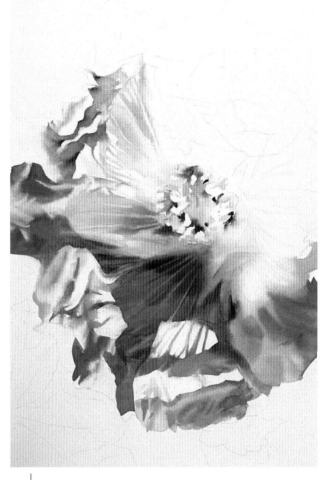

6 | Paint the Center Shadow

Turn the painting on its right side so gravity will make the paint move away from the center. Wet the large shape, including some of the already painted area so it will blend together. Then charge with Permanent Rose, Permanent Alizarin Crimson, Cadmium Red Purple, Antwerp Blue and New Gamboge using a large brush. Soften the edges and mingle the colors.

While the paint is damp, lift the light veins with a small brush. Blend these into the highlight on the petal where the veins are pink. Once dry, clean the veins with a small brush and glaze them with New Gamboge. Make the veins darker near the center and vary the yellows, adding Raw Umber.

7 | Refine the Right Side

With the painting still on its side, clean up the edges and veins if needed. Add any subtle shadows as a glaze. With a small brush, add the green near the center using Antwerp Blue and New Gamboge, pre-wetting first and then blending the edges. Paint the midtones of the top petal with Permanent Rose and Antwerp Blue and finish to its edge.

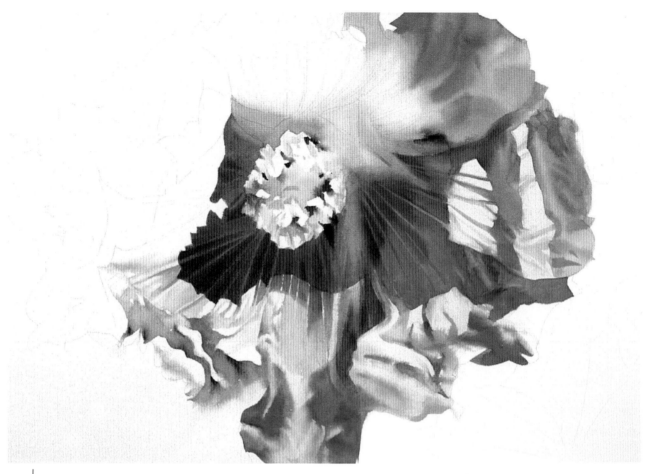

8 | Add the Center Shadow and Develop the Left Side

Turn the paper upright again. Wet the area that will become the shadow before charging with paint. Then paint in the shadow using a large brush with Cadmium Red Purple, Permanent Rose, Raw Umber and Raw Sienna. Make the paint rich and deep. Remember, it will dry lighter. Again, pull out veins with a small thirsty brush or scrubber, using its edge. Glaze with New Gamboge and Raw Umber. Blend the edges. For impact, add the darkest applications of Antwerp Blue and Raw Sienna just before the area dries.

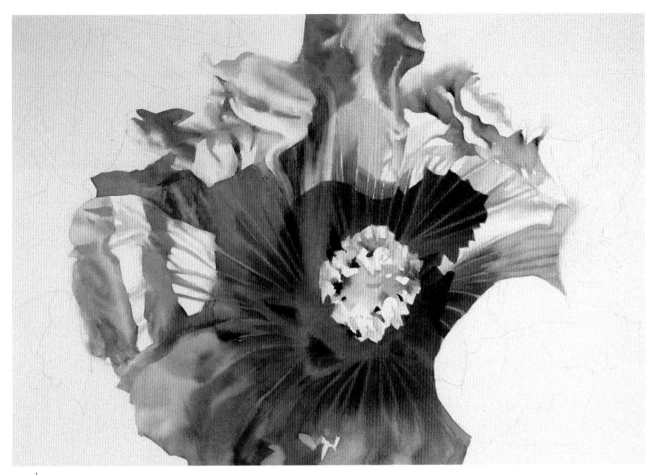

9 | Develop the Top Petals

Turn the paper upside down. Wet the portion above the flower's center and just over the nearest painted parts. Paint rich darks near the center using the same shadow colors as in step 6, blending into the neighboring darks. Add the small triangles of green using a small brush with Antwerp Blue and New Gamboge, blending into the yellow veins around them.

Then paint out to the edge of the paper, mingling Permanent Rose and Antwerp Blue. Lift out the veins. When dry, add a glaze of Raw Sienna and Raw Umber over the veins and near the center for shadow. Also paint the mid-tones to the left of center with Permanent Rose, Raw Umber, New Gamboge and Antwerp Blue.

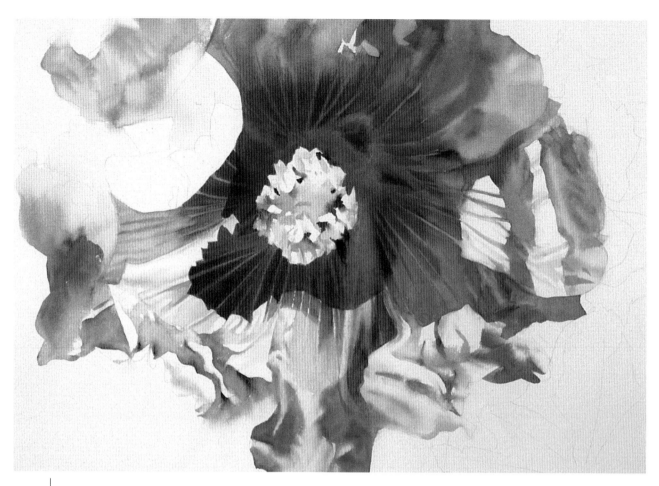

10 | Paint the Outer-Left Petals

Turn the paper right side up. Using a large brush, wet each outer petal area and float in mingled colors with Permanent Rose, New Gamboge and Antwerp Blue.

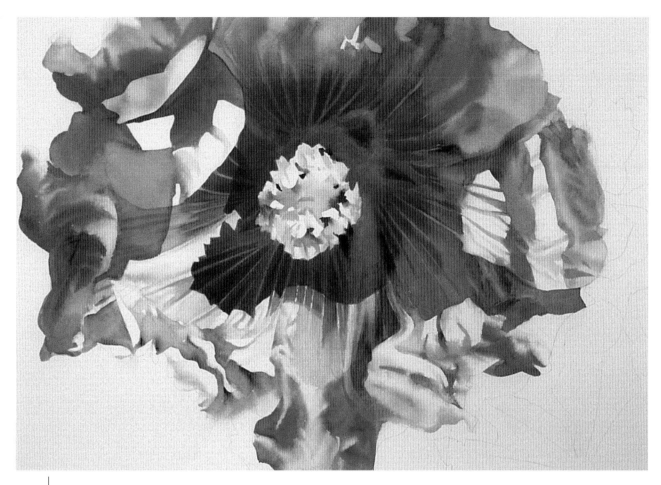

11 | Add Shadows on the Left Petals

Paint Permanent Rose, Antwerp Blue, Permanent Alizarin Crimson and New Gamboge with a large brush, allowing colors to mingle in the darker areas. Before the wash dries, charge in more color if the area needs greater intensity.

12 Develop the Upper-Right Corner

Wet the upper-right corner of the painting with the 1½-inch (38mm) flat. Paint the suggested flower in the background using a large brush with Permanent Rose, New Gamboge and Antwerp Blue. Make this a light midtone to keep it from drawing too much attention from the large flower.

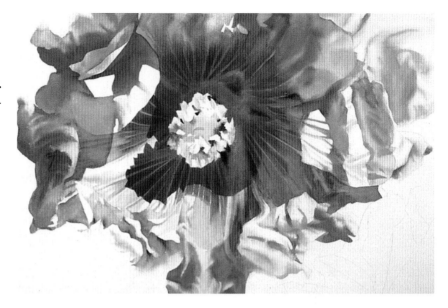

13 Make Adjustments

The artist was not pleased with the bottom petal shape. If you have any changes to make, this is a good time to do so. Even though you try to plan well, things sometimes fall short—but you can fix them. Carefully scrub out the area to be changed. When totally dry, re-wet the area and paint it again with the new shape. Soften the edges and mingle the color. You can also lighten the veins above the center by lifting gently. This gives a greater feeling of dimension to the petal. Refine the center too, glazing with midtone minglings of New Gamboge and Raw Sienna. Add deep red accents with Permanent Alizarin Crimson and Cadmium Red Purple.

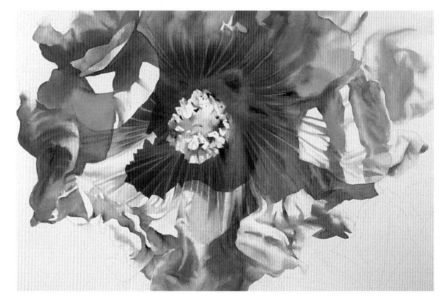

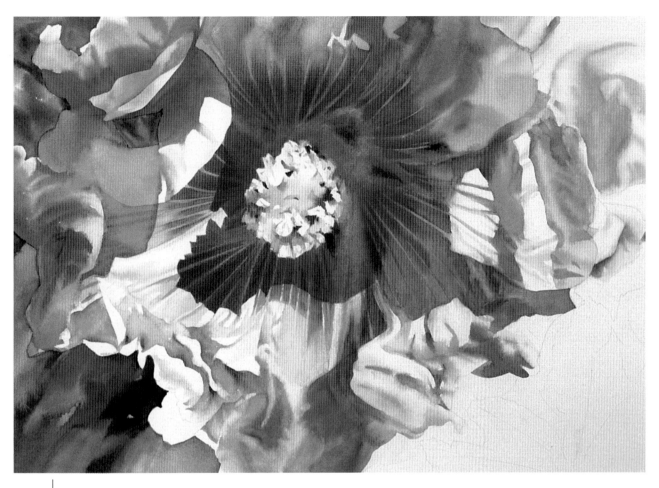

14 | Begin the Background

Wet the background at the upper left and float in New Gamboge, Winsor Green, Cadmium Red Purple, Antwerp Blue and Raw Umber using a large brush. Let the colors mingle. Work down the side, wetting each area as you go. The petal edges that touch the edge of the paper are convenient places to end a wash. Then finish the bottom left corner, stopping at the lower petal.

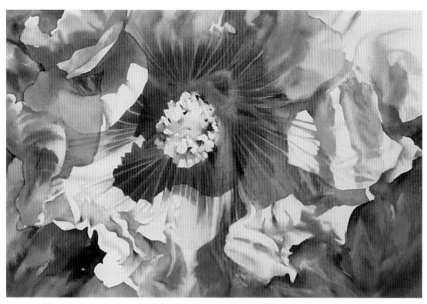

15 | Paint the Remaining Background

In the same manner as step 14, work carefully around the petals of the right side. Soften some areas into the flower petals to avoid a cut-out look to the flower. Let the same color and value flow between the flower and the background, linking them together.

16 | Add Refinements

Glaze over the background if it needs to be darker, using the same colors as in step 15. Blend the edges. At the upper-right corner, subdue the petal in the background with a glaze of Permanent Rose, Antwerp Blue and New Gamboge. This should create a feeling that this petal is behind the large flower.

Gladiola: High-Contrast Spotlight Effect

Materials List

PAPER
Sketch paper
200-lb. (425gsm) cold-pressed
 watercolor paper

BRUSHES
¼-inch (6mm), ½-inch (12mm), 1-inch
 (25mm), and 1½-inch (38mm) flats
Small round

WATERCOLORS
Antwerp Blue
Cadmium Red Purple
New Gamboge
Permanent Rose
Raw Umber
Winsor Green

OTHER
Pencil

A simple dictionary definition of *spotlight* is "a projected spot of light used to illuminate brilliantly a subject on stage; a light designed to direct a narrow intense beam of light on a small area; something that illuminates brilliantly."

The spotlight effect produces a high contrast of values. It is a fairly harsh type of lighting and will wash out the most subtle colors, but it can be dramatic and suggest a feeling of great energy. Many hard edges are formed, so it is necessary to design the shapes well, subduing some of the hard edges for variety by connecting them with similar colors, values or textures. Connect shapes together, forming patterns of light and dark. The staining transparent pigments can be useful in such a painting to produce rich darks, shadows and jewel-like colors.

Spotlighting is the kind of light you find on a bright day with a clear atmosphere. Remember to look for reflected colors in the shadow areas; even though shadows appear dark when contrasted with the lights, they receive reflected light, too. Both warm and cool colors will be in the shadows as well as the lights as a result of reflection.

REFERENCE PHOTO FOR GLADIOLA
You can turn a photo to find the shapes you like, using a small mat to help you isolate the forms. Be creative when working with photos: turn them, cut them if it helps, use a mat to mask parts out. Here the artist zoomed in on one flower, even though there is a whole stalk of them.

1 | Create a Pencil Sketch

Link shapes, make patterns, simplify and consider what effects are produced by the light as you draw your flower.

2 | Make a Value Sketch

Make a simple value sketch to work out the patterns of shapes. (See pages 64–65 for more information on value sketches.)

3 | Begin Painting at the Top

Use New Gamboge, Antwerp Blue and Permanent Rose to paint light value washes over the top petal after wetting the paper there with the 1½-inch (38mm) flat. Let the colors run down and blend into the center of the flower. Soften most of the outer edges to nothing with a large, wet brush.

Paint around the stamens using a small brush with New Gamboge, adding some Antwerp Blue to make green near the center. Just under the stamens at the center, mingle some Raw Umber with the green to make a rich brown.

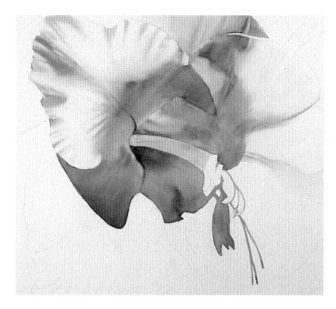

4 | Paint Around the Flower's Center

Begin with the frilly outer edges of the upper-left petal. Wet the whole petal and use a medium-size brush to float in small minglings of the colors you've been using, making a purple mix to emphasize the "frills." Soften the edges with a wet brush to keep color where you want it. Re-wet the petal near the center, and charge in Antwerp Blue and Permanent Rose for the shadow where the petal curves. Immediately paint the deep pink vein Permanent Rose with a small, well-pointed round brush or a flat with a good knife-edge.

Add New Gamboge near the very center with a large brush to create a glow. Continue working the shadow down below the stamens, wetting first to keep everything connected and allow mingling. Glaze over the area around the stamens you already painted. Use a small brush to paint around the end of the stamens and down into their shadow, merging this wash with the shadow above.

5 | Work on the Left Side

Wet the petals on the left side and use a large brush to mingle Permanent Rose, Antwerp Blue and New Gamboge. Keep the darker blue and lavender at the top third of each petal where there is a curve, and place the New Gamboge at the base of the petal. Use both hard and soft edges.

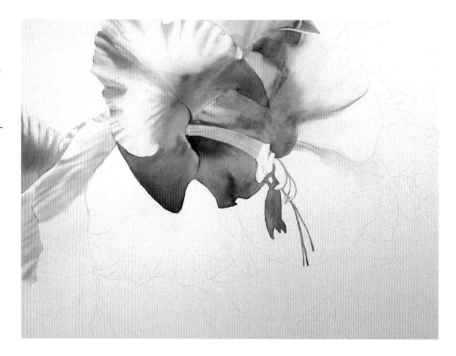

6 | Continue to Develop the Left Side

Using the same colors as in step 4 and a large brush, work down the side, wetting as you go. Save whites and make these washes a bit deeper in color. The yellow should produce a feeling of sunlight glowing through the petals.

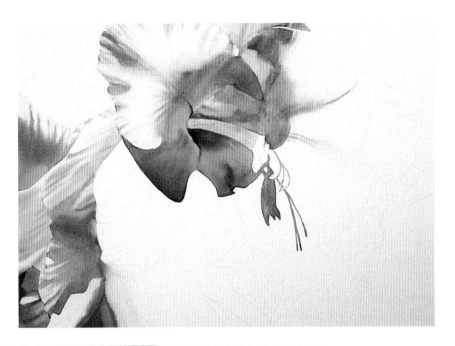

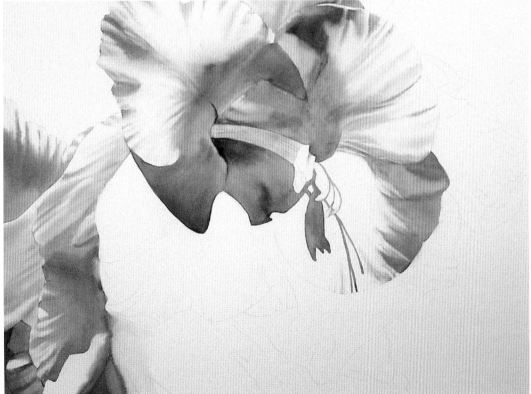

7 | Develop the Central Petals

Carefully re-wet over the right side of the center and onto the petals on the right with the 1½-inch (38mm) flat. Use a medium-size brush to charge in the same colors as in step 4, mostly on the outer edges and a few connecting shadows. Soften the edges. Make the shadows of the lower petal darker than those above it.

8 | Paint the Bud, Leaf and Stem

Use small and medium-size brushes to wet the bud shape and paint with light washes of New Gamboge, Permanent Rose and a bit of Antwerp Blue and Raw Umber for the darks. Mingle colors and make hard and soft edges. This bud is in the light so it should not be too dark. Wet the leaf shape above the bud and paint with New Gamboge, Raw Umber, Antwerp Blue and a touch of Winsor Green and Permanent Rose for the darks. Use these same colors to paint the small stem shape at the top right, varying the colors to show shadow and highlight.

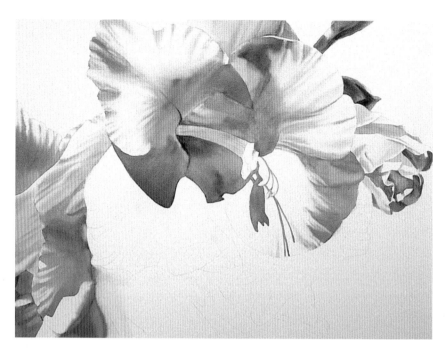

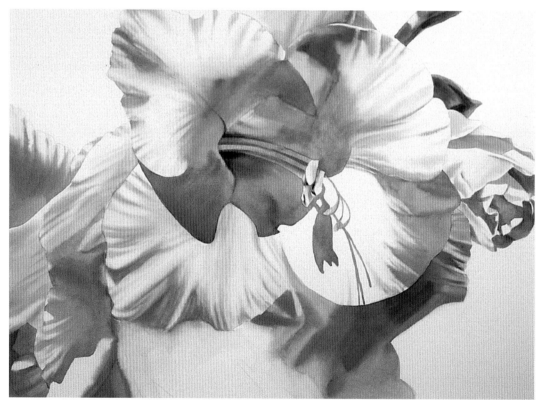

9 | Work on the Lower Petal

Wet the petal with the 1½-inch (38mm) flat and apply Permanent Rose, Antwerp Blue and New Gamboge using a medium-size brush, mingling them for color variation and shadow near the frilly edges. Lift whites with a thirsty brush. Wet below the bottom of the petal with the 1½-inch (38mm) flat to make the paint diffuse. This will merge into the next section. Save enough whites.

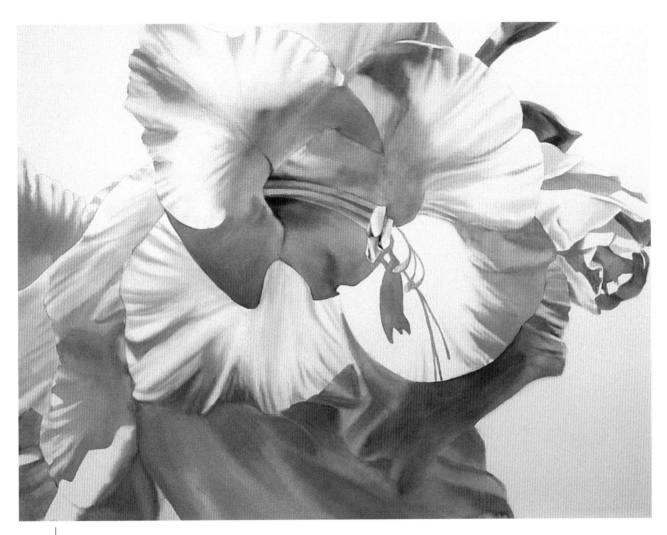

10 | Finish the Center

Use the 1½-inch (38mm) flat to re-wet around the center and include the stamens. Deepen and define the stamens using a small brush with New Gamboge, Antwerp Blue and Permanent Rose. Then paint the ends of the stamens with Permanent Rose and a bit of Antwerp Blue.

Wet the petal shape under the lower-right petal of the large flower with a large brush and float in Permanent Rose, New Gamboge and Antwerp Blue. Charge in darks as the area loses moisture. Use the 1½-inch (38mm) flat to soften the leading edge on the left to blend it with the next wash.

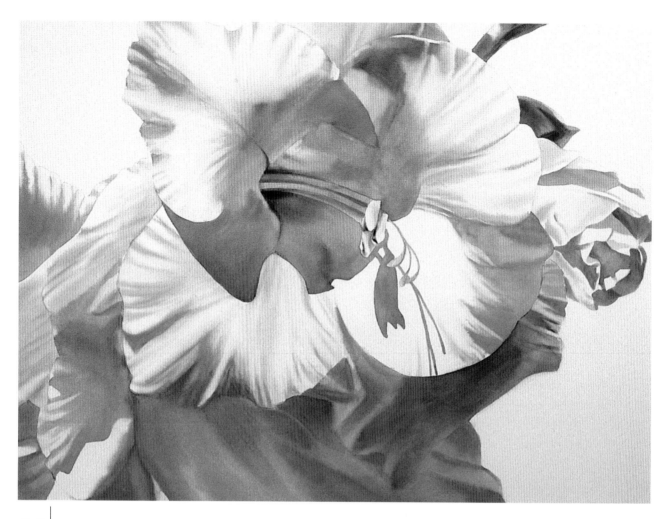

11 | Paint the Lower Shadow

Wet the whole shape, including the outer edges of the previous washes for blending. With the colors used in step 10 and a large brush, charge in color, adding darks as the wash loses moisture. Make this shadow dark enough. Include a bit of New Gamboge in your mingle to make the shadow glow.

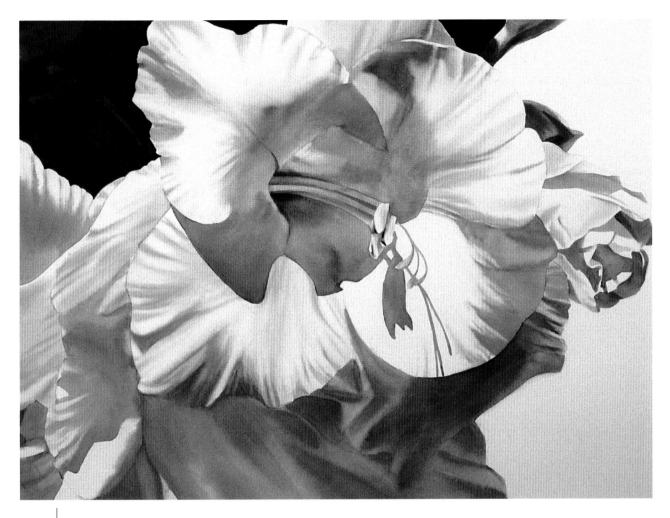

12 | Begin the Background

Wet the top background shapes and charge with Winsor Green, Cadmium Red Purple, Permanent Rose and Raw Umber using a large brush. Make it quite dark, using plenty of pigment. Be careful with the Winsor Green. You might want to mix it with one or several of the other colors before applying it to the paper. Generally, it is best to mix colors on the paper, but this color is so harsh it needs toning down. Once painted in a mixed form, it can still be mingled with more color.

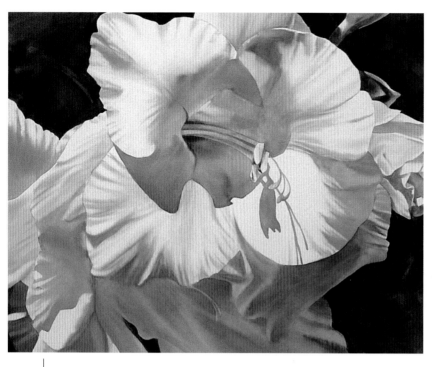

13 | Develop the Background

Continue on down and around the flower shapes to complete the background, mingling with the same colors as used in step 12.

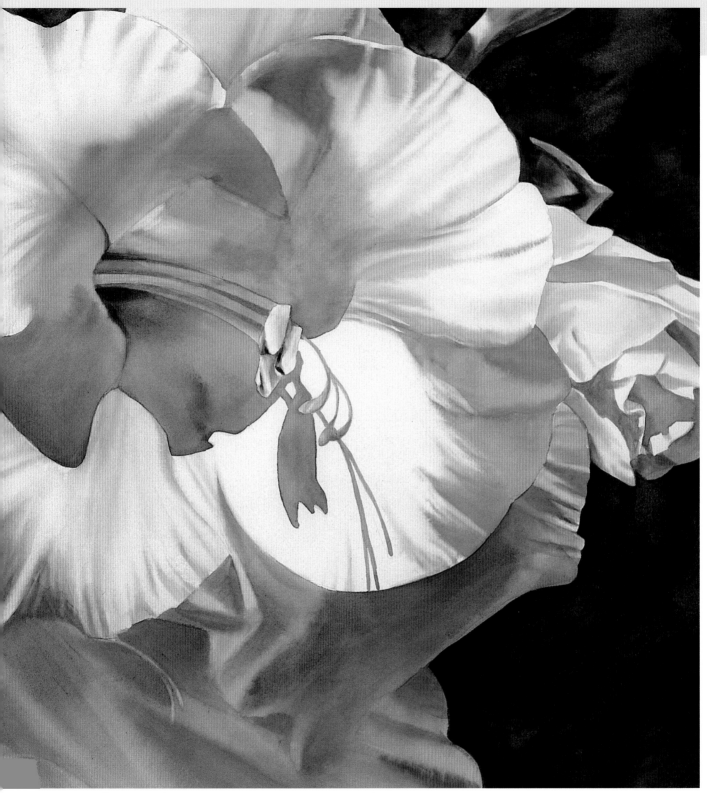

GLORIOUS GLADIOLA
Ann Pember
29½" × 21½" (75cm × 55cm)

14 | Make Refinements

Clean up the edges, glaze where needed and lift color where it is too dark. If your background needs to be darker, add a glaze of the same colors used in steps 12 and 13. While this is wet, slightly lift color with a soft brush in the upper-left, upper-right and lower-right corners to suggest foliage.

Rhododendron: Loosening Up

Materials

PAPER
140-lb. (300gsm) cold-pressed
 watercolor paper

BRUSHES
½-inch (12mm), ¾-inch (19mm),
 1-inch (25mm) and 1½-inch
 (38mm) flats

WATERCOLORS
Antwerp Blue
New Gamboge
Permanent Alizarin Crimson
Rose Madder Genuine

OTHER
Pencil

Sometimes it's hard to loosen up, so we wind up with tightly rendered paintings. If you tend to make tight paintings, give this demonstration a try.

1 | Drawing

Create a detailed drawing.

There is not enough color change in the background.

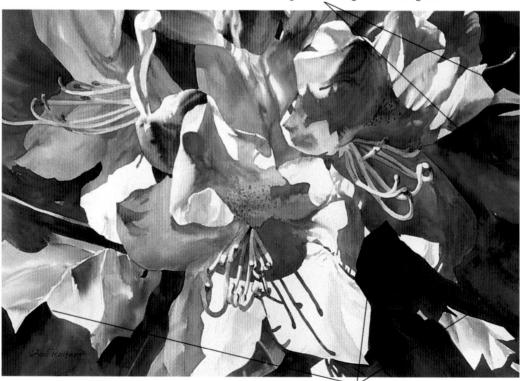

The edges are too hard here.

2 | Paint the Flowers

With your usual brushes, mingle the colors and soften some edges. Paint the foliage around the flowers, linking some shapes. Make the shadows fairly dark. Paint around the stamens in the center of the flower, then carefully paint them in. The large shadow around them should be linked to the small shadows made by the stamens.

RHODODENDRON RHAPSODY
Ann Pember
14½" × 21½" (37cm × 55cm)
Collection of Melinda and
Alexander McAra

3 | Make a Second Painting

This time, transfer some very simple drawing guidelines—just enough to place the major shapes. The thinking process was worked out in the first painting, so just have fun here. Mingle bold washes on pre-wet paper, painting in sections with large and medium-size brushes. Keep the detail on the flower centers. The background should be soft and out of focus.

RHODODENDRON RADIANCE
Ann Pember
14½" × 21½" (37cm × 55cm)

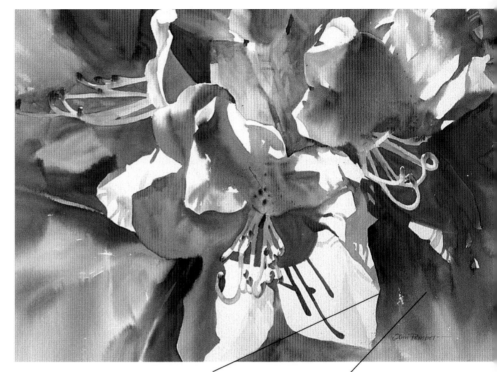

This edge is still too hard. The background color mingling is improved. It has more movement.

4 | Make a Third Painting

Do not make a drawing this time. Look carefully at the first and second paintings to paint in the shapes. This is good training for the eye. Look at shapes and mass instead of lines. Work directly, using a large brush to make each section quite wet before painting. Connect shapes and mingle colors, keeping to light and middle values this time. Most of the petals should be out of focus and should blend into a wet background in many places. With each consecutive painting you have the chance to correct and improve the design. Be spontaneous and work quickly. You might want to repeat the exercise several times with different subjects. Don't be afraid to paint a series of one subject. It can be a good learning experience.

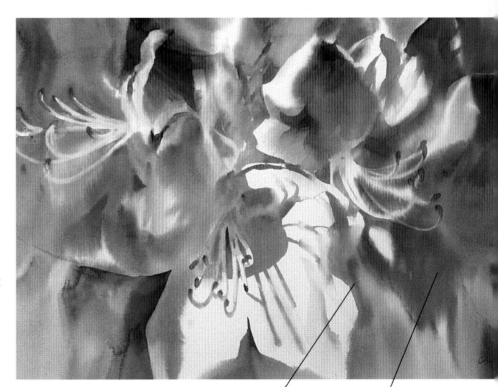

RHODODENDRON RAPTURE
Ann Pember
14½" × 21½" (37cm × 55cm)

The edge is better here. Background colors mingle and flow well.

Nasturtiums: An Unrestricted Approach

Materials

PAPER
140-lb (300gsm) watercolor paper

BRUSHES
Nos. 8 and 10 round sables

WATERCOLORS
Cadmium Red
Cadmium Yellow
Cadmium Yellow Light
Cadmium Yellow Pale
Carmine
Cerulean Blue

OTHER
Facial tissues

For this demonstration, we'll use pure color right from the start. The yellows and reds come directly from the color supply with only a brief stop and a minimum of mixing on the palette. Use very little water, just enough to keep the paint moving. Don't feel you must contain your flowers with firmly defined boundaries. Release the flowers in places, letting them work together and flow out into the background. Although you might make a fairly careful drawing, don't feel obligated to stay within the pencil outline.

1 | Develop Individual Flowers

Develop form in the yellow flower right from the start to preserve the delicate freshness of the color. The islands of dry white paper stop the yellow wash in places, creating slightly darker sections. Use Cadmium Yellow for a darker yellow value and Cadmium Yellow Light or Pale for the lighter yellow. Cerulean Blue is mixed on the palette with Cadmium Yellow for darker parts of the yellow flower. While the yellow flower is still wet, use Cadmium Red to start the red flower. The bleed may look a bit dramatic, but you don't want to isolate each individual flower.

2 | Define the Petal Areas

Give the inside of the red flower some definite shape. Let a little diluted Carmine into the upper-right petal to lighten it. Be careful when adding watery washes to still-wet areas—the water can create havoc. Paint some areas of background but don't isolate the flowers. Paint around the yellow flower with flat, solid color. There should be value differences where the background meets the flower. Don't always paint parallel to the petals; make some perpendicular strokes as well.

3 | Capture the Darks and Add Character

You will need a strong red with no water to absorb the watery Carmine inside the red flower. Leave the outside petals light. Leave some dry white paper in the red flower to capture some darks. Give each petal an individual character with careful, single brushstrokes. You want some blurs, but you also want precision. You should see traces of brushstrokes within the flower; it's a good sign that you're not overworking. The outside boundaries of the background color should be watery and suggest a casual design. Avoid scratchy dry-brush endings in your background; they look awful.

4 | Add Finishing Touches

Add another red flower, stems and more background. Try to keep the watery look but still keep areas that are definite and precise. Use lots of water and lots of moist paint.

NASTURTIUMS
Charles Reid

FIXING OVERSATURATION

If you add too much water, the best first aid is to apply pigment to the mixture directly from your paint supply. Have a tissue handy to delicately dab if necessary.

Single Dahlia: Practicing Brushwork

Materials

PAPER
140-lb (300gsm) watercolor paper

BRUSH
No. 8 round sable

WATERCOLORS
Cadmium Yellow Pale
Carmine

OTHER
Facial tissue
Pencil

Review the section on brushwork (pages 28–31). With dahlias and similar flower forms that have definite petal shapes, it's important to remember to start your strokes at each end of the petal.

BRUSHWORK
The hardest part of painting a dahlia is making a horizontal petal. You have to swivel your wrist in an awkward fashion, which takes some practice.

1 | Shape the Petals

Make a series of petal shapes using your no. 8 round sable. You want a very light petal tip with a medium-dark base. Mix a bit of Carmine with some water in your mixing area. You want just a blush of color. Rinse your brush and give it a good shake. If there's a lot of water in the mixing area, you may have to blot your brush with facial tissue. Start a stroke at the petal's tip with a very light wash and go about halfway down the petal. Go back to the Carmine in the paint supply and brush back from the petal's base into the damp light wash. Try several, then reverse the process, starting at the base with Carmine, going up about a third of the way, stopping, rinsing and painting back with your light wash until you meet up with the Carmine. These three examples are all different and imperfect. Some of your petals won't be perfect, either—just keep trying.

2 | Paint Petals Around the Center

Make a pencil circle for the center of your flower. Paint a series of petals around your center. Vary your method by sometimes starting at the base of the petal, sometimes starting at the tip.

3 | Add Final Details

Let your petals dry. Add Cadmium Yellow Pale in the center. Now add some darker green background shapes to bring the flower into focus. Don't paint your background in a solid rim around your flowers. Vary your brushwork in the green background. Sometimes make it parallel with the petal; sometimes use a perpendicular or angular stroke. If you're fading into white paper, make sure you have a watery, light-valued boundary. Avoid dry-brush, abrupt and scratchy boundaries.

DAHLIA
Charles Reid

Watery Dahlia

Sometimes you're so keen to paint a flower accurately that your work becomes tight and literal. This is a real danger when working from photographs; there's just too much accurate information to study.

The trick is to allow your paint and a little water to do the painting. Most people never stop to watch the paint and water work. So many wonderful things can happen if only you'd put your brush down and let your painting be your teacher.

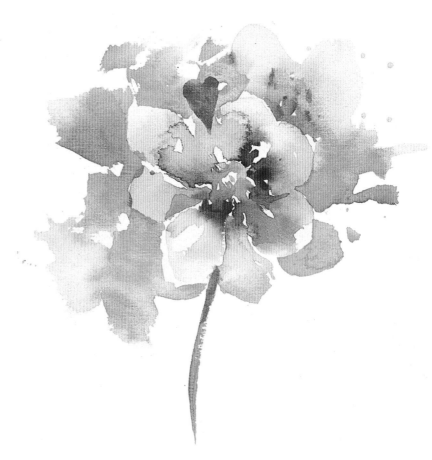

EXPERIMENT WITH DIFFERENT WATER-TO-PAINT RATIOS

Plan to make several flowers. Follow the directions for the dahlia you completed in the previous demonstration, but this time experiment with different water-to-paint ratios. Vary the waiting time before adding an adjacent color or wash. Allow washes to intermingle. You can go back with a midvalue definer, a shape that brings a blur into focus.

Here the artist let the background green seep into the top of his flower, watching the workings of watercolor paint. He let it dry without a dab of tissue or brush. When it was dry, he added a defining form in the shape of a heart.

Phlox Clusters: Simplifying With Backlighting

Materials

PAPER
140-lb. (300gsm) cold-pressed watercolor paper

BRUSHES
½-inch (12mm) and ¾-inch (19mm) flats

WATERCOLORS
Antwerp Blue
New Gamboge
Permanent Alizarin Crimson
Permanent Rose
Raw Umber

OTHER
Pencil

Painting a flower made up of a cluster of smaller flower shapes is an opportunity to hone your simplification skills. Use the lighting to help you see patterns of linked forms that create larger shapes. You may choose to paint just enough detail in some small flower shapes or parts to make the painting readable. The rest can mingle and blend. Avoid fussiness. Instead, seek to make a creative statement with your art.

1 | Create a Simple Drawing

Connect the shadow shapes.

2 | Paint the Large Shadow Shapes

Wet the area with a large brush and then use a smaller brush to charge with Permanent Rose, Permanent Alizarin Crimson and Antwerp Blue, from the top down. Let them mix and run together. Drop in New Gamboge to indicate a few centers of the tiny flowers. Don't get carried away with too many dots!

3 | Add Leaves and Buds

At the upper left, connect a few leaves and buds to the flower shape by softening their shared edges with a small brush. Use Raw Umber and Antwerp Blue. The outer pale petal shadows should be lighter toward the edges of the flower mass.

4 | Add Leaves Below the Flower

These leaves are away from the light and are quite dark. A few spots have sun shining through them. Keep these areas light. Wet the whole shape and add New Gamboge with a small brush. Drop in rich amounts of Antwerp Blue, Raw Umber and a touch of Permanent Alizarin Crimson. Also add the light petal shadows at the bottom of the flower.

5 | Paint the Lower Leaves and Stem

Wet the whole leaf section and paint loosely with New Gamboge using a small brush.

6 | Enhance the Darks

While the New Gamboge of the lower leaves is still wet, drop in Antwerp Blue, Raw Umber and Permanent Alizarin Crimson with a small brush, letting them mingle. Where you want hard edges, wait to paint the area until the color is dry. Soften the edges where needed, such as at the lower end of the stem.

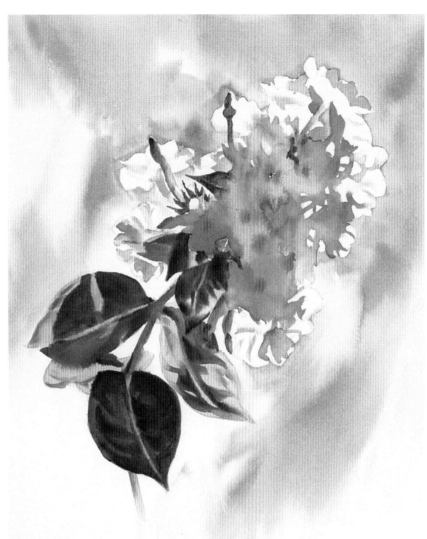

7 | Complete the Background

Begin at the top and wet the paper with a large brush, working around the flower shape carefully. Quickly add Raw Umber, Antwerp Blue and Permanent Rose and let them mingle. Re-wet the paper at the wet leading edge if it begins to dry. Keep it wet in advance of laying in the paint, so the colors will mingle. Soften the bottom edge to diffuse it to white paper for a vignette effect.

PHLOX
Ann Pember

Floral Improvisation: Developing an Image Out of a Glazed Wash

Materials

PAPER
140-lb. (300gsm) cold-pressed
 watercolor paper

BRUSH
No. 6 round sable

WATERCOLORS
Carbazole Violet
Cobalt Blue
Hooker's Green
Permanent Rose
Permanent Sap Green
Quinacridone Magenta

OTHER
Paper support (Plexiglas, Homasote or
 wood board)
4 pouring cups (such as plastic measuring
 cups from laundry detergent boxes)
Pump sprayer
Trigger sprayer

In this demonstration, the artist had to decide whether to compose the subject, glazing the first wash accordingly, or to pour on colors and then search for a subject. She did both. The subject is floral, but she works with whatever she gets in the initial glazing. There is no preliminary sketch. This is an exciting way to loosen up with your watercolors.

1 | Prepare the Paper

The first wash is an exciting part of the painting process. It establishes a color palette, creates a directional flow for the composition and lays a foundation for whatever subject you choose to develop. To prepare for the first wash, wet the paper by spraying clear water onto it with a pump sprayer. Use a pump sprayer so that the force of the spray will not damage the paper's surface fibers. Be sure the surface is completely wet but has no standing pools of water. Tilt the sheet up on an angle. Does the water slide off easily without catching on a dry spot? If not, spray that area with more water and again tilt to drain off the excess.

2 | Mix the Pouring Cups of Color

Mix a pouring cup of Cobalt Blue, one of Permanent Sap Green with a little Cobalt Blue and some Hooker's Green in it, one of Permanent Rose with a bit of Quinacridone Magenta in it, and one of Carbazole Violet. These colors are analogous (i.e., side by side on the color wheel): green, blue, violet and red. Using analogous colors helps you avoid dull or muddy areas where pigments merge together.

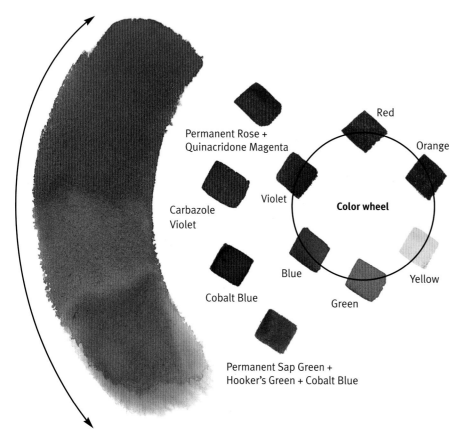

Permanent Rose +
Quinacridone Magenta

Red

Orange

Carbazole
Violet

Violet

Color wheel

Cobalt Blue

Blue

Yellow

Green

Permanent Sap Green +
Hooker's Green + Cobalt Blue

Analogous colors

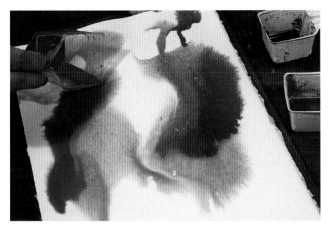

3 | Pour a Wet-in-Wet Wash

Respray the paper if it has begun to dry. Pour the colors on the dampened paper one by one in an analogous order (not on top of each other, but side by side). Remember to preserve some white spaces. Tip the paper up to allow some of the paint to run down the page at a diagonal. This starts to develop an eye path in the painting.

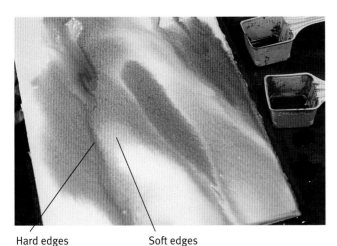

4 | Distribute the Wash

As you tilt and move the glazed color around, some pigment runs off the paper. This is a good base upon which to build this painting. This first wash of colors has a good pattern of color shapes and white spaces that gives an airy quality; solid color would have been too heavy and limiting. Notice how the first wash paled once it dried. Those vibrant wash colors were poured onto wet paper, which doubled the amount of water normally used with ordinary direct painting. When glazing wet-in-wet, you disperse the pigments in twice the amount of water, so the creamy consistency of the paint mixture is diluted.

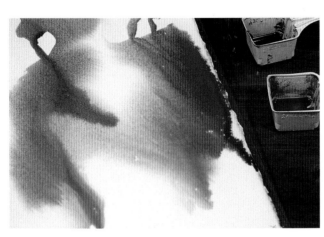

Hard edges Soft edges

5 | First Wash Results

Notice the hard edges at the top. You could re-wet and merge these into soft edges, but this artist was intrigued with the pattern she created, so she tried to work them into her design.

Also notice that the blue poured between the green and violet has been lost. This happened when the board was tipped to encourage the colors to mingle. Green and violet should be separated by blue to be analogous. You could spray that area and repour blue between the nonanalogous colors, but you must make a decision quickly before things dry. The colors have not muddied, and because they are muted in tone, they do not attract attention.

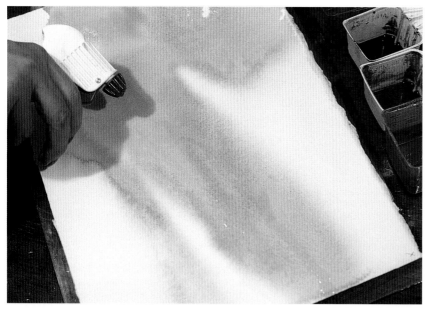

6 | Spray a Base for the Foliage

Once the color foundation is set, it is time to develop the shapes. Use the first wash colors as your base. Use a trigger sprayer to create a dramatic diagonal sweep as well as an impression of draping foliage. The trigger spray technique is perfect for creating an abstract suggestion of leaves and stems. Tilt the paper and run the sprayer down the length of the diagonal. You may want to repeat the spray to achieve more streams of water.

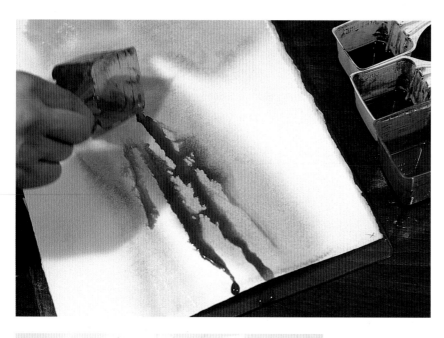

7 | Pour Colors for the Foliage

When you are satisfied with the way the water is flowing on the paper, pour directly into the stream colors that match the colors put down in the first wash. Tilt the paper to run the colors down and off. If you are handy, you will be able to catch the dripping paint right back into its pouring cup. Assess the design of the flow. You might spray more streams of water to soften the effect, or you can wait until this pouring dries and repeat the process with the same or another color.

USING ANALOGOUS COLORS

You can overpaint with a color analogous to what was put down in the first wash, but do not stray too far from the initial colors. For example, if there is a blue area in the first wash, you should paint objects in that area blue. You could use blue-green or blue-violet to paint an object within the blue wash, but be careful to match the warm or cool temperature of the original blue wash, and do not attempt to stray beyond blue's analogous colors. If you do, the colors will become muddy and dull. Keep a color wheel by your worktable for easy reference.

8 | Create Floral Images

Develop leaf and floral shapes by working in both positive and negative painting (see "Seeing Negative and Positive Shapes," page 67). That is, paint an object as it appears (positive), and in other areas paint only the spaces around and between objects (negative). Beginning at the upper left of the paper, paint a flower by creating a series of radiating hard- and soft-edged petals. Vary the size and shape of each petal. Use the white space, preserved in the first wash, to create a white flower. As the flower shape flows into the green wash, continue painting with a darker shade of green.

Move to the upper-right area of the paper and form a magenta flower using a darker shade of magenta. When the flower spreads out into the violet wash, start painting that part of the flower in violet. Staying true to the colors of the first wash assures you of pure, clear colors.

9 | Enhance the Value Pattern

As you work, consider where you might add a dark value. Establishing a dark value pattern will add impact because it creates a contrast with the light or white areas. Placing the darkest dark next to the lightest light will attract the most attention. Add the darkest tone around the flowers at the focal point. Use a very dark shade of whichever first-wash color exists around those flower shapes. If one section is green, paint a dark area over it with a very dark mixture of that same green pigment. If it flows into a blue, paint a dark value of blue. Make the dark values radiate from that area. Develop the very deep tones into a connected dark value pattern rather than having isolated or individual dark spots.

Adjust the value pattern as needed and add more flowers. As you move away from the center of interest, offer less detail. The most detail and the strongest value contrast are at the center of interest. Images become less distinct and softer in value as they get farther away from the focal area.

10 | Add More Flower Shapes, Evaluate and Finish the Composition

Continue adding flower shapes. It is not necessary or even desirable to detail every flower. As you move away from the focal area, hint at floral shapes by painting them in softer tones and painting only a portion of the petals. In this way, you can create an illusion of images rather than a realistic portrayal.

The finishing stage is for the final touches only. Do not overwork your painting. Check for the overall balance of shapes and colors. Evaluate the dark and light value patterns. In this painting, the artist defined a few more leaves and refined parts of the lower flowers.

Glazing a first wash of analogous colors helps enhance the fluidity of the watercolors, and it establishes a transparent base for your painting. If in stage two you stay true to the original wash colors, you will maintain a color harmony. In stage three, you can add fine detail and/or a final glaze of color over parts of the painting to dramatize the light or tone down passages in the composition.

You may decide to add a final glaze. This artist did not choose to apply any more glazing to this piece because she liked the placement of the white areas and did not want to change or darken any particular area.

Rose Garden II
Jan Fabian Wallake
14" × 10" (36cm × 25cm)
Collection of Donna Kidd

Floral Arrangement: Developing Positive and Negative Shapes

Materials

PAPER
140-lb. (300gsm) cold-pressed watercolor paper

BRUSHES
Nos. 6 and 9 rounds

WATERCOLORS
Antwerp Blue
Aureolin
Cadmium Yellow
Cobalt Blue
New Gamboge
Permanent Red
Permanent Sap Green
Rose Madder Genuine
Scarlet Lake

OTHER
Trigger spray bottle
Pump spray bottle
Graphite paper
Sketch paper
Soft-lead pencil
5 pouring cups
Damp sponge

In this demonstration painting, you will develop positive images of flowers, leaves and stems, then echo those shapes with negatively painted images of the same objects. Building upon the colors glazed on in the first wash, you will develop a harmonized, analogous color scheme with shapes that appear to move forward in the arrangement and shapes that appear to recede deep into the composition. A strong value contrast will exaggerate the spatial movement. The trigger spray bottle technique will add the contrast of a loose, abstract flow to the tighter rendering of the floral shapes. The pump sprayer technique will suggest a leafy pattern to enhance selected edges.

1 | Develop a Sketch and Prepare the Pouring Cups

Look through your reference photos for floral shapes. It is not important to replicate exact flowers of any specific nature. To get started, develop a rough sketch of interesting floral shapes. A diagonal sweep and movement toward the focal area (the cluster of flowers with a large rose in its midst) dramatizes the composition.

Develop your sketch on a separate sheet of drawing paper. It is helpful to work out a color scheme at this stage. Make notes on the sketch as reminders, such as where you want to retain white spaces or where you will add a sweep of color.

Transfer the basic sketch to your prepared watercolor paper by tracing over a graphite sheet.

Next, mix five separate cups of paint. Each cup should contain a single color as follows: Cobalt Blue, Rose Madder Genuine, Permanent Sap Green, Antwerp Blue and New Gamboge.

2 | Pour the First Wash

With a pump sprayer, apply clean water to the paper surface. Make sure it is completely wet and does not have dry spots that catch when you run off the excess water. Gently pour Cobalt Blue onto the top-left corner and pour a small amount of the same color on the right middle side. Tilt the board to spread the soft edges of the glaze. Pour approximately the same amounts of Rose Madder Genuine on the top-right corner and on the left side. Let these washes dry.

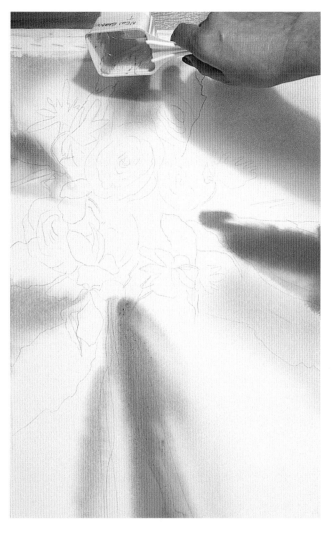

3 | Add Another Layer of First-Wash Colors

Re-wet the entire surface using your pump spray bottle, then drain off the excess water. Now, pour on Permanent Sap Green and small areas of New Gamboge and Antwerp Blue. These glazes all radiate out from the upper center of the paper where the focal area will be developed. The white areas are important to preserve, because you will be using a lot of bright color for the flowers and painting over a glaze would dull the intensity of the hues. Drain a wash of Cobalt Blue down the center. Let dry.

4 | Separate the Objects

On your palette, mix a variety of greens ranging from yellow-green to blue-green. Use Cadmium Yellow or Aureolin with Antwerp Blue for strong shades of green. Starting at the top center of the paper, begin to develop the negative branch area. Remember, you are painting around the branches, not the branches themselves. Hard edges describe and soft edges do not, so soften any edge that does not delineate a branch. Use your no. 6 round sable brush and keep a container of clean water nearby for those soft edges. It is helpful to have a damp sponge at hand to tap your brush onto after each rinse. The sponge will draw just enough water out of your brush so that you do not flood the painting.

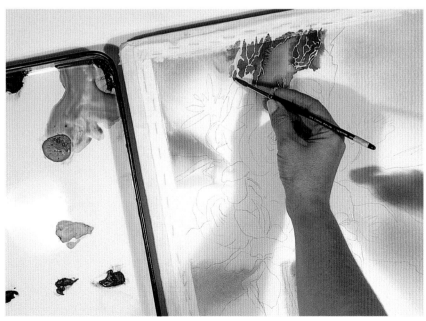

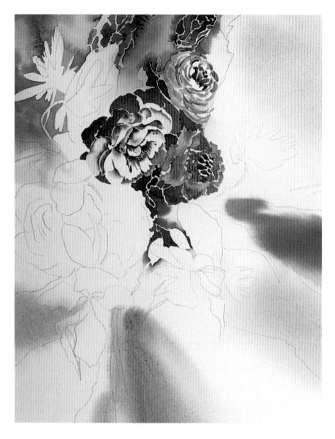

5 | Create Positive and Negative Images

Continuing down into the focal area, create the large red rose by using a series of hard and soft edges. Begin by painting the bottom petals of the flower in Permanent Red. As you move closer to the center of the flower, paint each petal edge with a single stroke of color. Work on one petal at a time. While the paint is still wet, use a no. 6 round sable brush dampened with clear water to soften the inside edge of each stroke. Use Permanent Red for this flower. Use Rose Madder Genuine for the top-right flower and Cadmium Yellow, Scarlet Lake and Permanent Red for the lower-right flower. The white spaces are important even within the flower shapes, because they offer light that contrasts with the intense color of the positive shapes. They also allow detail to be added and suggest illumination on the flowers.

Create negatively painted flowers on the upper left. Using the same Cobalt Blue that was poured in the first wash, paint around the flower forms. With a no. 6 round sable brush, paint a stroke of blue around each petal. Work in small sections, one or two petals at a time, so that the paint does not dry and leave a hard edge where it is not wanted. As you paint around each petal, you will leave a stroke that has two hard edges. The edge on the inside of the stroke will stay a hard edge. It will describe the petal. The outside edge of the stroke needs to be softened so that it does not describe anything. It should create a vignette effect into the surroundings. Dip a no. 9 round sable brush into clean water, place the brush 1" (3cm) away from the edge to be softened and bring the brush into that side of the stroke. Continue until the entire outside edge of the stroke is softened. Rinse your brush often so you don't drag color into the vignetted area.

6 | Paint Negative Shapes With a Shade of the First-Wash Color

Use the same negative painting process on the leaves at the upper right. Since the initial glaze in that area was Rose Madder Genuine, paint around the forms with that color. Soften all outside edges using clear water and a no. 6 round sable brush.

Paint the remaining two flowers using the positive painting process. Make a hard edge and a soft edge for each petal.

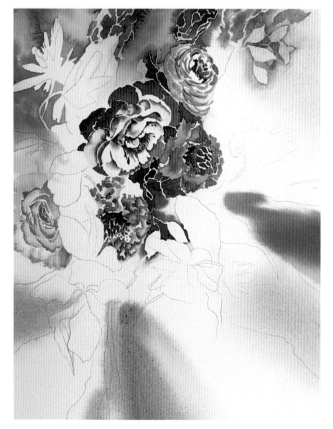

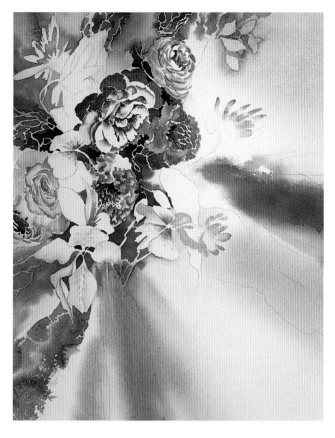

7 | Use Special Techniques

Some special techniques will add a bit of zip to this painting. Create a leafy pattern on the lower left side by spraying an area of water droplets with the pump sprayer. Drop Antwerp Blue onto the water pattern and tilt the board to allow the color to run. Blend some areas within this section using a dampened no. 9 round sable brush. Repeat this technique on the top side of the green area that flows off to the right. If you use a special technique in one area of a painting, it is wise to repeat it at least once more in another area. It will not pop out at you as much if it is used more than once. Remember, these techniques are meant to add interest, not dominate.

Continue to develop negative images in the lower-middle area. Using a no. 6 round sable brush, paint around the shapes with a darker shade of the first-wash colors of Cobalt Blue, Rose Madder Genuine and Permanent Sap Green. Work on one or two petals at a time so that each stroke of color stays wet long enough for you to soften the outside edge of the stroke. Use a no. 9 round sable brush dampened in clear water for this vignetted edge. If the area is small or other objects are close by, use a no. 6 round sable brush to achieve the vignette effect.

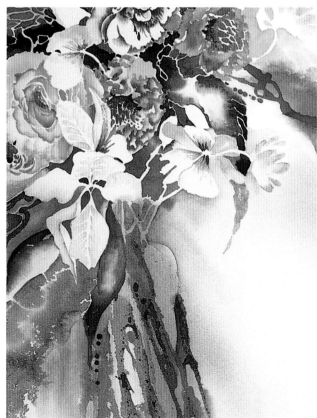

8 | Add Finishing Touches

Using a trigger sprayer, run a few splashes of water down the center, then drop Permanent Sap Green from a fully loaded brush onto them and tilt the board to allow the color to run. Where the sprayed water lines run over the blue, drop on Cobalt Blue.

Add a few linear strokes to the green area at the right side. These may appear as branches or possibly shadows, but they add a good contrast to the soft even washes behind them. Drag a no. 6 round sable brush dipped in water along some branch-like lines. When you are satisfied with the water stroke pattern, drop onto them (from a brush dripping with paint) a dark value of Permanent Sap Green (mixed to its most intense color—a water-to-pigment ratio the consistency of heavy cream). Tip your paper to encourage the color to run along the water stroke lines.

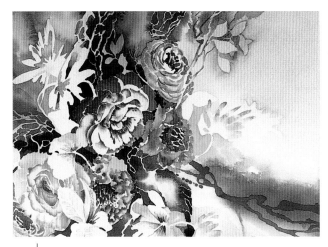

9 | Evaluate the Painting

A stronger value pattern will enliven the composition. Mix a pool of ten parts Antwerp Blue, four parts Permanent Sap Green and three parts Rose Madder Genuine. Go back into the focal area and add this darker value of blue-green to the negatively painted background.

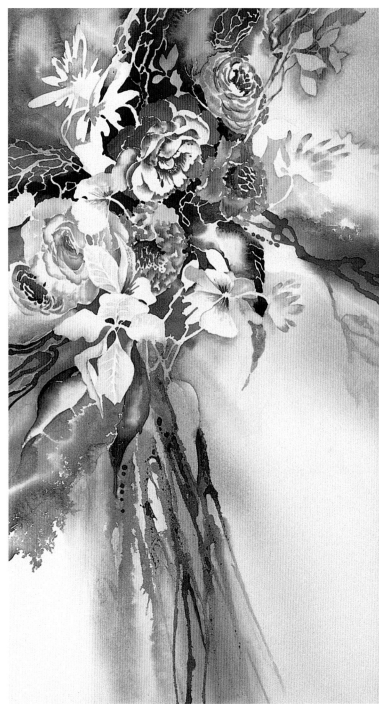

FLORAL PALETTE
Jan Fabian Wallake
21" × 14" (53cm × 36cm)

Hard and Soft Edges

Maximize the natural qualities of watercolor by taking advantage of a variety of edge effects. Wet-in-wet painting sets the stage for soft, flowing edges. These blurred shapes are an inherent part of the nature of watercolor. Emphasizing the soft—sometimes referred to as *lost*—edges will actually make a contrasting hard edge stand out more. You can lead the eye of your viewer by selective placement of soft (lost) and hard (found) edges.

The mingling of various edges creates an intriguing journey for a viewer. If, for example, the focal area is described in hard edges while the rest of the piece has soft edges, you can stir movement throughout a painting by a subtle procession of smaller, less intense but cleverly placed hard-edged shapes leading to the area of interest. The trick is to develop a lively approach to the center of interest without concocting a busy or jumpy jumble of sharp shapes. You will have to judge the balance between hard and soft edges by evaluating flow and movement. Hard edges attract attention and stop the eye suddenly. Soft edges are rest areas where the eye can linger.

Hard edges attract attention. Soft edges are restful.

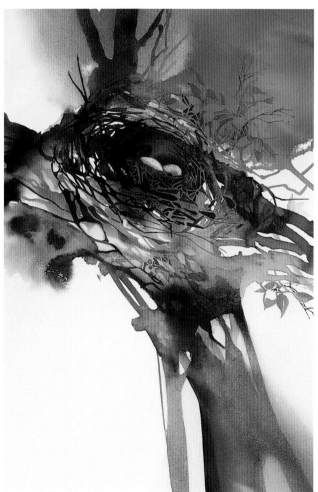

Enhance the intrigue of your paintings by depicting some objects with soft edges only. Every part of an image does not need to be completed with a hard edge.

HOMEWARD BOUND
Jan Fabian Wallake
28" × 21" (71cm × 53cm)
Collection of Kim Skrzypczak

145

Floral Still Life: Loose Approach

Materials

PAPER
140-lb (300gsm) watercolor paper

BRUSHES
Nos. 8 and 10 round sables

WATERCOLORS
Cadmium Orange
Cadmium Red
Carmine
Cobalt Blue
Raw Sienna
Yellow Ochre

OTHER
Pencil

A first sign of spring is beautiful batches of wild daffodils. In this demonstration, you will use these flowers to practice controlling the edges on your painting subjects.

COLOR MIXING

Color mixing on the paper is nice but hard to keep a consistent value. It's more important to keep a consistent value and have good edges. If you're getting color blotches, do more of your mixing directly on the palette.

1 | Create a Contour Drawing

Because there are very light-valued flowers in this composition, start with the background, painting around the blossoms but don't isolate your lighter shape with a solid surrounding dark. It's best to vary the background with both parallel and perpendicular strokes. This will let your light shape breathe and give you both hard, defined edges as well as slightly softer edges out in the light. Don't pre-wet the entire paper. Mix your green, yellow and Raw Sienna on the paper, wet-in-wet. Leave white paper for hard edges in the flowers, but let some of your yellows meet the still-wet background to make some blurs. You want to start right off with a watery look with both lost and found edges.

2 | Add a Window Frame

Create the hard edge along the top of the sill and in the edge of the cast shadow. Add more yellows and stems. Work pretty quickly here to make sure you can get blurs where the stems meet the flowers. Let the paint and water do the painting. Paint a yellow flower on the left and let it mix with the window frame.

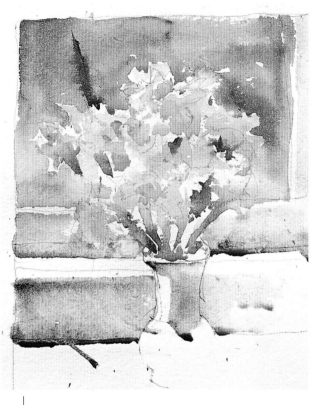

3 | Create the Vase Shadow

The left boundary of the vase where it meets the lower window frame should be firm because it faces the light. The shadow on the vase also has a hard edge at this point. Mix your blue, Yellow Ochre and Carmine on the paper. You should still see the partially mixed color. Paint across the shadow boundary of the vase into the window frame on the left.

4 | Study the Edges

Squint and paint separations where the light meets the dark. Don't paint separations at object boundaries. Here's a closeup of the lower part of the vase. Study where the kept edges stay separate and where they cross over. Paint the light, not the object.

5 | Finish Your Cast Shadow

You'll see color changes where Cobalt Blue, Yellow Ochre and Carmine meet the cast shadows. Try to get the shape of the cast shadow with consistent values.

6 | Paint the Scissors Handle and its Cast Shadow

The scissors are painted with Cadmium Orange, Cadmium Red and Raw Sienna. Use Cobalt Blue for the cast shadows. Paint the scissors handle and the Cobalt Blue cast shadows so that the colors can merge. The cast shadows should have a firm edge.

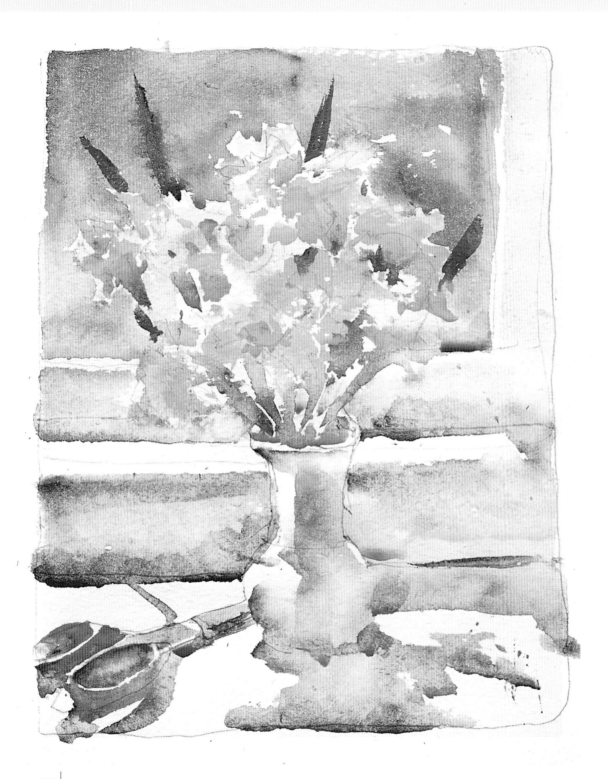

7 | Add the Final Details

A painting is nearly finished when you find yourself refining and adding small darks. Add a firm edge in the vase's shadow where it meets the light. The body of the vase isn't round but is made up of a series of obtuse angles. Don't fuss too much; let it end gracefully.

FLORAL STILL LIFE
Charles Reid

Mums: Painting Large, Simple Flowers

Materials

PAPER
140-lb. (300gsm) watercolor paper

BRUSHES
Nos. 8 and 10 round sables

WATERCOLORS
Cadmium Orange
Cadmium Yellow
Cadmium Yellow Light
Carmine
Cerulean Blue
Cobalt Blue
Mineral Violet
Olive Green
Raw Sienna
Ultramarine Blue

In this demonstration you will be painting a bouquet of wilting purple and white mums. The best thing to do is to simplify and make this an exercise in painting good strong local color values.

1 Lay In a Base of Leaves and Petals

On dry paper, paint the darker leaves and flowers behind the white flower, working carefully around the specific petal shapes in the white flower. Use Mineral Violet for the flowers and Olive Green for the leaves. Allow the leaves and flowers to mix together. You'll need lots of paint and little water. A very light Carmine and Cerulean Blue wash is added to the flower. The edges of the petals should remain dry so you won't lose the white flower's boundaries.

2 Paint More Flowers and Leaves

Add some Carmine, Cobalt Blue and Ultramarine Blue to parts of the flowers. Allow some of the flowers and leaves to blend. Other parts should be dry before adding an adjacent color. Cadmium Yellow is used in the flower centers. Begin to paint a watery background using Cerulean Blue, Raw Sienna and Carmine to blur some of the flowers and leaves. Use the same diluted colors on the left side of the pitcher. The pitcher's handle is painted with a slightly darker version of the same colors. The cool strip is Cobalt Blue and Carmine.

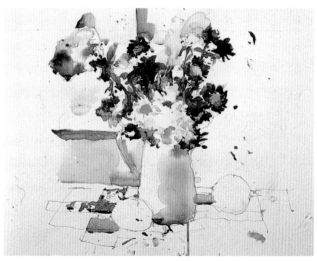

3 Paint More Background Shapes

Use the same Carmine, Cerulean Blue and Raw Sienna to paint more background shapes. Change the ratio of water to colors to vary the values.

The pitcher's shadow starts off with Cerulean Blue at the halftone (the border where light and shadow meet). As you paint into the shadow, add Cadmium Yellow Light to show reflected color from the orange. Paint the patterned cloth using Cobalt Blue and Raw Sienna.

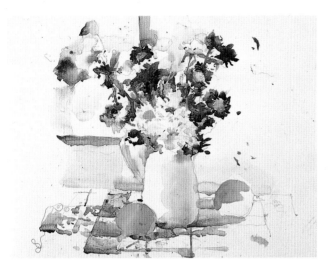

4 | Add Fruit

You want a watery pattern within relatively defined outer borders. Never paint a pattern like this on wet paper unless the whole painting is painted on wet paper. Try for varied color mixes with the Cobalt Blue, Raw Sienna and water. The pattern has low-intensity, quiet blues, so use a pure Cerulean Blue to pep up the shadow under the pot and at the base of the orange on the left. Use Cadmium Yellow for the orange in the light area and Cadmium Orange with a touch of Raw Sienna in the shadow. Allow some orange to creep into its cast shadow and mix with the blue. Start your fruit with the light side first, as you'll see in the orange on the right.

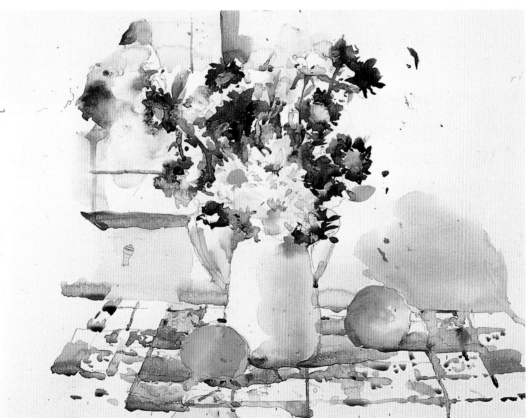

5 | Tie In Subjects With Shadows

You don't want an exact repeat in your second orange, so leave the shadow side fairly light. Use Cerulean Blue and Cobalt Blue in the cast shadows. Allow these colors to mix with the wet paint in the objects casting the shadows. This assures a color tie-in between the objects and their cast shadows. Wet the paper above the table on the left with clear water, then paint a cast shadow with Cobalt Blue, Carmine and Raw Sienna.

MUMS
Charles Reid

Sunflower Still Life: Connecting Elements

Materials

PAPER
140-lb. (300gsm) rough
watercolor paper

BRUSHES
Nos. 8 and 10 round sables

WATERCOLORS
Burnt Sienna
Burnt Umber
Cadmium Red
Cadmium Yellow
Cadmium Yellow Light
Cadmium Yellow Pale
Carmine
Cerulean Blue
Cobalt Blue
Ivory Black
Olive Green
Raw Sienna
Raw Umber
Ultramarine Blue

Painting the yellow of the sunflower is the best approach to begin this painting. Try to make the shape large enough. Then create colorful blossom shapes that dominate the greens of the leaves and stems—too often they take over. You can cheat and add more blossoms than are actually in the bouquet in front of you.

1 | Create the Petal Shapes

Start with Cadmium Yellow for the sunflower, making it a bit larger than it actually is. Try for petal shapes around the outside edges of the flower; don't worry too much about being accurate. You will "find" the actual shapes later when adding adjacent darks. Do not try to show the individual petals within the flower. While the yellow is still wet, add a second flower with diluted Carmine, allowing it to blend with the first flower. Add a stem of Olive Green on the left, making a soft edge.

2 | Paint the Pink Blossoms and Stems

Use Carmine to paint the pink flowers by placing the loaded brush tip at the base of the blossoms and then pressing with the body of the brush, which contains more paint. Place the point carefully, pressing and then lifting. You'll need a no. 10 round sable to manage this. Don't stroke.

While the pink blossoms are still wet, add stems of Olive Green. The stems shouldn't be too watery. Take green from your paint supply, go directly to the paper and let the stems and blossoms mix on their own.

3 | Add the Center and Jar Top

When the sunflower is practically dry, add Burnt Umber for the dark center. Use lots of paint and very little water for this dark center, otherwise you'll lose control. Find some petal shapes with your Olive Green and paint down to the lip of the jar. You don't want to isolate the flowers completely from the vase, but you do want some definition in the jar top. Carefully paint along the dry white paper jar lip, working from right to left, then paint down into the jar with Raw Umber and Olive Green. Be sure to paint the umber and green next to one another, but don't mix them on the palette. Save a few bits of white paper in the upper part of the jar.

4 | Paint the Jar and Table Items

The shapes of dry white paper are necessary in the vase. They isolate the wet paint in the stems, giving them shape and pattern. Add a dark base in the jar with Cobalt Blue and let it flow to the left to start the pattern in the cloth. Paint the tablecloth with diluted Carmine and Cobalt Blue. Never mix diluted colors on the palette; instead, add water to each color in separate sections of the mixing area. When the values are similar, let them mix on the paper. Dampen the paper near the flowers with clear water. Start with semidiluted Cobalt Blue on the top of

the cast shadow and diluted Raw Sienna at the bottom where the shadow works into the tabletop. Allow colors to mix in their own way. Carefully paint the pattern on the cloth on dry paper, then make perpendicular strokes to soften and lose parts of the pattern. The folds in the cloth keep the design looking definite in some places and fluid in others.

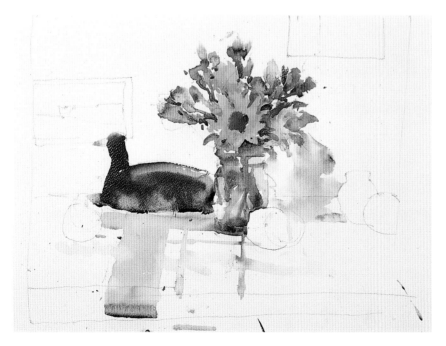

5 | Paint the Coot

Add another green next to the right side of the sunflower to get more definition. Paint the coot decoy using fluid Ultramarine Blue, Ivory Black and Burnt Sienna.

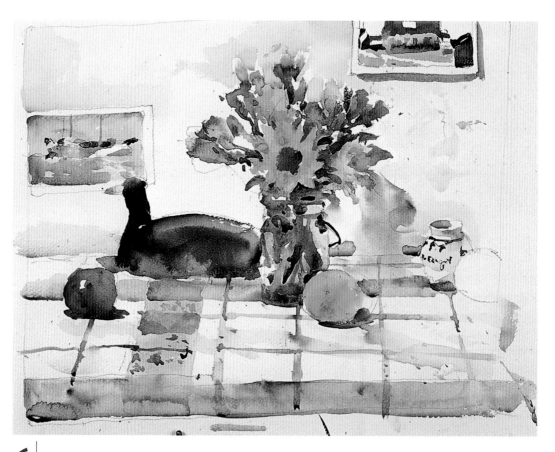

6 | Add More Table Details

Use Cadmium Red for the apple and Cadmium Yellow and Cadmium Yellow Light for the lemon. In the light area, negative shapes of adjacent background darks butt up against the positive object lights with firm edges. Paint the darks forming the cast shadows while the objects are still wet, making softer edges.

The shadows inside the top and under the lip of the mustard jar have the most contrast where they meet the light. In the top of the mustard jar, the shadow meets the front edge. There is also shadow in the far side meeting the wall. Make sure the part of the jar closest to you draws more attention. Darks and strong value contrasts come forward, while lighter values and weaker value contrasts recede.

The postcards of works by Winslow Homer and Edward Hopper help fill an empty background. Add some darks and cast shadows to the cards. If you need a cool color, just paint the cast shadow blue. If you need a warm color, paint the cast shadow orange and Raw Sienna. Use your cast shadows as color and value accents.

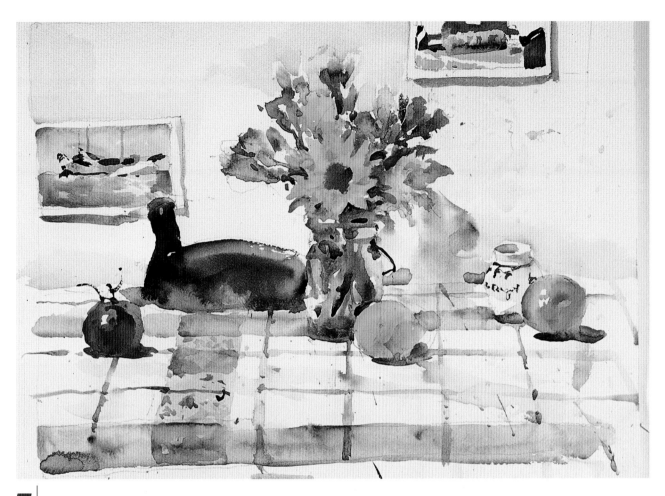

7 | Add the Finishing Touches

Paint the green apple with Cerulean Blue and Cadmium Yellow Pale with a Cobalt Blue cast shadow. Notice that everything in the painting is connected. There are no isolated objects.

A SUNFLOWER WITH A MIXED BOUQUET
Charles Reid
10" × 14" (25cm × 36cm)
Courtesy of Munson Gallery

CONNECTIONS WITHIN PAINTINGS

Almost every element in your painting should be connected. A good rule of thumb is 80 percent of the objects connected with 20 percent isolated.

Iris and Fruit: Controlling the Edges With Your Brushstrokes

Materials

PAPER
140-lb. (300gsm) rough
 watercolor paper

BRUSHES
Nos. 6, 8 and 10 round sables

WATERCOLORS
Cadmium Red
Cadmium Yellow
Cadmium Yellow Light
Carmine
Cerulean Blue
Cobalt Blue
Mineral Violet
Olive Green
Raw Sienna
Ultramarine Blue

OTHER
Pencil

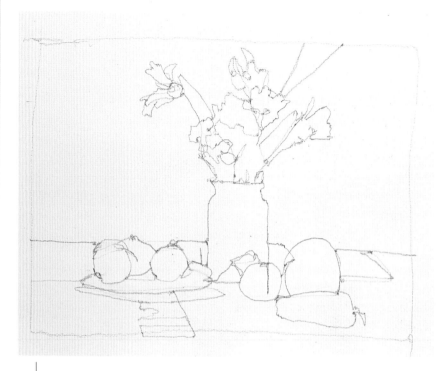

1 | Sketch It Out

Draw your composition, being mindful of boundaries, shadows and the shapes you want to create.

2 | Paint the Iris Blossom

Load your brush tip with Mineral Violet and place it at the base of the iris blossoms. Carefully paint around and up from the dry white flower. Always start your stroke where you want a darker value or where you want a crisp, definite shaped edge. If you paint toward the white flower, you'll probably get a fuzzy, clumsy shape in the flower. Lift the brush in the midsection of the iris and place the brush with renewed dark violet for the darker upper petals. Remember your brushwork technique: Point, press, and lift (pages 28–31).

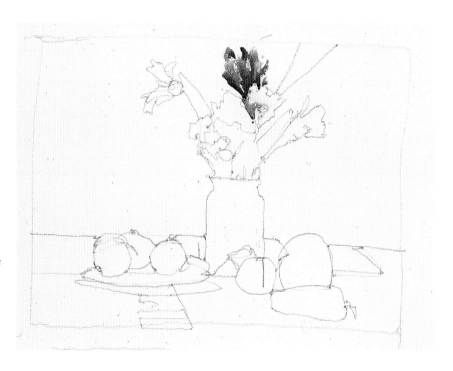

3 | Construct Yellow and White Flowers

The iris is still wet, so leave a very narrow strip of dry paper as you paint the yellow flower. Start the Olive Green leaf stroke at the carefully shaped white flower. Press the brush, then lift slowly as you form the lighter, upper part of the leaf. The hardest part is achieving delicate expressive shapes in the blossoms and controlling values and edges with your brush. This brushwork is akin to oriental brush painting, where every stroke expresses an idea.

CREATING VARIED EDGES

If you want a firm edge in any part of a wet flower, leave a very narrow barrier of dry paper. If you want colors to blend, paint one wet flower or green right up against the adjacent flower or green. Always add the stems wet-in-wet to the base of the blossoms so that the colors connect and create unity.

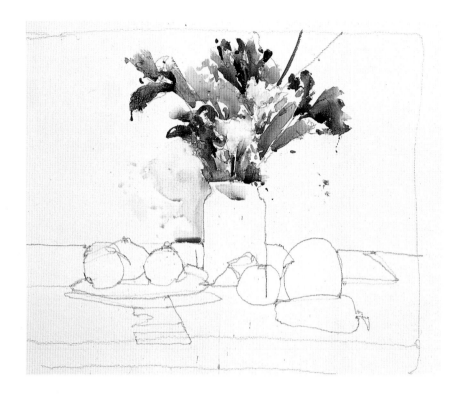

4 Finish Your Bouquet

Using the techniques described in steps 1 and 2, finish the bouquet. You should be able to see where you begin strokes, where you hold firm edges and where edges blend. Start the shadow on the front of the vase where it meets the light with a firm edge using Cerulean Blue. Use very diluted Cerulean Blue in the background. The stems should still be damp and mix slightly with the blue.

MAKE EACH STROKE COUNT

Although the bouquet may look loose and spontaneous, it's actually painted very slowly and with great care. You want to make each stroke count. Many students paint too quickly and carelessly, using too many strokes. Stop after every stroke. If you need to darken a value, vary a color or soften an edge, make the correction wet-in-wet. Don't plan on coming back later to make corrections.

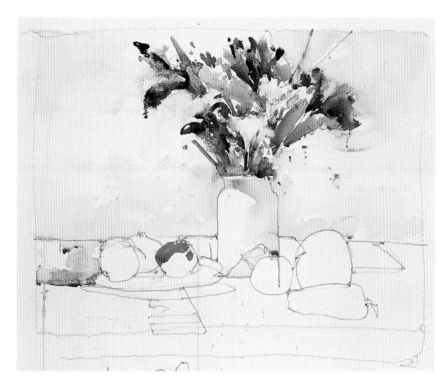

5 | Paint the Shadows and Start the Tablecloth

Soften the shadow on the round vase with very diluted Raw Sienna and allow it to mix on the paper with the blue. The warm Raw Sienna will give a color temperature tie-in with the apple. You want the light side of the tomato to be rich, so start with Cadmium Red. Remember to start your stroke where you want emphasis.

Start the pattern in the tablecloth with diluted Mineral Violet.

Paint the shadow side of the vase with a diluted Cerulean Blue and a little Raw Sienna background. Carry the Raw Sienna into the background on the right. Leave a hard edge and a subtle contrast between the vase and background on the light side and a lost edge and no contrast on the shadow side of the vase.

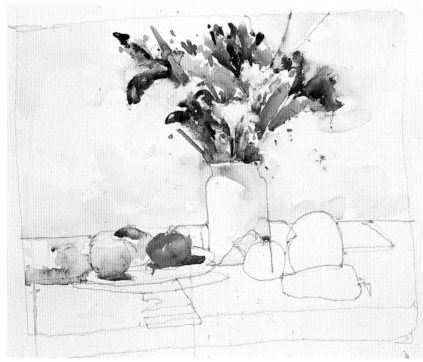

6 | Paint the Table Items and Add Cast Shadows

Finish the tomato and add a Cobalt Blue cast shadow wet-in-wet. There are two small white onions with a red Bermuda onion behind. Make sure that you don't mix the tomato color with the onion color. You want to keep the essence of whiteness in the smaller onions. Paint the onion on the left with a very diluted Cerulean Blue. Paint a diluted Raw Sienna cast shadow next to the onion's bottom. Allow the two colors to blend on their own. Paint the red onion with Carmine and Cerulean Blue. This darker shape brings the top of your white onion into focus. When the tomato is dry, paint the middle onion with Cerulean Blue and Cadmium Yellow Light.

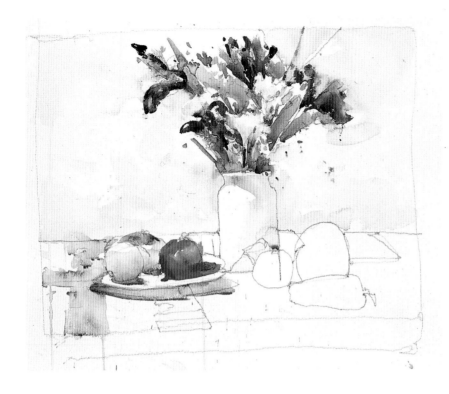

7 | Paint the Shadow and Cast Shadow of the Plate

Paint the shadow and cast shadow under the plate with only two strokes. You'll need a no. 10 round sable to manage this. Starting at the left, paint the rim of the plate with semidiluted Raw Sienna. When the rim is completed, rinse, shake and load the brush with semidiluted Cobalt Blue or Cerulean Blue. Starting at the left, point and press the brush to its midsection. The lower part of the brush makes a firm lower edge for the cast shadow. The top part of the brush runs along the still-wet rim. If you can manage these two strokes quickly, you'll get a blend and some of the Raw Sienna will merge with the blue. The darker rim and darker cast shadow boundary help the lighter, midshadow/cast shadow to suggest reflected or bounced light.

8 | Add the Tablecloth Pattern

Add the pattern of the tablecloth using Carmine, Mineral Violet and Ultramarine Blue. Never paint a pattern into a wet paper; patterns should be painted on dry paper and then softened in places to keep them from appearing rigid. They should be watery but definite in places. Always vary the values in your patterns.

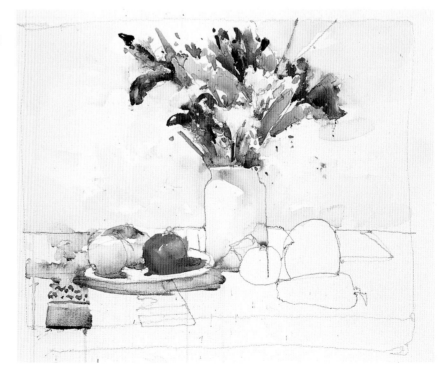

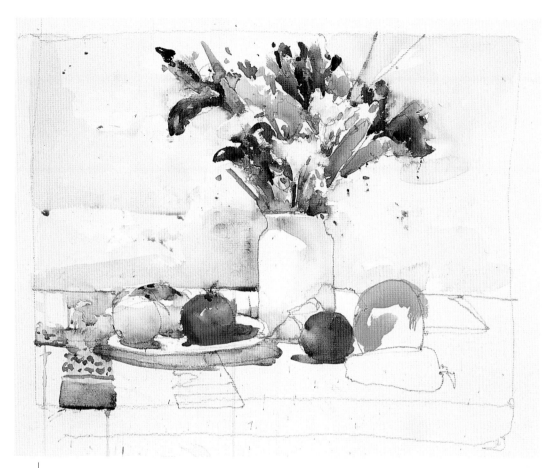

9 Create the Tomato and the Grapefruit

Add the other tomato under the vase. The upper part of the tomato has a hard edge with intense color. Lose the edge as you go down the left and light side of the tomato. Tie in the midsection of the tomato to the bottom of the vase by letting it soften and blend with the vase's bottom boundary. The cast shadow under the tomato is Raw Sienna. You don't want to repeat the cool cast shadow under the plate.

Start your grapefruit with Cadmium Yellow straight from the color supply with only enough water to keep your pigment fluid and workable. Always start your fruit on the light side so you keep strong local color. Avoid washed-out and vapid colors in your light areas.

COLORS FOR CAST SHADOWS

Students ask what color to use in cast shadows. Most cast shadows look a neutral gray, but cast shadows make great color notes, so choose a color that suits the painting. Never use a generic puddle color in any part of your painting. Cast shadows need to be rich and flavorful and always fresh. Check the colors you've used in an adjacent object and cast shadow. You don't want to repeat the same color idea, so vary the ratio and preparations of three colors: blue, red and yellow. Choose a blue for its value rather than its color. Choose Cerulean Blue for light areas, Cobalt Blue or Ultramarine Blue or Mineral Violet for dark areas. For red, use Carmine or Alizarin Crimson (Cadmium and other opaque reds don't make good mixers). For yellow, use Raw Sienna because it's so quiet and never dominates. Cadmium Yellow is too assertive.

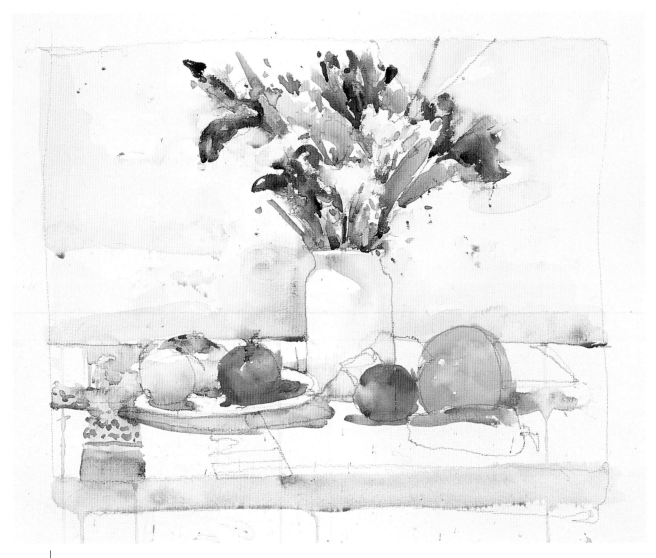

10 | Create the Table Edge and Finish the Grapefruit

Paint a strip of a slightly darker value to show the table edge. Use any diluted blue with Carmine/Alizarin, any yellow or Raw Sienna. Just make sure you mix the colors on the paper. Use plenty of paint and enough water to achieve your value. Complete the grapefruit. Don't try to show light and shadow. Stress the inherent value and color in the fruit and flowers, making forms defined by light and shade secondary. Add the Cobalt Blue cast shadow. Paint the green pepper, starting with the top and light side. Because the yellow grapefruit and the Cadmium Yellow Light mixed with Cerulean Blue in the pepper are compatible, you can paint the top of the pepper while the grapefruit is still wet. A blend between the grapefruit and the pepper would be fine here.

CREATING VISUAL UNITY

Always connect the objects in your painting with adjacent objects or the background. There's a tendency to paint an object really well and completely and then go on to the next thing. Don't do this. Instead, paint parts of your subject with exquisite care for shape and crisp edges— usually, but not always, these will be the parts out in the light—then blur and lose other parts.

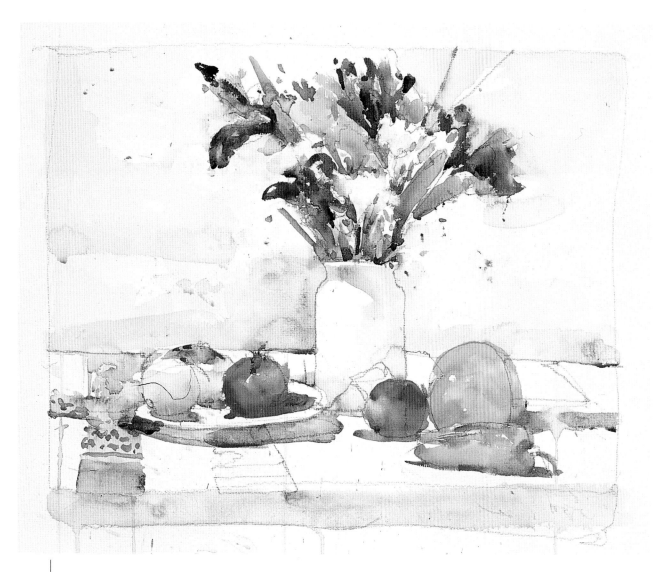

11 | Add Finishing Touches

Finish the lower part of the green pepper with a midvalue green of Cadmium Yellow Light and Cerulean Blue, leaving bits of dry white paper. Paint a dark blue cast shadow under your pepper. Doesn't the rich cast shadow make the pepper luminous?

IRIS AND FRUIT
Charles Reid
12" × 15" (30cm × 38cm)
Courtesy of Munson Gallery

PAINT COLOR AND VALUE

You can ignore light and shade when you're painting dominant colors and dark values. Don't stress dark shadows in a fruit or flower; instead, paint their local color and value. Hold a pepper or any fruit in your hand. Study it briefly. Close your eyes and then write your color and value impressions of the pepper, grapefruit or tomato. You'll probably remember the true color and value of your object. Paint the color and value you remember. Darks in shadow should never destroy the object's "lightness of being." Dark cast shadows are a wonderful way to enhance the true color of your objects. Never be bound by rules—no good painter follows them. They are only meant as signposts.

Seaside Still Life: Plein Air Painting

Materials

PAPER
140-lb. (300gsm) rough watercolor paper

BRUSHES
Nos. 3 and 10 rounds

WATERCOLORS
Alizarin Crimson
Antwerp Blue
Cadmium Orange
Cadmium Yellow
Carmine
Cerulean Blue
Cobalt Blue
Lemon Yellow
Mineral Violet (Holbein)
Olive Green
Opaque White (optional)
Peacock Blue
Ultramarine Blue
Viridian
Winsor Blue
Winsor Violet
Yellow Ochre

OTHER
Pencil

This reference photo was taken in very bright sunlight. If you are painting en plein air in direct sun, try to use an umbrella to shade your paper so you can properly judge your values. Also, never paint with sunglasses because they deaden values and colors.

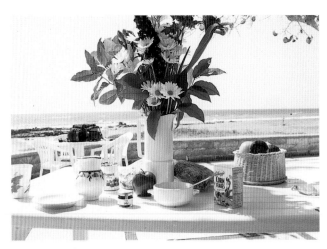

REFERENCE PHOTO

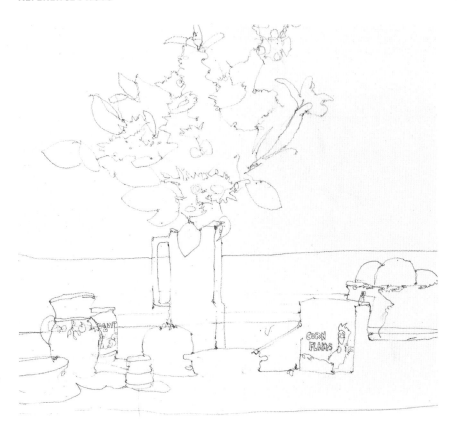

1 | Create a Contour Drawing

Working outside with the wind and light changing requires a speedy and concise drawing. There's no time for tentative sketching. Cast shadows are included with some of the objects. Notice the correction line on the vase. Don't correct; use your mistake to guide you for a better boundary.

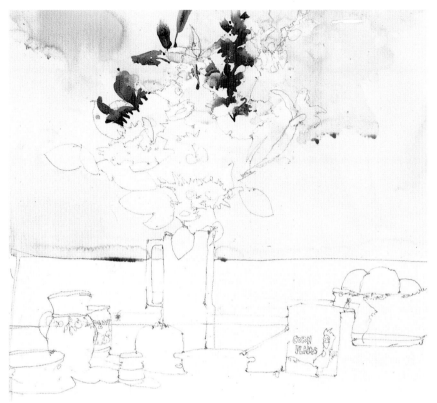

2 | Start With a Medium-Dark Value

Don't plan to overpaint—there's no time. Make the color rich, not a gray, watery mix from your palette's mixing area. Go to your paint supply. Use Winsor Violet or Mineral Violet with Cobalt Blue and Ultramarine Blue. Don't think a lot about what color you use. Your brush should go to darks—blues, greens, Olive Green— for the stems and unopened iris. Think more of what value you want.

Do a bit of watery Cerulean Blue sky. When it is dry, start with your dark blues, violets and greens. Get a good, rich color value. That's the game. Press, lift the brush with the handle at a forty-five-degree angle, then stroke up with your little finger on the paper.

TAKE A CLOSER LOOK

Here's a close-up detail. It's better to enrich with color wet-in-wet now. Don't do a weak flower and think you'll fix it later. Sometimes you start the stroke at the base of the petal; sometimes you start at the petal's tip and paint toward the base. Look at the leaves and flowers, then begin your stroke where you see the darkest color value. Think of placing strokes as spots of color. Think of oriental brushwork. Each stroke must have good water-paint consistency. Press the brush's midsection into the paper, then lift with a feathering stroke.

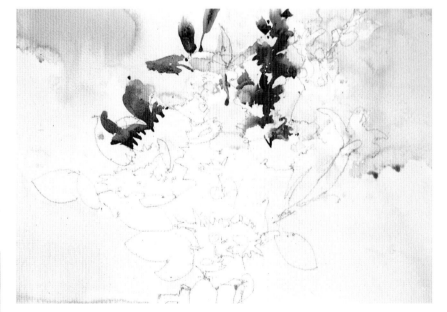

THE SECRET OF SUCCESSFUL WATERCOLORS

Do as little brushwork as possible. Let the water, paper and paint do most of the work.

3 | Paint the Blurred Iris, Daisy and Shadows

In some places, the paper will be dry. In other places, the paper will be wet. If necessary, you can add water or paint in the background next to the flower you're painting. Paint the blurred iris on the right into a damp background. Paint slowly and decisively. Make good, careful shapes. Notice the careful way the Mineral Violet and greens are painted around the upper side of the daisies: Viridian in some places, Olive Green in other spots. (Don't mix greens together. Get in the habit of going to the paint supply and choosing different greens or blues.) Paint the daisy on the left with Mineral Violet. Some edges are firm. If you want a firm edge, wait for the dark behind the daisy to dry before adding the daisy's shadow shape with diluted Cerulean Blue and a tiny bit of Cadmium Orange mixed lightly with water on your palette. Paint the shadow shape and let it drift out of the daisy into the background. Add a touch of pigment, either green or blue, near the daisy. Let the diluted color from the daisy mix with the darker blue or green. Let them mix on their own; try not to interfere.

4 | Create the Pink Flowers and Lemon

Paint the pink flowers with a diluted Alizarin Crimson or Carmine. Under the pink flowers, paint a section of green. Vary the values here. Don't fill it in as a solid mass or you will isolate the pink flowers from the daisies. Shadow shapes in the upper part of the daisies are important. The shadow shapes and carefully painted negative areas give the daisies form.

Use the ocean to define the vase. The shadow on the white vase should be very subtle and light in value. If it is too dark, it will destroy the whiteness of the vase. Paint in some sky. Any very watery blue will do down to the horizon. Starting from the left margin, paint a stripe of Antwerp Blue or any dark blue. Make a single stroke up to the vase handle and then behind, all the way to the right margin. When the stripe is almost dry, add a more diluted section of Antwerp Blue on the right, up to and around the drawing of the lemons and apple.

Allow the water to dry. Paint the lemon with Lemon Yellow at the top and a bit of Cadmium Yellow at the bottom. When the lemon is almost dry, paint the apple with Alizarin Crimson, leaving some white paper for highlights, then add the lemon on the right. Dampen the basket so some apple color seeps down.

5 | Paint the Water and Grass

Paint the closer water with a diluted Antwerp or Peacock Blue. Leave some whites above the rocks. There's surf with the strong breeze. Either scratch out whites with a penknife or use Opaque White.

Add the Olive Green grass when the water is still wet. It's very important to keep the sense of white in the vase, pitcher and yogurt container. Instead of shadows that might gray and dull the white containers, use the designs and patterns in the containers for your darks along with dark cast shadow shapes. You need to add definite, rich, small darks while you're painting an object. If you add them later, they'll look added on and out of context.

6 | **Paint the Foreground Water, the Apple and the Orange**

In the right foreground water, use Peacock Blue, a nice clean transparent color for shallow tropical waters. Winsor, Cerulean or Antwerp Blue could work here also. When the lemon is wet, add more blue cast shadow. Never paint an object without adding its cast shadow almost immediately. (The cast shadow can't be too watery. Use mostly paint, little water.) Paint the apple and orange, leaving white paper for highlights. When deciding what color to use in fruit, simply look at your palette's color supply and see what seems to match what you want to paint. Add a bit of dark blue wet-in-wet to the Alizarin Crimson in the apples. Add a bit of Yellow Ochre to the Cadmium Yellow for the lemon on the left.

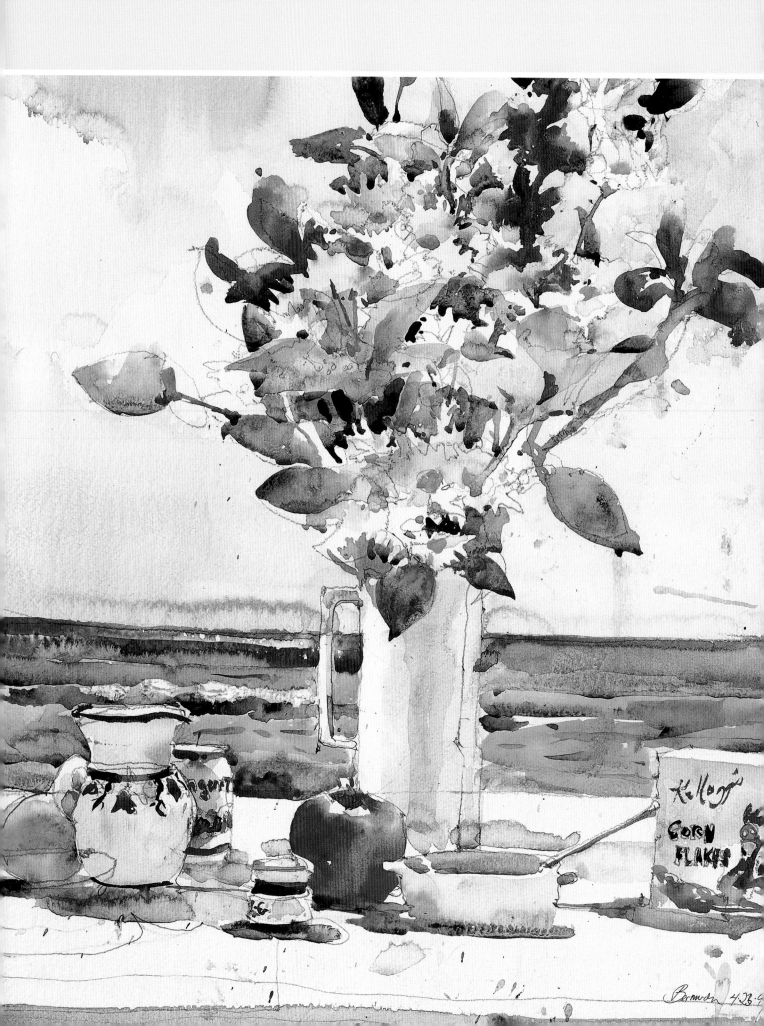

Bermuda 4.28.9

7 | Add the Final Details

Add the orange and the saucer on the far right. Add the corn flakes package and the cereal bowl. The artist used diluted Alizarin Crimson, Cobalt or Cerulean Blue and Yellow Ochre for light grays; this combination doesn't work well for many students. If you have a good gray, use it. When the corn flakes package's shadow value is dry, add the lettering with a no. 3 round brush.

Kellogg's Corn Flakes and Flowers
Charles Reid
20" × 24" (51cm × 61cm)

KEY TO COLOR

People think a picture will be good if they use the right colors. More important than the right color is the right color value. When painting outside with strong sunlight, no matter how strong the sun, your darks must remain dark in the light and white objects must retain their whiteness in shadow.

Fruit should always retain its strongest color out in the light. Fruit in shadow should keep its color. The darkest part should be where light and shadow meet.

Cast shadows are often darker than the light-valued objects that cast them. Cast shadows should be rich and dark, but not dense. They should have a feeling of light in them.

Flowers and Crystal: Creating Realistic Textures

Materials

PAPER
300-lb. (638gsm) rough
 watercolor paper

BRUSHES
Nos. 1, 2, 3, 4 and 5 rounds

WATERCOLORS
Burnt Sienna
Cadmium Orange
Cadmium Yellow Deep
Gold Ochre
Indian Yellow
Payne's Gray
Permanent Magenta
Permanent Rose
Permanent Sap Green
Quinacridone Burnt Sienna
Quinacridone Gold
Quinacridone Magenta
Quinacridone Red
Quinacridone Rose
Quinacridone Violet
Rose Doré
Ultramarine Turquoise
Winsor Red
Winsor Yellow
Yellow Ochre

OTHER
Pencil

This demonstration covers the full value scale (see page 57) in the painting of two crystal birds and three flowers. The glaze method of painting is time-consuming, so patience is a must! Let each layer, or *pass*, of color dry completely before painting another pass of values.

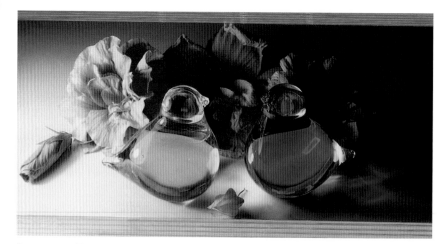

REFERENCE PHOTO
You may need to tape off portions of your photo to crop in and create an interesting composition.

VALUE SKETCH
Work out your values ahead of time with a thumbnail value sketch so you can figure out the value combinations that will really pop the subject from the background.

1 | Plan the Values and Begin Painting

Review the value scale on page 57 to help you determine relative value gradations. Plan the number 1 values and leave these areas alone. Mix and paint value 2 glazes on your palette (with the colors specified below), moving across the painting from left to right, letting each object dry completely before painting the object next to it.

Paint the left flower bud with a mixture of Yellow Ochre, Winsor Yellow and Rose Doré using a no. 4 brush. Use a mixture of Yellow Ochre and Rose Doré to glaze the larger left hibiscus, adding a glaze of Yellow Ochre toward the top of the bloom. This will give these flowers a warm glow.

Mix a glaze of Yellow Ochre, Burnt Sienna and Rose Doré, then paint the left crystal bird with your no. 3 brush.

Glaze the foreground with a pale Yellow Ochre glaze using your no. 4 brush. Let all glazes dry completely.

2 | Paint the Middle Flower

Mix a glaze of Cadmium Yellow Deep, Rose Doré and Indian Yellow, then paint the middle flower with your no. 4 brush. Let dry.

3 | Paint the Right Flower

Mix a glaze of Indian Yellow and Yellow Ochre, then with your no. 3 brush, paint the right crystal bird. When this glaze dries, add some Payne's Gray to the mix and paint in the bird's head and tail area with your no. 1 brush. This will begin the dark bands that make the crystal look like glass.

Paint the right flower using your no. 3 brush with a glaze of Burnt Sienna, Yellow Ochre, Permanent Rose and Permanent Magenta. Let dry.

4 | Continue Building the Values and Paint the Background

Mix and paint value 3 and then value 4 with the colors specified below, letting each object dry before painting the one next to it. Again, move from the left to the right as you paint.

Use your no. 4 brush to paint the left background with clear water, then drop in a Yellow Ochre glaze. Let the water and paint fuse to capture a smoky appearance. Let this glaze dry. Then mix a glaze of Yellow Ochre and Payne's Gray, and continue painting with your no. 5 brush from the middle background to the right side of the painting. Mix thinned Burnt Sienna into the Yellow Ochre–Payne's Gray background glaze mixture and paint the background on the right side with your no. 5 brush, helping this side become darker and more olive in appearance.

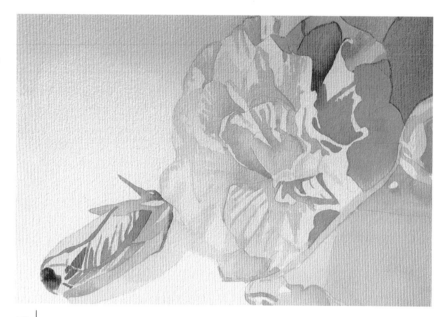

5 | Paint the Left Flowers

Make the green stem warm with reflected color from the surrounding flowers by painting it wet-in-wet with a mixture of Cadmium Orange, Payne's Gray and Permanent Sap Green and your no. 3 brush.

Add Cadmium Orange on the tips of the flower bud with your no. 1 brush. Continue the bud, painting in the veins with your no. 2 brush and Winsor Red.

Work on the bud's shadow by mixing Rose Doré and Cadmium Orange into the Winsor Red to give the shadow ambient color.

Paint the larger bloom wet-in-wet using your no. 2 or no. 3 brush, beginning cooler areas with a mixture of Rose Doré, Winsor Red and Permanent Rose.

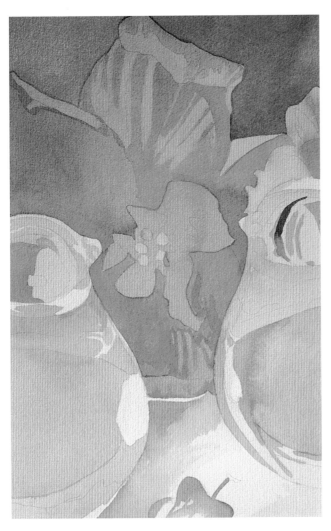

6 | Paint the Left Bird and the Middle Flower

Paint the left crystal bird wet-in-wet using your no. 2 brush with a glaze made from Cadmium Orange and Burnt Sienna plus the mixture on your palette from the left flowers and shadow.

Paint the foreground with this same mixture, adding some Yellow Ochre and Cadmium Yellow Deep.

Paint the middle flower with a mixture of Burnt Sienna, Indian Yellow, Cadmium Yellow Deep and Cadmium Orange. For cooler areas on the flower, use your no. 3 brush and a glaze of Quinacridone Burnt Sienna and Winsor Red.

When these glazes dry, mix a glaze of Indian Yellow, Cadmium Orange and Cadmium Yellow Deep for the center of the flower, then paint with your no. 2 brush.

7 | Paint the Right Side of the Painting

Paint the right crystal bird using your no. 2 brush with a glaze of Cadmium Orange and Burnt Sienna. When this dries, continue painting the bird's head with a glaze of Burnt Sienna, Yellow Ochre and Payne's Gray.

With your no. 3 brush, paint the right flower with a Quinacridone Burnt Sienna glaze, then use a mixture of Quinacridone Rose, Quinacridone Violet and Burnt Sienna to glaze the bottom of the flower.

Add some of this darker glaze to the head and tail of the right bird as reflected color. Also go back in with this color on the bottom of the left bird and the left flower shadow using your no. 1 brush.

Create a deeper value toward the center of the right flower using your no. 3 brush with a glaze mixed from Rose Doré, Payne's Gray, Burnt Sienna, Quinacridone Burnt Sienna and Quinacridone Rose. Let all glazes dry completely.

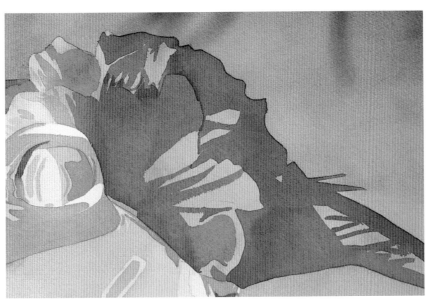

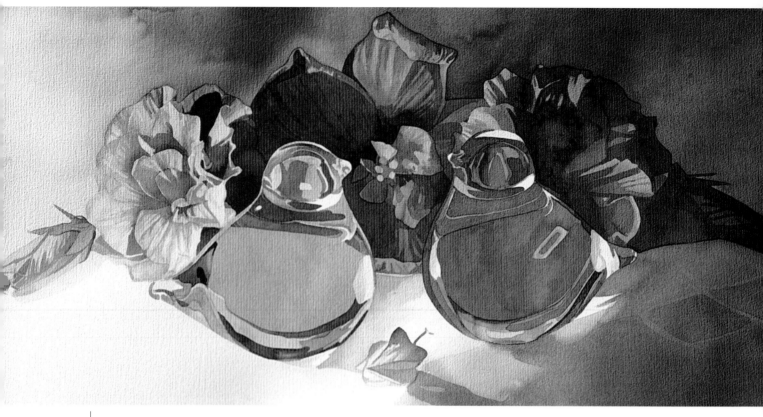

8 | Build the Darker Values and Paint the Background

Mix and paint values 5, 6 and 7 with the colors specified below, again letting each object dry before painting the one next to it as you move from left to right.

Use your no. 5 brush to add clear water to the left side of the background, pulling it over to the right side of the painting. Mix a glaze from Payne's Gray, Yellow Ochre and a small dollop of Burnt Sienna, and let it fuse with the water on the right side of the background. Let dry.

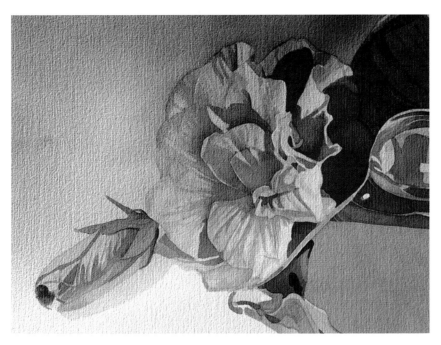

9 | Paint the Left Flowers

Use your no. 2 brush to paint the large flower bloom on the left with a glaze of Cadmium Yellow Deep and Rose Doré, going over all of the bloom except the highlights. Let dry.

Deepen the inside folds with a glaze of Winsor Red and Rose Doré, topping the edges of the petals with a mixture of Gold Ochre, Rose Doré, Burnt Sienna and Cadmium Orange and your no. 1 brush.

Add some Winsor Red to the inside of the flower bud and under the greenery of the stem. Add a mixture of Permanent Sap Green and Payne's Gray to the stem to add dimension. Add a glaze of Burnt Sienna, Winsor Red and Rosé Dore to the shadow.

10 | Paint the Left Bird and the Middle Flower

Use the Burnt Sienna–Winsor Red mixture from the previous step to glaze the left crystal bird using your no. 3 brush.

Use your no. 1 brush to paint a mixture of Cadmium Yellow Deep, Yellow Ochre, Burnt Sienna and Rose Doré on the bottom curves of the bird and on the top of the bird's head. Paint a glaze of Payne's Gray on the bands of color in the bird's head to darken them.

Paint the middle flower using your no. 2 brush with a mixture of Quinacridone Gold, Burnt Sienna, Quinacridone Red, Payne's Gray, Yellow Ochre and Cadmium Orange. Paint the center wet-in-wet with your no. 1 brush, dropping in Winsor Red in the center as ambient color reflected from the hibiscus on the left.

To add light behind the flower petals, make the petal more gold by adding a glaze of Indian Yellow and Rose Doré. Add veins to the petals with a mixture of Burnt Sienna and Payne's Gray and your no. 1 brush, going wet-in-dry.

When dry, glaze the center of the flower with a mixture of Indian Yellow, Cadmium Orange and Rose Doré. When dry, add a glaze of Payne's Gray behind the center stamens.

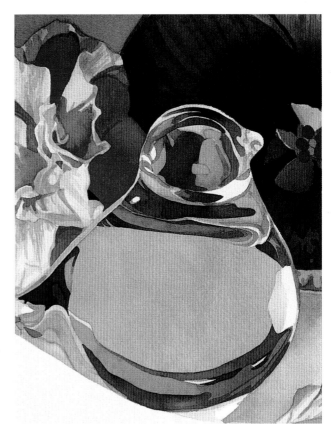

11 | Paint the Right Bird

Mix Quinacridone Magenta, Yellow Ochre, Quinacridone Burnt Sienna, Quinacridone Violet and Payne's Gray, then paint the right bird with your no. 3 brush.

When dry, use your no. 1 brush to paint the colored bands of the bird with a mixture of Rose Doré and Indian Yellow, adding whatever is already mixed on your palette. Let each band dry.

For the bird's dark bands, glaze on Payne's Gray with your no. 1 brush, keeping the edges hard. When this dries, add Ultramarine Turquoise to the top of the head and tip of the beak as a complementary and unexpected color.

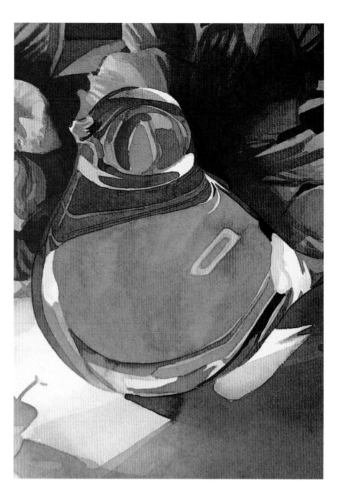

12 | Paint the Right Flower

Paint the shadow areas of the right flower with a mixture of Rose Doré, Burnt Sienna, Quinacridone Violet, Payne's Gray, Quinacridone Rose and Permanent Magenta with your no. 3 brush. Use this same glaze to paint in the veins of the petals with your no. 1 brush.

13 | Add the Darkest Values and Paint the Flowers on the Left Side

Mix and paint your 8, 9 and 10 values with the colors specified below. Continue moving from the left to the right, letting each object dry before painting the one next to it.

Use your no. 2 brush to paint over the entire flower bud and leaf with a Cadmium Yellow Deep glaze to create the illusion that this flower is in bright light.

Deepen the folds of the larger bloom with a mixture of Permanent Rose, Rose Doré and Winsor Red, helping the hibiscus appear to turn from the inside to the outside.

Paint the edges of the petals with your no. 2 brush, using a glaze made from Gold Ochre, Rose Doré and Burnt Sienna.

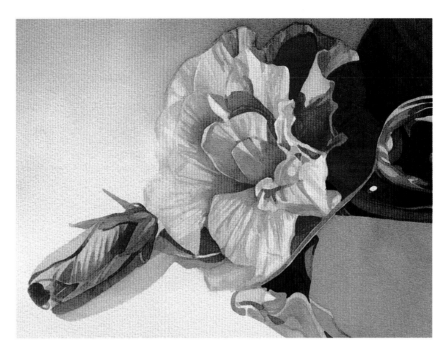

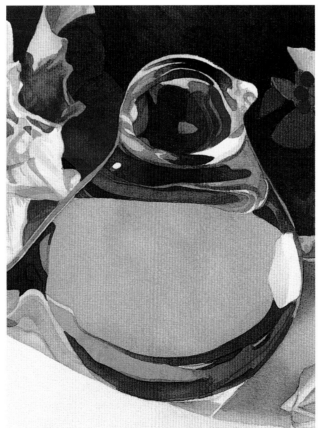

14 | Paint the Left Bird

Use your no. 1 brush and the glaze from the left flower (previous step) to paint the lighter bands on the bird. Paint the dark bands on the left bird with a mix of Payne's Gray and Burnt Sienna.

15 | Paint the Middle Flower

Paint the middle flower using your no. 3 brush with a mixture of Payne's Gray, Quinacridone Burnt Sienna, Winsor Red, Gold Ochre and Cadmium Orange.

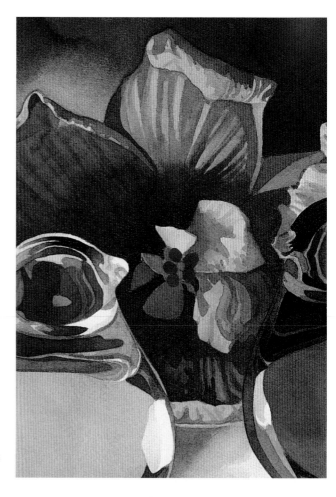

16 | Paint the Right Bird

Paint the bands on the right bird with a mixture of Payne's Gray and Burnt Sienna using your no. 1 brush. Make the reds on the bird darker with a glaze of Permanent Magenta and Winsor Red to help the bird appear to be in shadow.

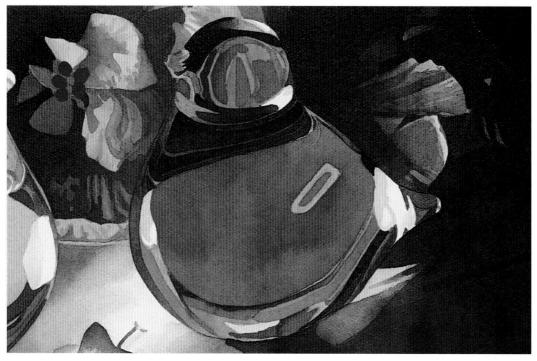

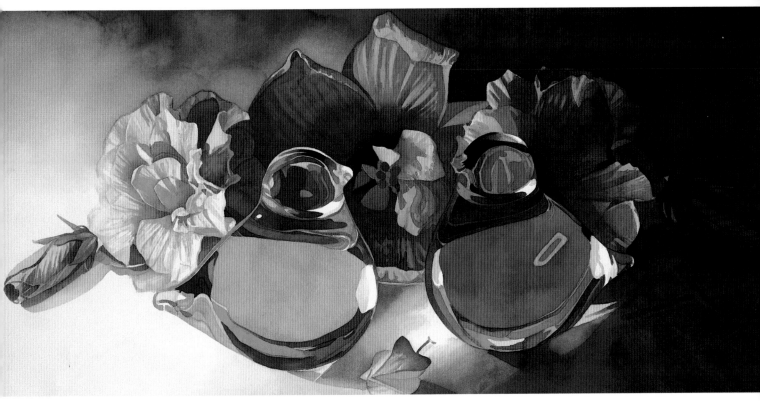

17 | Paint the Right Flower and the Background

Paint the right flower with a glaze of Payne's Gray, Permanent Magenta, Permanent Rose and Burnt Sienna to put this flower in shadow as well.

Use your no. 5 brush to paint clear water over the middle of the background. Mix a glaze of Payne's Gray and Yellow Ochre, and drop it into this wet area, going from the right middle to the far right side of the background.

Let all dry and you're finished!

TWO-STEPPIN' TWINS
Susanna Spann
20" × 40" (51cm × 102cm)
Collection of Carol and Edward Lecuyer

Flowers and Silver: Using Multiple Reference Photos

Materials

PAPER
300-lb. (640gsm) cold-pressed
 watercolor paper

BRUSHES
Nos. 4 and 8 rounds

WATERCOLORS
Alizarin Crimson
Aureolin
Cobalt Blue
French Ultramarine Blue
New Gamboge
Permanent Rose
Quinacridone Gold
Raw Sienna
Rose Madder Genuine
Winsor Green

OTHER
2H pencil
Kneaded eraser
Soft rags or paper towels
Dr. Martin's Bleed-Proof White

In this demonstration you will learn
how to use multiple reference
photographs to capture the details
for one painting.

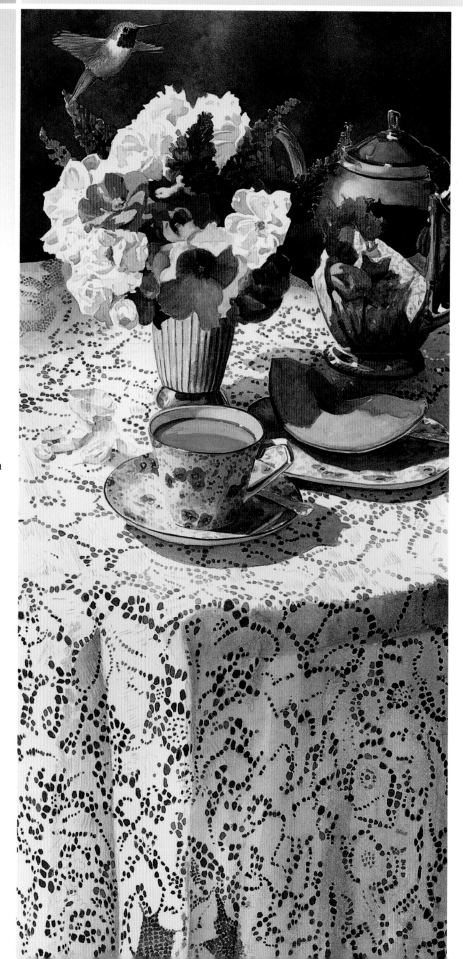

BREAKFAST FOR TWO
Adele Earnshaw
23" × 12" (58cm × 30cm)
Collection of Lt. Col. Peter and Mrs. Anne
Pitterle, USMC (Ret.)

REFERENCE PHOTO FOR SILVER

Silver is so reflective that it tends to get lost against either a dark or light background when you photograph it. You can see in the reference photos that parts of the silver pitcher have disappeared against the lace tablecloth.

VALUE REFERENCE FOR SILVER

REFERENCE PHOTO FOR FLOWERS

This shot gives a better portrayal of the flowers.

VALUE REFERENCE FOR FLOWERS

1 | Create Your Drawing

Create your drawing with a 2H pencil using the pitcher from one photograph and the flowers from the second photo. Pencil in edges that got lost in the background. Draw all the details: the little blobs of dark, the shapes that will stay the white of the paper and the detail on the handle. Use your kneaded eraser to avoid damaging the paper.

Don't try to draw each petal of the flowers. If you can't distinguish where one petal ends and the other begins, then paint it that way. Remember to save the white of the paper for the lightest value on the center roses. This is how you will give the effect of sunlight bouncing off the petals.

Crosshatch the dark areas to serve as landmarks when you paint.

2 | Lay the First Washes

Glaze the light parts on the dark band across the center of the pitcher with a little Cobalt Blue, using your no. 8 round. Glaze the other lighter values of the pitcher with a pale mix of Raw Sienna and Permanent Rose. Look carefully at the lid; a few spots need a wash of Cobalt Blue. Switch to a no. 4 brush for the more detailed areas.

Glaze the pink roses on the left with a thin wash of Rose Madder Genuine. Wash over the mauve rose on the right with a light mix of Rose Madder Genuine and Cobalt Blue. Wash the pale multicolored rose with the gold center with an underpainting of Aureolin and Rose Madder Genuine, saving the white of the paper for the top petals of this flower.

The pretty yellow rose with pink edges has a lot of white paper in the center. Underpaint the yellow part of the rose with a thin wash of Aureolin. Paint the pink edges with Permanent Rose.

There's a white rose at the top of the arrangement, but because the background of this painting will be the white paper, we'll change the color of this rose to pink.

Paint the light values on the purple butterfly bush with a mixture of Permanent Rose and Cobalt Blue. Paint the pink, frothy flower with Permanent Rose. Paint the little bits of green with a mixture of Quinacridone Gold and Winsor Green.

3 | Paint the Middle Values

Use your no. 8 round to wash the middle values of the handle and the foot of the pitcher with Raw Sienna and a little Cobalt Blue. The bump on the inside part of handle is warmer, so add some Permanent Rose to this spot. The dark reflection across the center of the pitcher is reflecting blue sky and clouds. Wash this blue with a medium value of pure Cobalt Blue. Paint the streak on the right side of the pitcher with a mixture of Permanent Rose and Raw Sienna, but add blue as it moves upward. Apply a pale glaze of Raw Sienna to the lid, adding a tiny bit of Winsor Green as you move closer to the flowers.

Adding the middle values of the flowers will start to give the flowers depth. With a medium-value wash of Cobalt Blue and Rose Madder Genuine using your no. 8 round, glaze the petals of the mauve rose on the right. Apply the color just at the bottom and soften it with a damp brush, dragging the color out to a lighter value. Now do the same with the pink rose on the left with Rose Madder Genuine, and the yellow rose with New Gamboge, adding Permanent Rose at the base. The center of the pale multicolored rose is blue, so use Cobalt Blue to paint it. The edges of the petals are pinker, so use Permanent Rose here. Leave the red rose unpainted for now.

4 | Develop the Middle Values

The bottom half of the pitcher's dark reflection has blue in it, so paint that entire section French Ultramarine Blue and Permanent Rose using your no. 8 round. Remember that we are using the pitcher from one photograph and the flowers from another. If you look at the reference photo you are using for the flowers, you'll notice that the red rose is reflecting in the silver. Using Permanent Rose and New Gamboge, use your no. 8 brush to paint a reflection as you see in the flower reference photo. Then switch to your no. 4 round and paint some of the darker values in the base of the pitcher using Raw Sienna and Cobalt Blue. Systematically paint all the darker medium values, without putting in detail yet.

Use your no. 8 round to wash the red rose in a medium-dark wash of Alizarin Crimson, Permanent Rose and New Gamboge. Leave a white edge around a few of the petals. This initial wash covers up most of the drawing. The white edges will serve as landmarks as you paint the rose.

Develop the medium values in the other roses, using the same color mixtures as in the previous steps, but with less water to make the values stronger.

As the values get darker and more detailed, you'll use your no. 8 round less and your no. 4 round more. Remember that you are working loose to tight, light to dark.

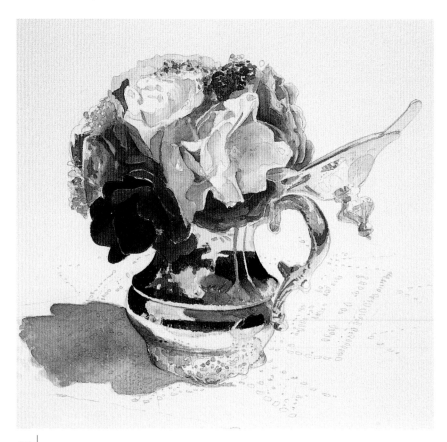

5 Start the Detail Work

Use your no. 8 round to paint the dark band around the middle of the pitcher, and a mixture of Alizarin Crimson, Winsor Green and French Ultramarine Blue. Now get picky and paint some of the looser detail at the base of the pitcher with your no. 4 round and a mixture of Cobalt Blue and Raw Sienna. Define the detail in the lid and handle with this same combination. Use Cobalt Blue on the handle of the lid.

The shadow will help anchor the pitcher to the table, but it doesn't need much detail. Use your no. 8 brush to paint the shadow with a combination of Cobalt Blue, Permanent Rose and Raw Sienna. Start at the back of the shadow, and as you move toward the front of the shadow, add more Raw Sienna to the mixture.

Use your no. 8 round to apply a dark mixture of Alizarin Crimson, New Gamboge and French Ultramarine Blue for the darker values on the red rose. Don't worry about detailing this rose too much. Switch to your no. 4 round and hop from flower to flower, darkening values, using the same color combinations as in the previous step, but with less water in the mixture.

The overlapping petals and areas between petals can be confusing. Use your no. 8 brush and a medium wash of Permanent Rose to glaze over the areas between the flowers. This will unify these confusing spots, giving them some cohesion and knocking back the value in these areas, making them less prominent.

MAY FLOWERS
Adele Earnshaw
9" × 10" (23cm × 25cm)
Collection of Wick Ahrens

6 | Make It "Pop"

Use your no. 8 round and a medium-value mix of Cobalt Blue and Permanent Rose to darken the shadow closest to the pitcher on the tablecloth; then soften the edge.

With a medium-value wash of Cobalt Blue, glaze over the dark middle band on the pitcher, except for the palest value left of center. This pulls together all the areas you previously painted.

Darken the lower-left side of the pitcher using a no. 4 round and a mixture of Alizarin Crimson and Winsor Green to make it stand out a little against the shadow.

Use your no. 4 brush and a mixture of Winsor Green and Alizarin Crimson to noodle the dark detail on the handle. If you're hesitant to darken an area, pencil it in first with your 2H pencil. Don't forget the darks and reflected lace holes on the lid. Once you finish the darks on the pitcher and your paper is dry, glaze over the base and the handle of the pitcher with Raw Sienna, sometimes adding a tiny bit of Permanent Rose to the mix. This softens the hard edges of your darks a little and adds color to the silver. If your pitcher appears a little flat, use a damp brush on dry paper to lift a little line of paint on the right and left sides of the pitcher, just about ⅟₁₆" (2mm) in from the edge. Now on the light parts of the pitcher reverse the process, putting a slightly darker-value line just a little in from the edge. This will make the pitcher look round. Next paint the lace holes on the tablecloth using your no. 4 brush and a mixture of Cobalt Blue and Permanent Rose. Add some French Ultramarine Blue for the darker spots.

Putting the darks in the flowers will really make the arrangement "pop!" Paint the green of the yarrow with a medium-value combination of Quinacridone Gold and Winsor Green. Then while it is still wet, hit the base of the yarrow with a dark mixture of Quinacridone Gold and Winsor Green and Alizarin Crimson. This will soften into the still-wet lighter wash you just applied.

Paint the gold center of the pale rose using New Gamboge and Permanent Rose. For the dark center, add a little French Ultramarine Blue to the mixture. Saving the white paper for the lightest value and using transparent watercolors will give your flowers vibrancy.

Gallery

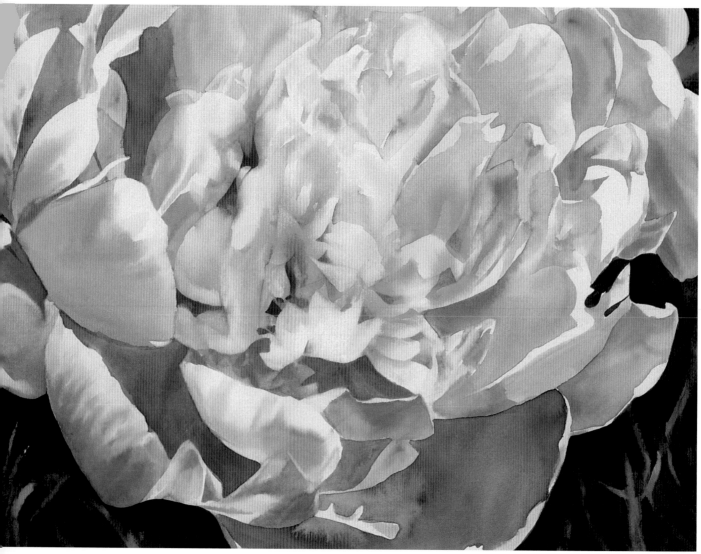

SUNNY PEONY
Ann Pember
14½" × 21½" (37cm × 55cm)

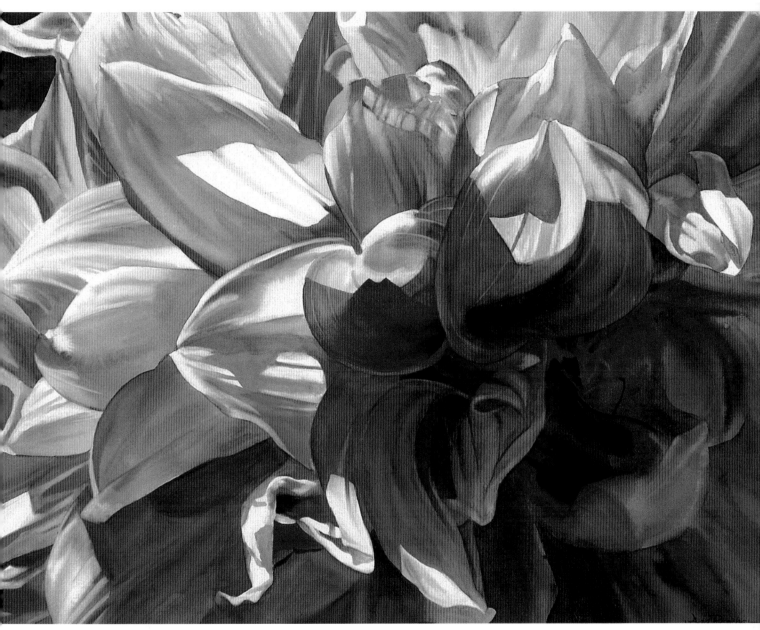

DYNAMIC DAHLIA
Ann Pember
21" × 29" (53cm × 74cm)

Index

Amaryllis, 73
Analogous colors, 44, 45, 134, 136
Angled brush, 13
Apple blossoms, 2, 96–97
Atmosphere, 46

Background, 31, 67, 101
Backlighting, 131–133
Balanced design, 68
Basswood board, 20
Bird's-eye view, 85
Bleed, 80
Bloom, 33, 54
Board
 basswood, 20
 gator, 20
 tilted, 12
Brushes, 13–14
 loading, 26, 29
 stiff bristle, 104
 See also specific types of brushes
Brushstroke
 for background, 67
 basic, 29
 controlling brush for accurate, 30–31
 controlling edges with, 156–163
 perpendicular or angular, 129
Brushwork
 minimizing, 165
 practicing, 128–130

C composition, 80
Cast shadow, 57, 59, 62, 147–148, 159
 colors for, 161
 dark, 163
 hard-edged, 93
 in black and white, 57
 in color, 57
 light-valued objects and, 171
Charging, 37, 96
Chemical reactions, 33
Chroma, 44
Circular flowers, 72
Clustered flowers, 72
Color(s)
 adding, 38
 adjusting, 49
 altering, 17

analogous, 44, 45, 134, 136
basic palette of, 15
cast shadows and, 57
charging in, 96
complementary, 44, 45, 48, 59
graying down, 48
lifting, 92
matching, 48–49
mingling, 54–55, 98–99
mixing. *See Mixing color*
pass of, 172
primary, 44, 48
pure, 53, 126
repetition of, 45
secondary, 44
softening, 40
temperature, 46–47
terms related to, 44, 47
tertiary, 44
value and, 163
warming up, 49
Color mixing. *See Mixing colors*
Color scheme, 140
Color wheel, 44, 134
Complementary colors, 44, 45, 48, 59
Composition
 balanced, 68
 ineffective, 69
 planning, 64
 strong, 69
 types, 80–85
Conical flowers, 72
Connecting elements in paintings, 152–155
Contour drawing, 78, 146, 164
Cool colors, 44, 46
Corrections, wet-in-wet technique for, 158
Crosshatching, 184
Crystal, flowers and, 172–181
Curve form, 40

Daffodils, 77, 146–149
Dahlia, 72, 128–130, 189
Daisies, 94–95, 166
Darks
 capturing, 127
 in cast shadows, 163
 charging in, 65
 painting with palette knife, 42
Depth of field, 47

Design, balanced, 68
Direct painting, 24. *See also Wet-on-dry painting*
Drawing, contour, 78, 146, 164
Drops, 33
Drybrushing technique, 25, 27

Easel, 12
Edges
 controlling, with brushstrokes, 156–163
 firm, 166
 hard, 74–75, 102, 124, 141, 145
 soft, 74–75, 102, 141, 145
 varied, 74–75, 157
Eye movement, 47

Feathering stroke, 165
Finishing stage, 139
Firm edge, 166
Flare effect, 34, 93
Flat brush, 13
Floodlight effect, 102
Floral still life, loose approach, 146–149
Flower(s)
 buds, 72
 circular, 72
 clusters, 72, 77, 131–133
 conical, 72
 crystal and, 172–181
 developing individual, 126
 essence of, 67
 floral improvisation, 134
 large and simple, 150–151
 radiating forms, 77
 shapes, 72
 silver and, 182–187
 transparent washes for, 92
 See also specific types of flowers
Foreground techniques, 40–41
Form
 creating illusion of, 57
 curved, 40
 defined, 66
 leaf, 78–79
 See also Shape(s)
Found edges. *See Hard edges*
Foxglove, 35
Fritch scrubber, 13, 104
Fruit, 151, 156, 163, 167, 169

Gardenia, 78–79
Gator board, 20
Geometric shapes, 66
Gladiola, 114–123
Glazing, 25
Granulating colors, 16
Grays, mixing vibrant, 56
Greens, mixing, 59, 78, 141
Gum Arabic medium, 16

Hair dryer, 38
Hake brush, 14, 36
Hard edges, 74–75, 102, 124, 141, 145
Hibiscus, 68, 71
High-contrast spotlight effect, 114–123
High-key paintings, 102
Highlights, white of paper, 58
Hollyhock, 102–113
Homasote, 20
Hue, 44
Hydrangea, 72

Intensity of color, 44
Iris, 156–163, 166

Key, 44

Leaf forms, developing, 78–79
Lifting color, 40, 92
Light
 backlighting, 131–133
 floodlight effect, 102
 shadow and, 62–63, 70
 sources of, 19
 spotlight effect, 114–123
 sunlight, 171, 184
 value and, 70
Limited palette
 mingling colors with, 98
 using, 99–101
Liner (brush), 13
Local color, 58–59
Loose approach, 146–149
Lost edges. *See Soft edges*

Magnolia, 89
Masking fluid, 18
Masonite, 20
Materials. *See Supplies*
Middle values, 64, 185
Mixing color, 48–56

basic principles, 52
greens, 59, 78, 141
matching color vs., 48
optical, 49
on paper vs. palette, 146
triadic pigments, 50
vibrant grays, 56
Mums, 150–151

Negative shapes, 66–69, 71, 137, 140–144
Neutral, 47
Nonstaining colors, 16
Nonstaining transparent pigments, 50–51

Opaque pigments, 50–51
Organic shapes, 66
Overdefining, 67
Oversaturation, 127
Oxgall medium, 16

Paint, 15–17, 26, 29, 36
Painting area, 19
Palette, 14
 basic colors, 15
 limited, 98–101. *See also*
 Limited palette
 mixing color on, 146
Palette knife, painting with, 42–43
Pantograph, 88–89
Paper supports, 20
Paper, 13
 mixing color on, 146
 stretching watercolor, 21
 white of, 58
Pencil sketch, 114
Peony, 72, 188
Perspective composition, 85
Petal shapes, 72
Phlox, 99–101, 131–133
Pigment, 34, 47, 50–51
Plein air painting, 164
Plexiglas, 20
Pointillism, 49
Positive shapes, 66–69, 71, 137, 140–144
Pouring colors, 135, 136, 140
Primary colors, 44, 48
Pump sprayer, 143
Pure color, 53, 126

Reference photos
 cropping, 172
 enlarging, 86–87, 88–89
 finding lights in, 62
 lighting for, 70–71
 using multiple, 182–187
Reflections, 71
Refractions, 71
Rhododendron, 124–125
Rose, 64–65, 80, 139
Round brush, 13, 28–31

S composition, 83
Salt, 43
Seaside still life, 164–171
Secondary colors, 44
Sedimentary colors, 16
Shade, 17, 47
Shadow
 cast. *See Cast shadows*
 defining shapes with contrast and, 94–95
 light and, 62–63, 70–71
 tie in subjects with, 151
Shape(s), 66
 arranging, in painting, 68
 balancing composition with, 68
 dark, 62
 defining, 74–75, 94–95
 detailed, mixing on paper, 77
 flower and petal, 72
 geometric, 66
 light, 62
 lighting, for photo shoots, 70–71
 linking, 100
 organic, 66
 planning, 66
 positive and negative, 66–69, 71, 137, 140–144
 simple, mixing on paper, 76
 See also Form
Silver, flowers and, 182–187
Soft edges, 74–75, 102, 141, 145
Spattering, 32
Sponge, 141
Spotlight effect, 114–123
Spray bottle, 18
Sprayer, 136, 143
Spraying colors, 32, 38
Staining colors, 16
Staining transparent pigments,

50–51
Still life
 floral, loose approach, 146–149
 seaside, 164–171
 sunflower, 152–155
Streaked effect, 96
Studio setup, 12
Sunflower still life, 152–155
Sunlight, 171, 184
Supplies
 brushes, 13–14
 masking fluid, 18
 miscellaneous, 19
 paints, 15–17
 palette, 14
 paper, 13
 spray bottle, 18
 water containers, 18–19
"Sweet spot" of *X* composition, 84

T composition, 81
Taboret, 12
Techniques
 combination of, 43
 drybrushing, 25, 27
 glazing, 25
 wet-in-wet, 24. *See also*
 Wet-in-wet technique
 wet-on-dry, 24, 93
Temperature, colors, 46–47
Tertiary colors, 44
Texture, 32–33, 172–181
Tint, 17, 47
Tone, 17, 47
Transparent pigment, 16
Transparent washes, 92–93
Triadic pigments, 50
Trigger sprayer, 136, 143
Tulips, 87

Underwashes, cool, 94

Value, 44
 color and, 163
 dark, 65
 enhancing, 93
 for illusion of form, 57
 light and, 70
 local color, 58–59
 middle, 64, 185
 variation in, with wet-in-wet

technique, 67
Value pattern, enhancing, 138
Value scale, 57
Value sketch, 64, 103, 115, 172
Vignette effect, 133
Visual unity, 162

Warm colors, 44, 46
Washes, 34
 building, 41
 even, 26
 flowing onto paper, 37
 foundation, 92
 tips for successful, 39
 transparent, 92–93
 wet-in-wet, 34–41. *See also*
 Wet-in-wet technique
Water, balance between pigment and, 34
"Water, shake, palette, paint", 30
Water containers, 18–19
Watermarks, 38
Water-to-paint ratios, 26–27, 130
Wet-in-wet technique, 24, 34–41
 for corrections, 158
 paint ratio for, 26
 variation in value with, 67
Wet-on-dry technique, 24, 93
Window frame, 147

X composition, 84

Y composition, 82

Zigzag strokes, 26

The best in fine art instruction and inspiration is from North Light Books!

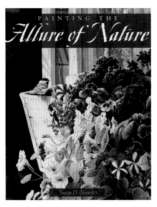

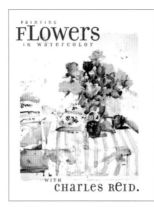

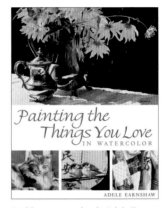

Take advantage of the transparent, fluid qualities of watercolor to create startling works of art that glow with color and light! Jan Fabian Wallake shows you how to master special pouring techniques that allow pigments to run free across the paper. There's no need to worry about losing control or making mistakes. Wallake empowers you to trust your instincts and create glazes rich in depth and luminosity.

ISBN 1-58180-487-3, PAPERBACK, 128 PAGES, #32825-K

Nature paintings are most compelling when juxtaposing carefully textured birds and flowers with soft, evocative backgrounds. Painting such realistic, atmospheric watercolors is easy when artist Susan D. Bourdet takes you under her wing. She'll introduce you to the basics of nature painting, then illuminate the finer points from start to finish, providing invaluable advice and mini-demos throughout.

ISBN 1-58180-458-X, PAPERBACK, 144 PAGES, #32710-K

Charles Reid is one of watercolor's best-loved teachers, a master painter whose signature style captures bright floral still lifes with a loose spontaneity that adds immeasurably to the whole composition. In this book, Reid provides the instruction and advice you need to paint fruits, vegetables and flowers that glow. His step-by-step exercises help you master techniques for painting daffodils, roses, sunflowers, lilacs, tomatoes, oranges and more!

ISBN 1-58180-027-4, HARDCOVER, 144 PAGES, #31671-K

In this gorgeous book, Adele Earnshaw shows you how to colorfully combine your favorite nostalgic items like handmade quilts, china and lace with small songbirds or kittens, then bathe them all in beautiful sunlight. You'll find guidelines for developing any heart-warming memory or curious story into a lovely composition. Each step is shown through invaluable mini-demos with finished examples.

ISBN 1-58180-181-5, HARDCOVER, 128 PAGES, #31948-K

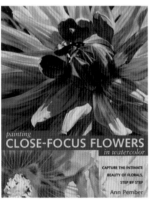

Infuse your watercolor florals with drama and intimacy! In these five step-by-step demonstrations and easy-to-follow instructions, Ann Pember shows you how to capture nature's beauty up close. You'll learn how to mingle colors, manipulate light and design dynamic compositions. It's all the information you need to portray stunning, close-focus flowers with confidence and style.

ISBN 0-89134-947-2, HARDCOVER, 128 PAGES, #31604-K

Packed with insights, tips and advice, *Watercolor Wisdom* is a virtual master class in watercolor painting. Jo Taylor illustrates every important technique with examples, sketches and demonstrations, covering everything from brush selection and composition to color mixing and light. You'll learn how to find your personal style, work emotion into your work, understand and create abstract art and more.

ISBN 1-58180-240-4, HARDCOVER, 176 PAGES, #32018-K

Capture the unmatched beauty of crystal and flowers in watercolor. Susanna Spann teaches you to build your painting layer by layer and value by value to create work that is full of drama and feeling. Detailed mini-demos, instructional art and a complete painting demonstration will arm you with the skills you need to successfully portray the texture, glowing light and color of crystal and flowers.

ISBN 1-58180-031-2, HARDCOVER, 128 PAGES, #31799-K

No matter how little free time you have, this book gives you the confidence and skills to make the most of every second. Learn how to create simple finished paintings within 60 minutes, then attack more complex images by breaking them down into a series of "bite-sized" one-hour sessions. Patrick Seslar gives you 12 step-by-step demos make learning easy and fun.

ISBN 1-58180-035-5, PAPERBACK, 128 PAGES, #31800-K

These books and other fine North Light titles are available from your local art and craft retailer, bookstore, online supplier or by calling 1-800-448-0915.